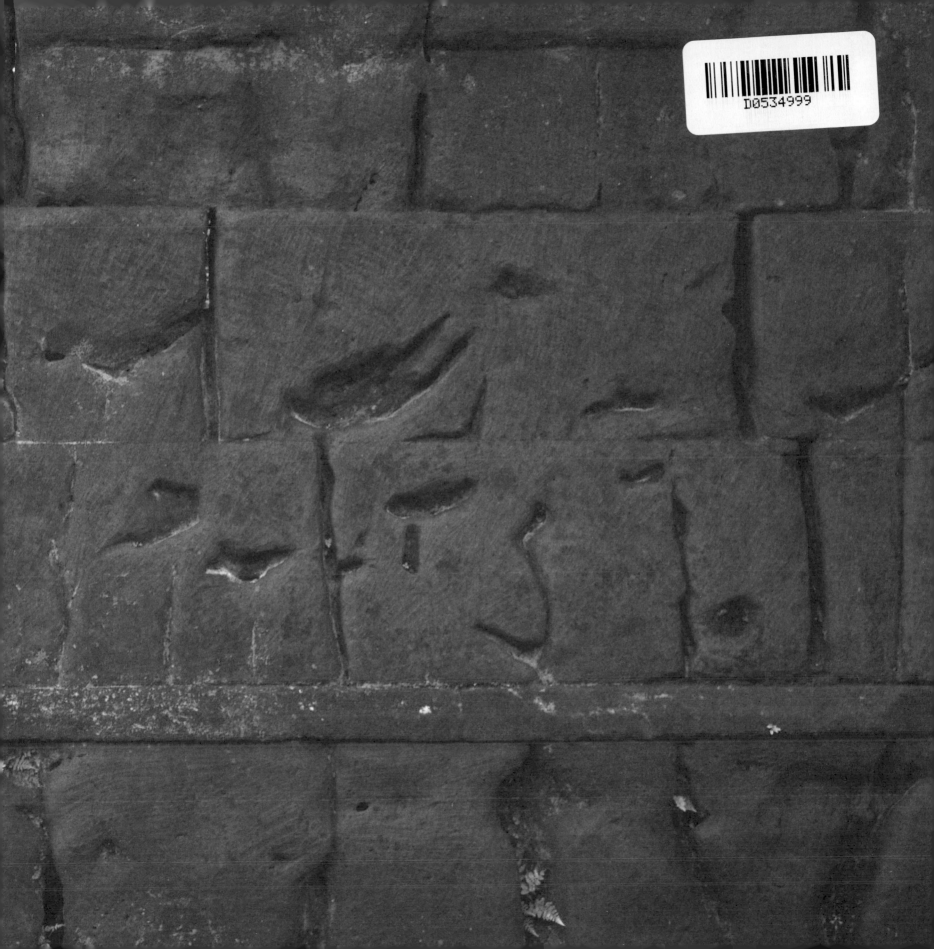

To the memory of my mother,
Ayse Zerrin Helmi,
who believed in doing things with style. — R.H.

For Grace Walker and for the people of Bali whose
beautiful spirit creates the morning of the world. — B.W.

First published in the USA by
The Vendome Press
1370 Avenue of the Americas
New York, NY 10019

Reprinted 1996, 1997, 1999, 2000

Distributed in the USA and Canada by
Rizzoli International Publications
through St Martin's Press
175 Fifth Avenue
New York, NY 10010

Library of Congress Cataloging-in-Publication Data
Helmi, Rio.
 Bali Style / by Rio Helmi and Barbara Walker.
 p. cm.
 ISBN 0-86565-983-4
 1. Architecture—Indonesia—Bali Island. 2. Vernacular architecture—Indonesia—Bali Island. 3. Interior decoration—Indonesia—Bali Island. 4. Decoration and ornament—Indonesia—Bali Island. I. Walker, Barbara. II. Title.
 NA1526.6. B34H45 1996
 720' , 9598 ' 6—dc20 96-16993
 CIP

Color separation by Colourscan Co. Pte Ltd, Singapore
Printed in Malaysia

Page 1: *Stone relief carving on the outer wall of Pura Dalem temple in the village of Negari shows not the ravages of time but of Bali's tropical climate.*
Pages 2-3: *The Amandari Hotel near Ubud captures the essence of a traditional Balinese village with narrow lanes defined by compound walls. Pavilions cascade through rice terraces down a steep ravine toward the River Ayung.*
Page 4: *Fierce stone* raksasas *(demons) dressed in loin cloths guard the entry gate of the Pura Batur temple in Kintamani.*

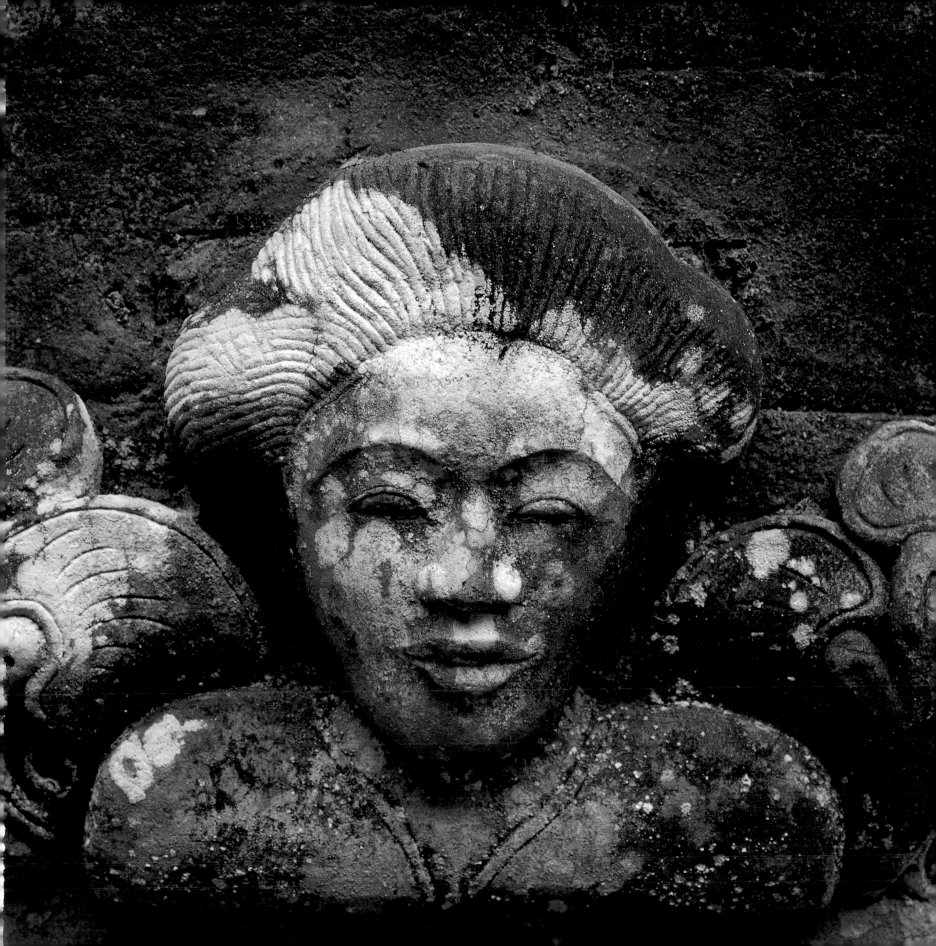

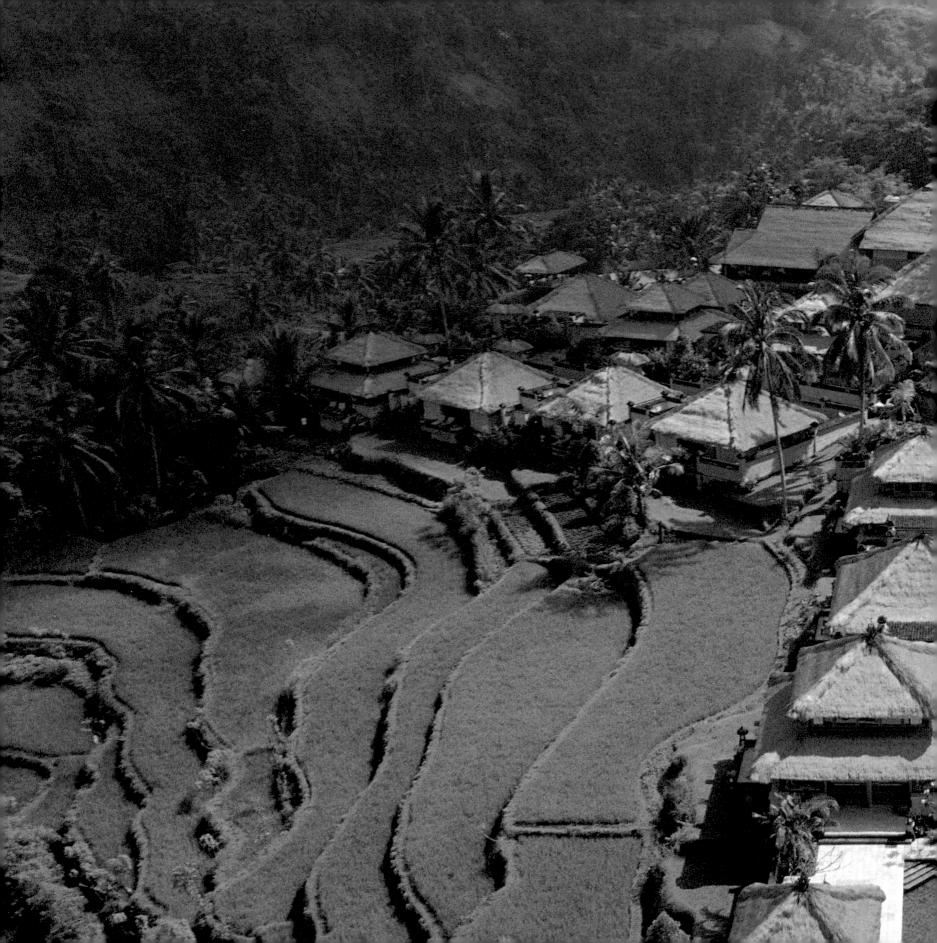

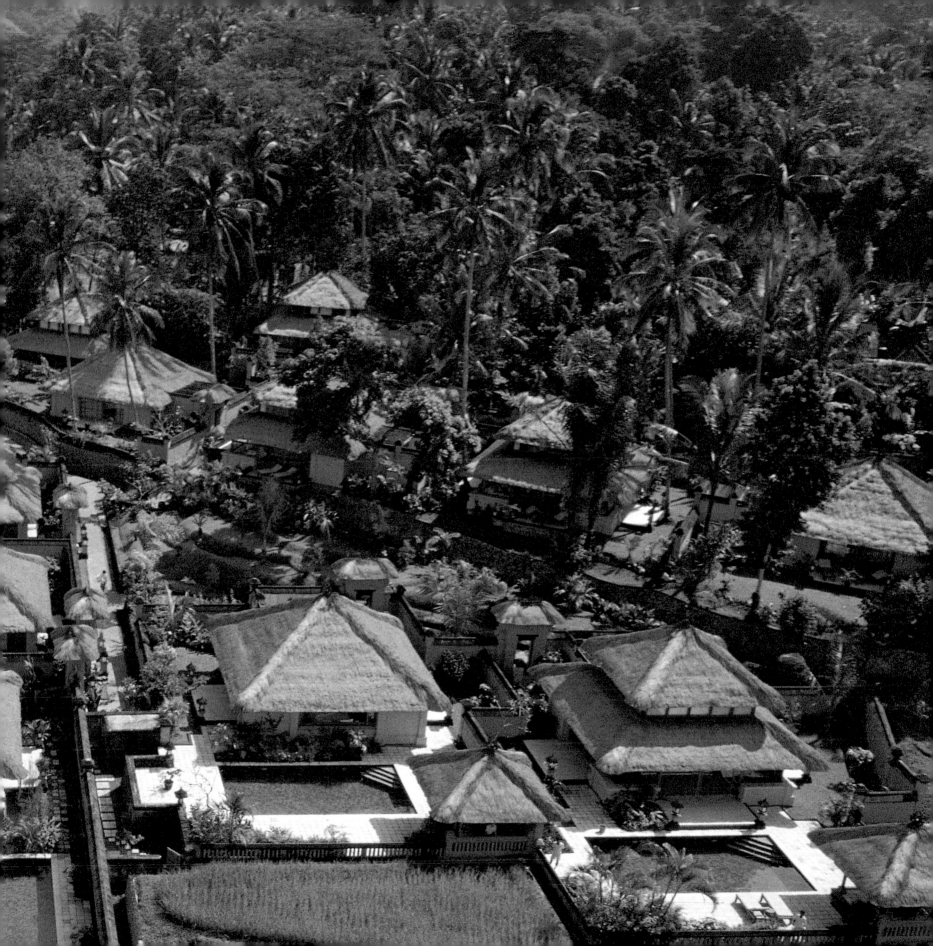

BALI STYLE

Photographed by

RIO HELMI

Written by

BARBARA WALKER

THE VENDOME PRESS

Pages 6-7: *Pavilion-style architecture of Bali integrates the beauty of nature into living spaces.*

Page 8: *Visions of heaven in this Kamasan painting encircle the ceiling of the Kerta Gosa (Hall of Justice) in Klungkung. Old Javanese literary classics provide themes for Kamasan (or wayang-style) paintings developed during Bali's "golden age."*

Page 9: *Usually made with a wavy blade, kris are considered to possess considerable magic. A part of formal male attire, it is also worn by male dancers.*

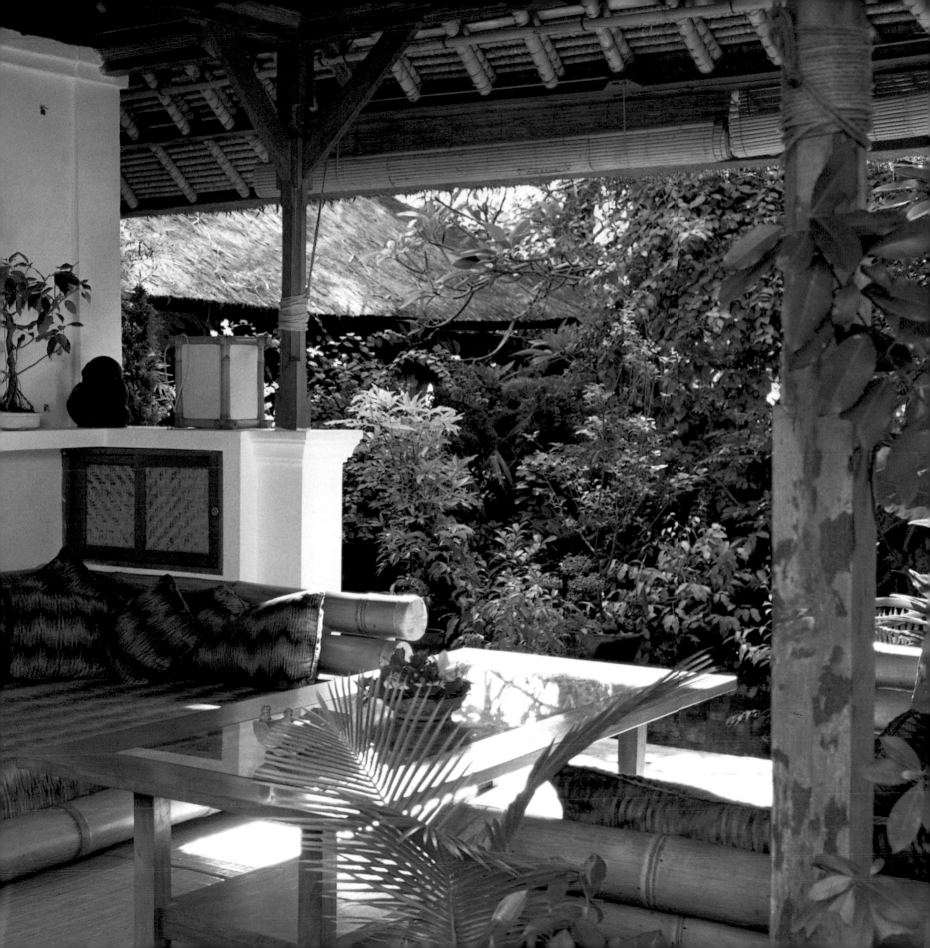

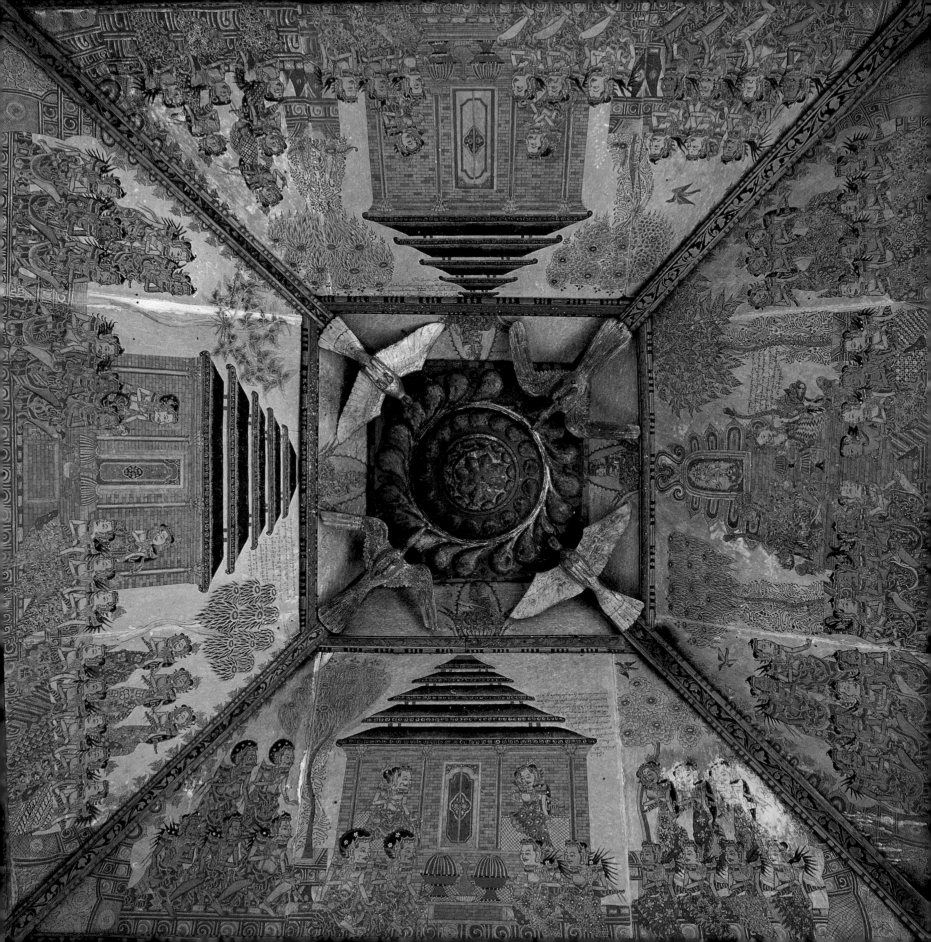

CONTENTS

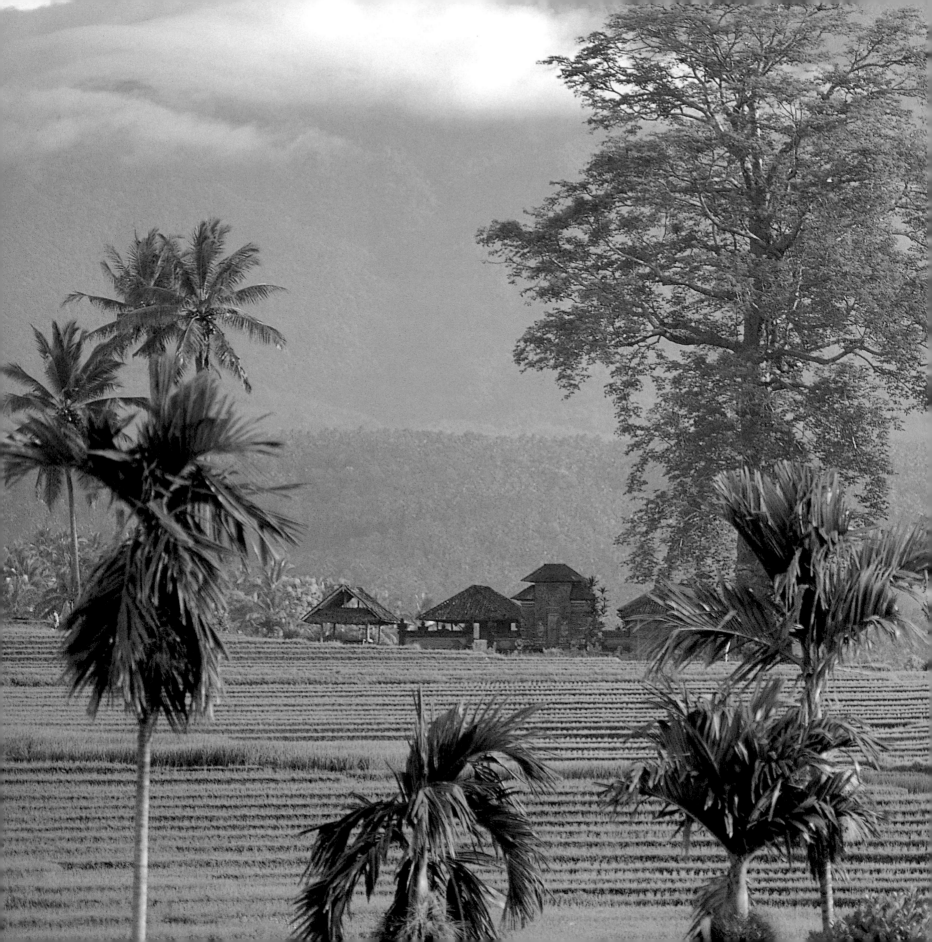

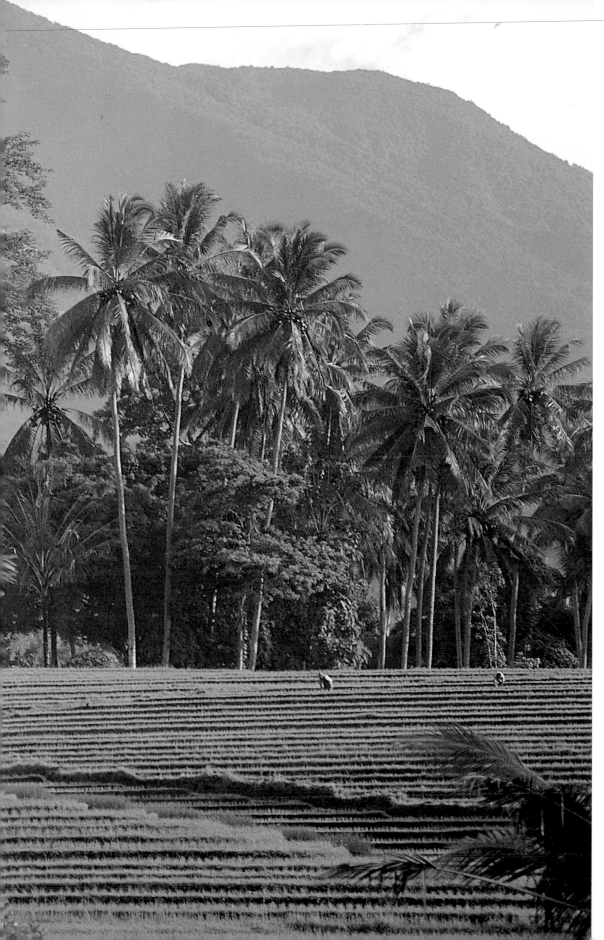

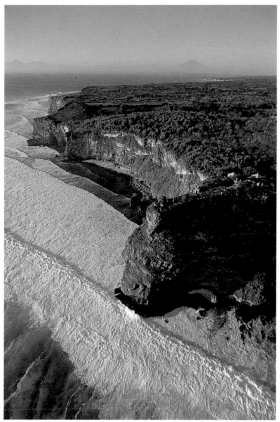

Left: *Majestic Bali...an island of rice terraces, temples, exotic foliage and volcanic mountains. Mount Batukau forms a spectacular backdrop for a subak temple nestled into a rice field. Subak organizations consist of villagers who oversee agricultural concerns, particularly irrigation of sawah (rice fields). This highly sophisticated system of gravity-fed irrigation supplying water to the sawah that is in use today was already in place in recorded history from 300 B.C.*
Above: *The sea temple Ulu Watu, fantastically perched on a rock cliff, is believed to be the petrified ship of Dewi Danu, Goddess of the Waters. Pura Ulu Watu is held sacred as one of Bali's holiest temples while the sea below is honored by surfers around the world as a legendary challenge.*

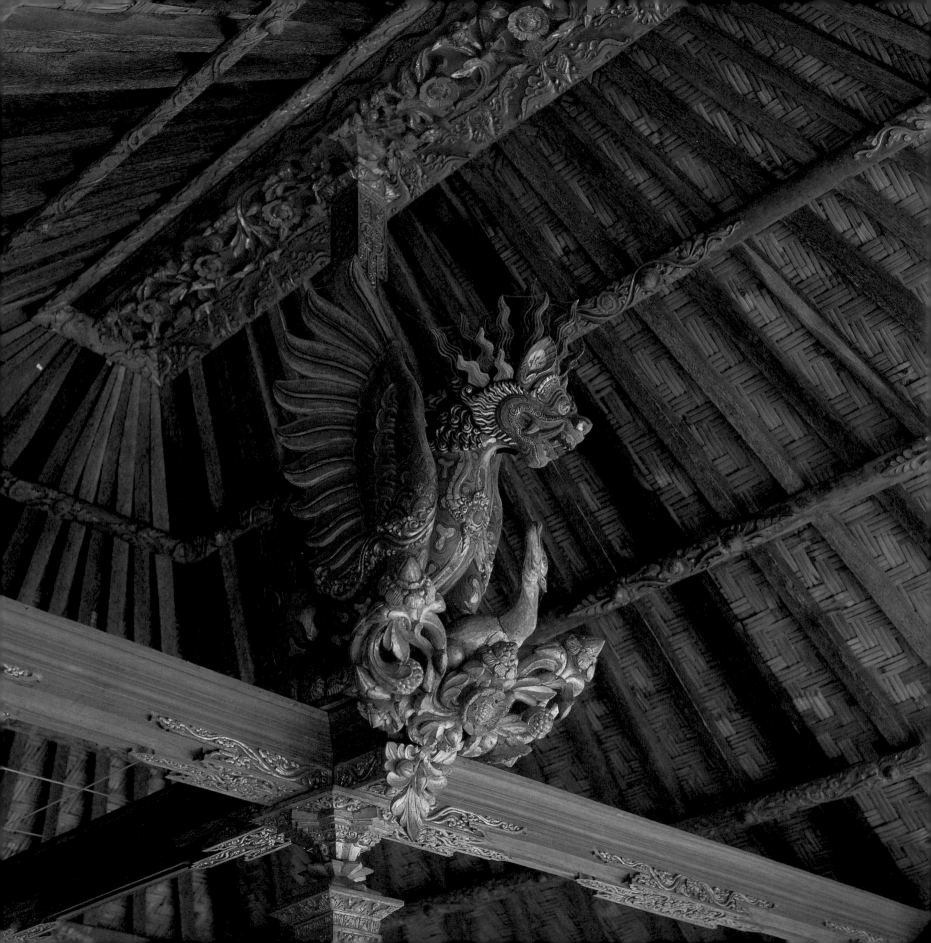

INTRODUCTION

Blessed with an ancient society of beautiful, lighthearted people, Bali has a cultural style like no other in the world. Bali style is a mosaic, a varied heritage of many cultures.

For more than ten centuries, the Balinese have welcomed intrepid voyagers and carefree globetrotters to their shores who brought with them their own ideas and beliefs. An elegant people who wear an innate nobility and possess an artistic temperament, the Balinese have tenaciously observed their beliefs while incorporating new ideas from the outside world. Throughout their history they have creatively adapted and adjusted these outside influences to fit their needs and nourish their spirit. Theirs is a culture intrinsically endowed with an essence that has created an authentic Bali style.

On Bali, a saturation of the style permeates sights, sounds, and feelings as surely as the exotic array of birds and butterflies, fruits and flowers. An effervescent spirit of creativity is felt in everything, everywhere. Balinese style is ever present, a moment to moment experience. The style is vividly expressed in architecture, in the visual and performing arts and through observance of religious ideals.

Bali's distinctive style is a multiplicity of concepts intricately woven for dramatic effect; a layering of vivid colors, textures and rhythmic patterns boldly revealed in elegant forms. Forms speak a visual language of the people that astonish the intellect and bewilder the imagination. Startling imagery and highly sophisticated design motifs are unexpectedly interlaced with pure whimsy. Incredibly beautiful art forms contrast with a sense of humor to create a smile and provide a reminder that life is not so serious.

Architectural styles in Bali are generally distinguished as "before Majapahit" influence and "after Majapahit." The earlier style may be called "monumental" or Bali Aga, a style of imposing primitive simplicity. The period after the Majapahit Hindu-Javanese migrated to Bali (beginning about A.D. 1200) is a style of elaborately carved temple gates embellished with mystical figures and layers of patterns and textures in rhythmical themes.

Bali is bestrewn with thousands of temples, sprinkled as if the gods have broadcast them like seeds throughout the island. Whether located in a small mountain village, in major towns or on a jutting coral cliff by the sea, the temples are endowed with fanciful carvings. Hosts of stone and wood carvings depicting mystical and magical animals, flora and fauna, sorcerers, gods and goddesses embody ageless examples of Balinese art. *Candi bentar*, the dramatic, ornately carved temple gates for which Bali is so well known, are a backdrop for the Balinese theater of life.

The lifescape of Bali is filled with an artistic palette of color as well as spectacle of visual interest. Stone or wood statues are adorned with fresh flowers, dressed with a sarong and gaily hold painted umbrellas. Colorfully patterned batik fabrics are stylishly worn by peasants as they go about their daily work. Temple ceremonies are staged so often that somewhere on Bali there is always one happening. The drama of Balinese life is most clearly represented in

Left: A singa roof support stands ready to ward off evil spirits while providing highly decorative interest to a building in the palace complex in Tabanan village. Above: Woodcarving of a fantasized lizard.

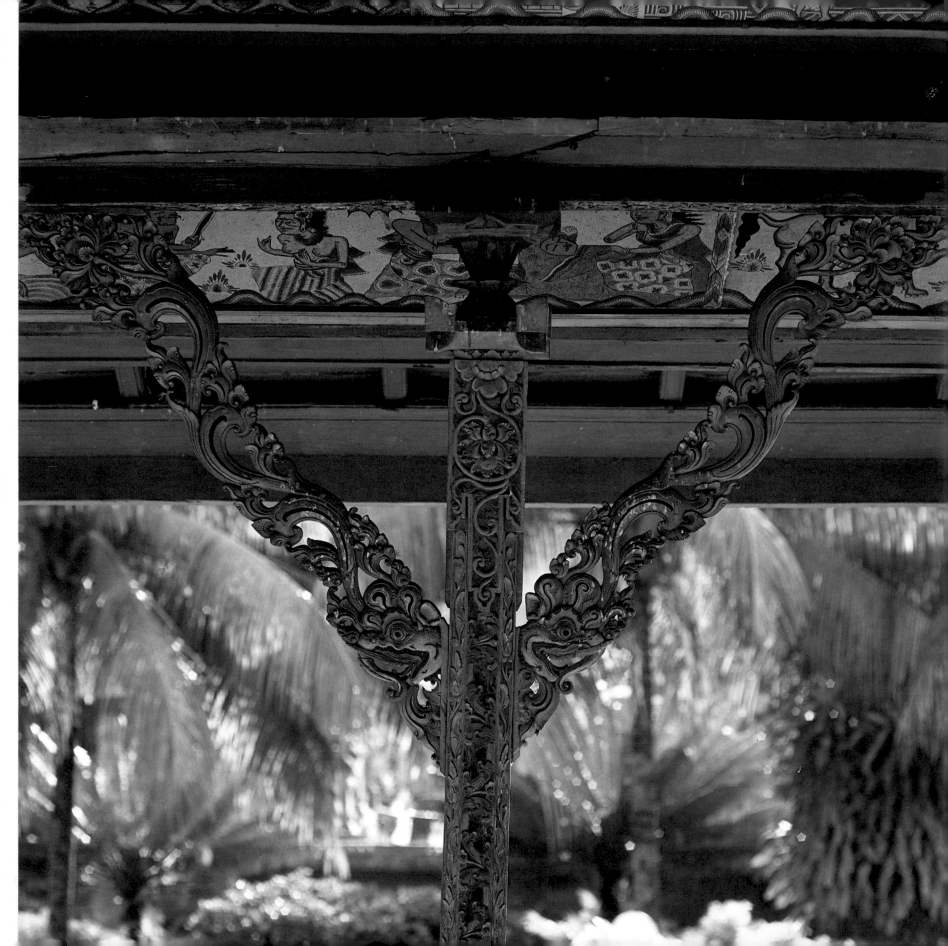

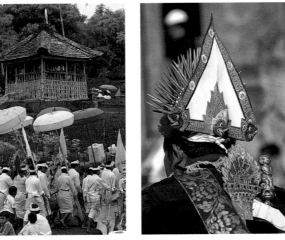

migration to Bali. Traders from India brought perhaps the single greatest influence from the outside world to Bali with the introduction of Hindu philosophy. Elements seen in the arts today include Chinese and Indian influence creatively adapted to fit Balinese concepts of style.

The change of primitive Bali to a Hinduized society was accomplished not by conquest or colonization but a desire of the rajas of Bali and the enthusiastic acceptance of the people to move toward civilization. Hinduism, in a form which combined Buddhist concepts, was easily adapted to the Bali Aga belief system of animism without the latter having to renounce its existing ideology. The Balinese Hindu Dharma today is a mix of all these religions. Aboriginal Bali Aga culture evolved over the following fourteen centuries using the religious, political, social and artistic Hindu model from India.

Marco Polo's travels to Indonesia in A.D. 1290 whetted Western palates for spices and other riches from the Indonesian islands. Various Portugese and Spanish voyagers touched on Bali during the following 200 years and by A.D. 1600 the Dutch East Indies Company was fully established on Java. Bali was largely bypassed due to the island's treacherous reefs and lack of safe anchorage. This lack of attention from the Western world was ultimately beneficial to the culture of Bali in that it was left to its own creative evolvement.

The arrival of Islam to Java in A.D. 1600 resulted in the fall of the Hindu-Javanese Majapahit Empire there. Intellectual Hindu-Javanese, including priests, royalty, soldiers, artists and artisans, fled to Bali. These refugees brought with them archives of Buddhist books, texts of Javanese literary heritage and other treasures of Java. Javanese tradition was not simply preserved by the Balinese but provided additional stimulus to their developing culture. The influence of Hindu-Javanese royalty, artists as well as artisans began what can only be termed a "golden age" of Bali.

As the 19th century began, Bali was still virtually unaffected by commercial, political or religious influence from the West. During this period many rajadoms of Bali engaged in feudal skirmishes with each other and with kingdoms on Java. The Dutch chose to overlook such reprisals until it became apparent the English were providing the rajas with arms, were buying slaves and trading in opium. The fear that the English might lay claim to the little island of Bali was perhaps a contributory factor to the Dutch-English conflict during the French Revolution.

During the Napoleonic wars, Holland was occupied by France and the British East India Company moved to Indonesia. Sir Thomas Stamford Raffles became Lieutenant-Governor and was posted to Java from 1811-1816. During his office he abolished the ruthless slave trade on Bali and introduced partial self-government.

By the early 1840s, the Dutch had re-established themselves in Indonesia and were attempting to convince the Balinese rajas, through ideas of treaties of friendship, trade and politics, to give Holland complete sovereignty over the island. All efforts met with little success and an incident surrounding salvaging rights gave Holland the neccessary excuse to use force.

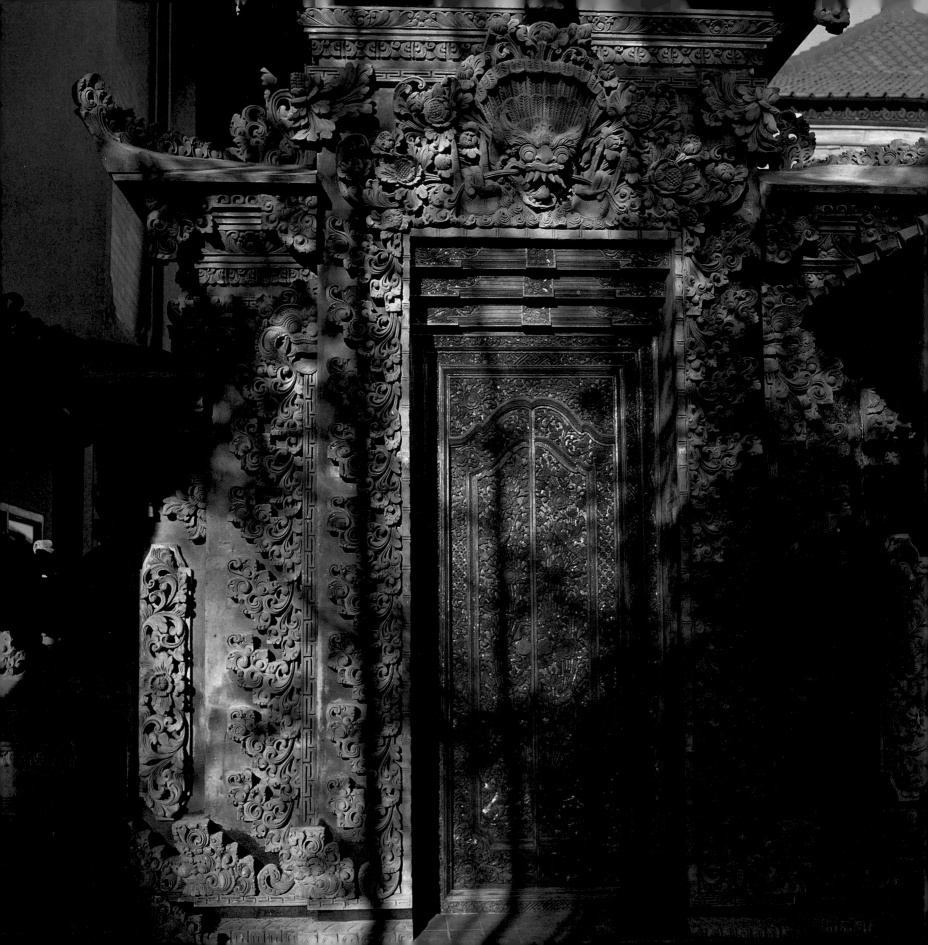

The Balinese rajas felt that salvage rights were theirs and laid claim to all cargoes from the wrecks of Dutch frigates. Whatever came to rest upon the coral reefs surrounding Bali was accepted as a gift from the sea deity Batara Baruna. It was incomprehensible to the Balinese rajas to return such gifts, an affront to the god. The government of Holland was furious, sent a new commissioner to Bali to protest further such acts and to extract agreements to be formally ratified by all of the rajas.

The independent attitude of the Balinese that has assured a continuity of their authentic style is exemplified by the dynamic young prince, I. Gusti Ketut Djelantik, during ratification meetings with the new Dutch commissioner. Prince Djelantik defied the commissioner and became a great hero of 19th century Bali by announcing: "Never while I live shall the state recognize the sovereignty of the Netherlands in the sense in which you interpret it. After my death the Raja may do as he chooses. Not by a mere scrap of paper shall any man become the master of another's lands. Rather let the *kris* decide."

Sixty years of war and unrest ended in 1906 with the *puputan* (mass suicide of Balinese families). Proud Balinese rajas, no longer able to confront the strength of the Dutch, led their entire households to suicide by facing Dutch troops at close range and died by their own ceremonial knives.

News of these mass suicides reached Europe and protests were heard in The Hague resulting in administrative reforms on Bali against foreign exploitation. The *puputan* ended expeditions against Bali by the Dutch and once again Bali escaped Western rule, enabling it to sustain an authentic Balinese culture.

Japanese occupation was brief during World War II and of no noticeable influence to the style of Bali. The Japanese invasion gave hope for independence to the Indonesian people with the knowledge that European nations were vulnerable. Following the war, the Netherlands promptly moved back to Indonesia and Bali. President Sukarno declared Indonesia's national independence in 1945; however it was not until 1949 that the Dutch finally conceded and the Republic of Indonesia was established.

Tourism began on Bali in the 1920s with Westerners stopping off during "the grand tour." Reports of a magical island called Bali have drawn tourist in ever-increasing proportions since the first visitors arrived. Much of the literature written in the 1930s about Bali feared the worse: that through foreign influences the island paradise would be lost and its culture eliminated.

Bali today, as we near the 21st century, is evolving toward many Westernized ways with the arrival of television, motorcycles and international communication. However the strength of the culture continues as evidenced each day through the ritual of family and social organization. Bali is a place of communal life...a sharing of work, religious obligations, and social responsiblity to the immediate family as well as the broad family of community.

The outside world is a mirror to the Balinese with which they can reflect what is most important. A reflection which assures them Bali is the center of the Universe, "the morning of the world."

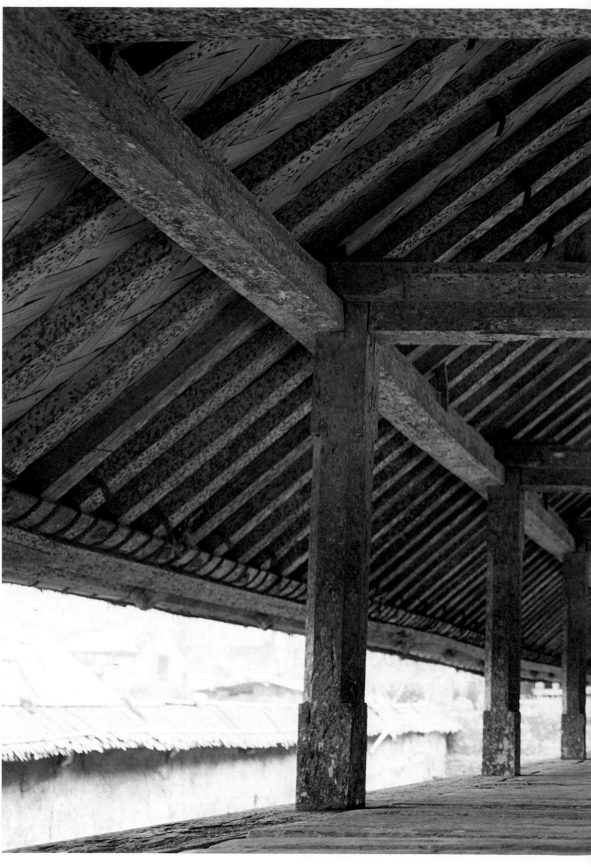

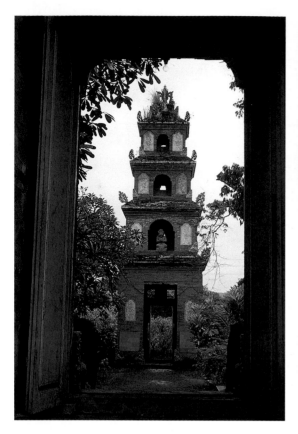

BALI AGA AND MAJAPAHIT

In Bali's long recorded history, there have been only two distinct styles of architecture — the "Bali Aga style" and the "Majapahit style." These two styles are beautifully illustrated in the pictures above and to the right. An architectural style has recently emerged in resort buildings and custom-built homes that may be called "Balinese International Style." However, this contemporary adaptation relies heavily upon details from the Majapahit and original Bali Aga styles.

Above: *A Majapahit period gateway to the palace, Puri Agung Karangasem, in Amlapura.*
Right: *The* bale agung *(public pavilion) in the Bali Aga village of Bayung Gede is a fine example of early Balinese architecture. Carved wooden Bhomas on crossbeams discourage evil spirits from entering the* bale. *The roof of this building is bamboo shingle with a lining of heavy weave bamboo,* bedeg.

20

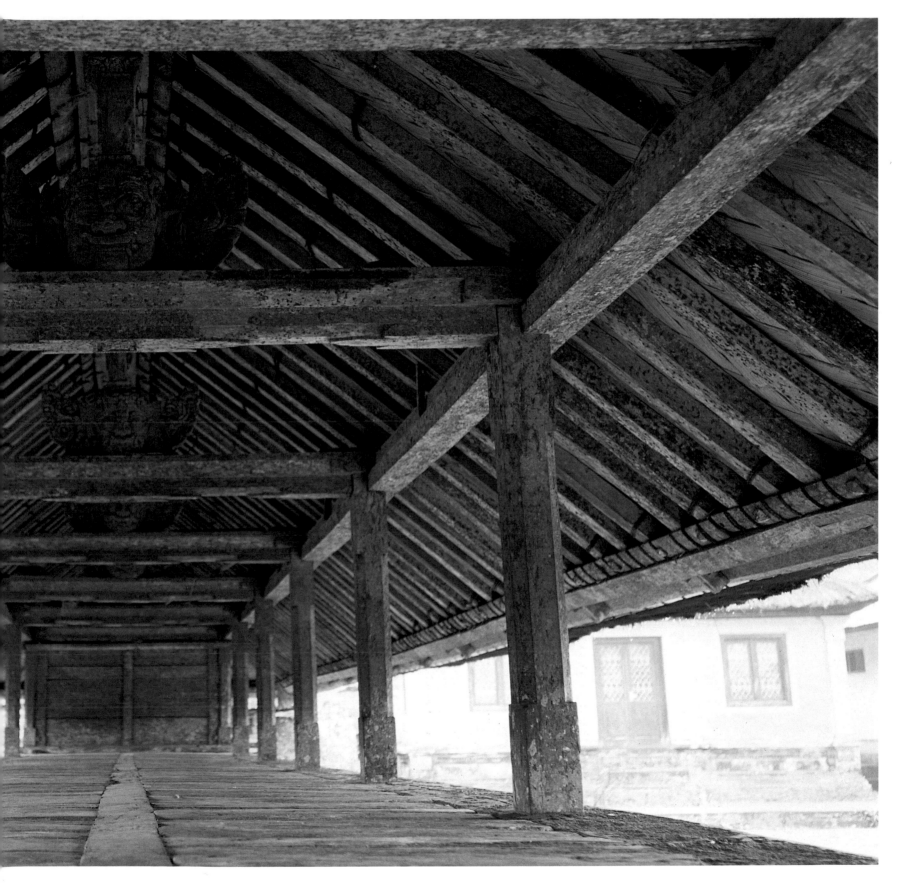

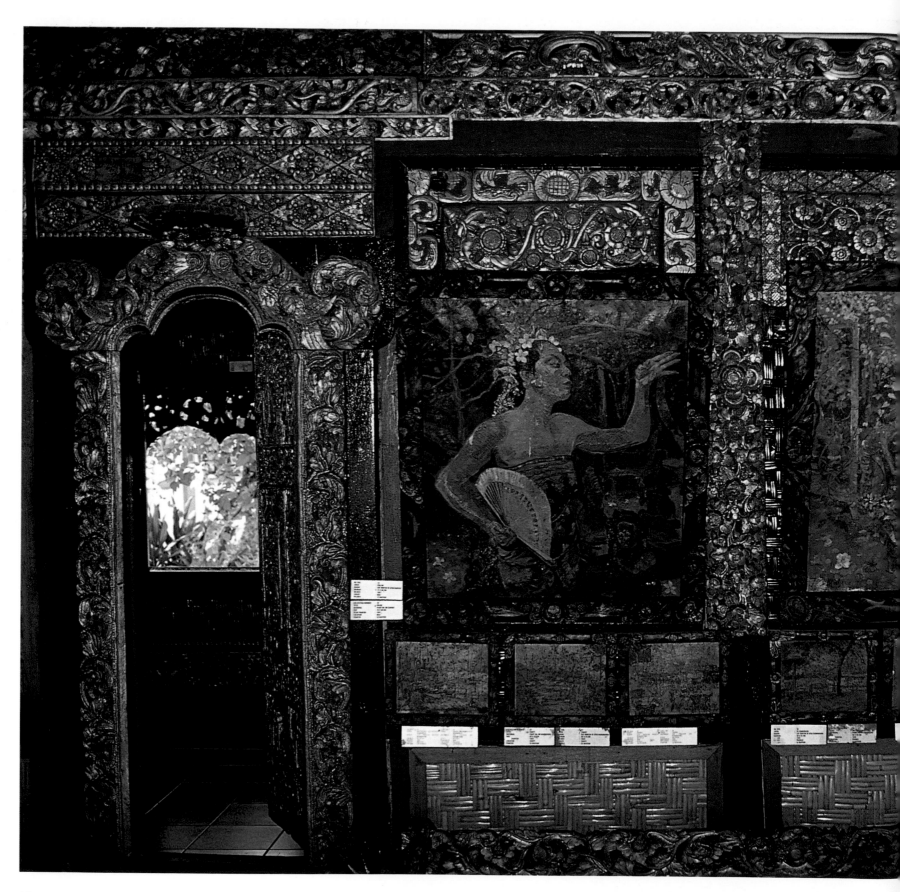

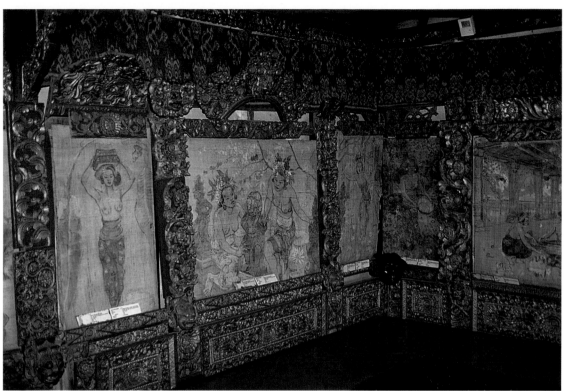

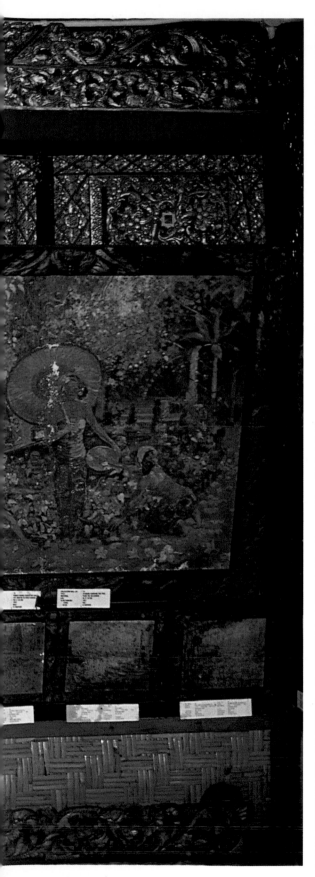

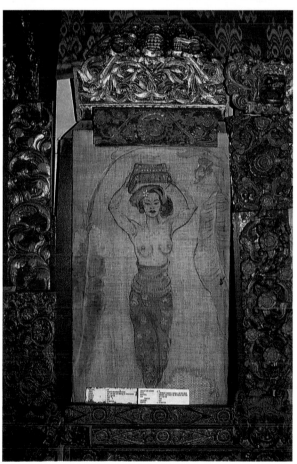

ARTISTIC INFLUENCE FROM THE WEST

Exquisite crimson and gold panels in the seaside home of Belgium painter A.J. Le Mayeur de Merpres. Le Mayeur was one of several European artists to make Bali their home during the 1930s, a time of growing tourism and Western influence. Le Mayeur moved to Bali in 1932 where he lived for 26 years with his beautiful Balinese wife, Ni Pollok. Rooms of their home are lined with the artist's paintings depicting scenes of Paris, Venice and Bali framed in old architectural panels he restored. Upon Le Mayeur's death his home and lovely gardens in the village of Sanur were willed to the Indonesian government and are now open to the public.

TRADITIONAL INTERPRETATIONS

Elements of traditional Balinese architecture are successfully interpreted in many new international hotels in Bali. Organic materials such as bamboo and *alang-alang* grass are used for roof structures. Practical, functional thatched-roof designs in Bali have handsome exterior proportions with appealing organic textures.

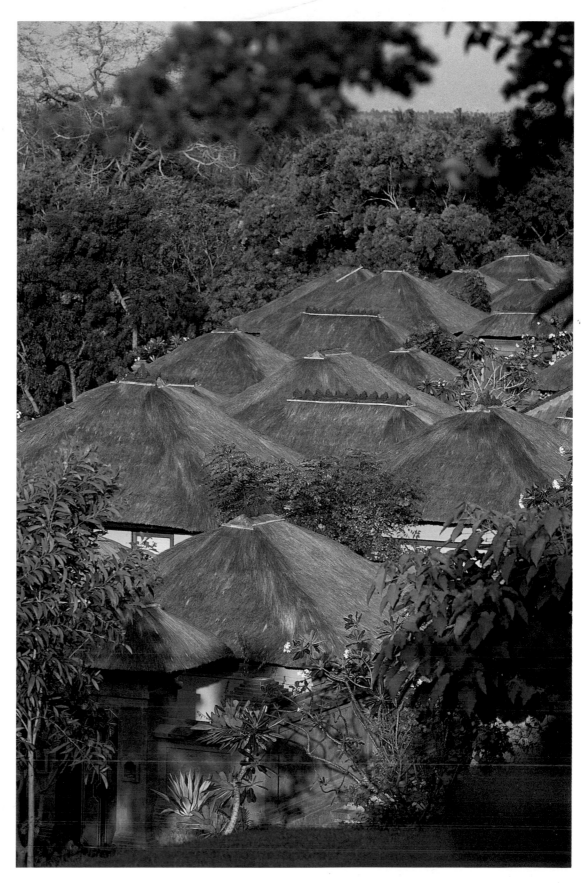

Left: *The lounge of the Tandjung Sari Hotel offers guests a traditional Balinese architectural experience. Soaring spaces of this open-air pavilion are given visual interest and warmth from the many organic materials. The natural colors and textures of the alang-alang grass roof, bamboo rafters, carved wood, stone and brick walls create a grand frame for the Kamasan-style painting mounted on the pavilion's gabled end.*
Right: *Grass roofs of cottages at the Four Seasons Resort Hotel could easily be mistaken for a typical Balinese family compound.*

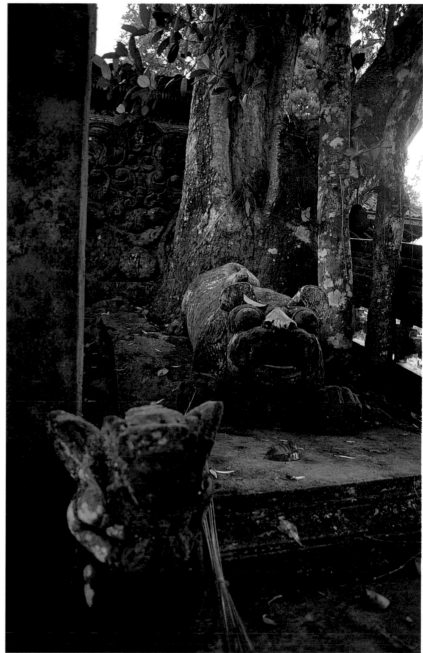

DIVINE OUTDOOR SPACE — TEMPLE COURTYARDS

Courtyards in Bali's Hindu temples are open-air cathedrals that express a love of nature inherent to the spirit of Balinese people. Sacred spaces are created using the magnificent out-of-doors rather than building enclosed, interior spaces for worship.

Left: *A temple in the village of Taro is an open to-the-sky courtyard surrounded by lush tropical foliage.*
Above: *The entrance to Pura Griya Sakti in Manuaba is an inviting aerie for meditation and worship.*

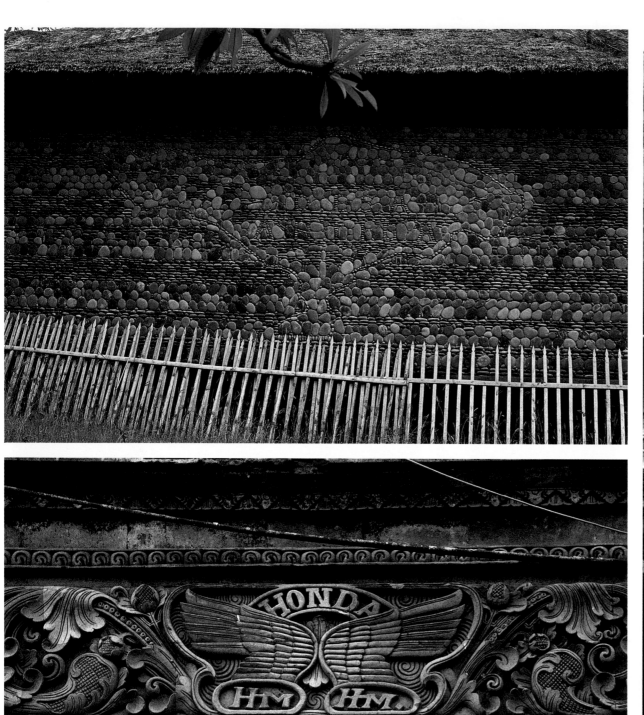

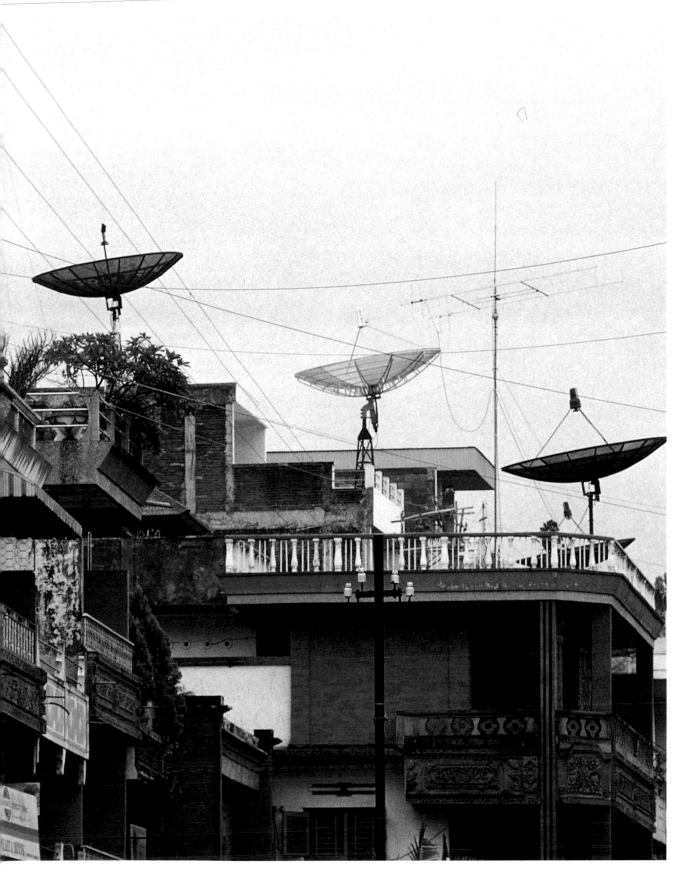

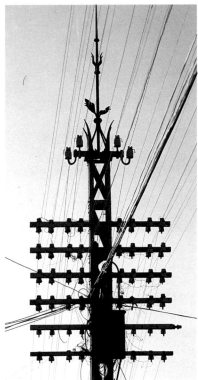

THE UNEXPECTED DELIGHTS THE EYE

Balinese playfully add ornamentation and layer details to intrigue the eye and create busyness. Every opportunity is seized to add a bit more...a final touch to the point it often seems there is not a spare inch of unadorned space in Bali.

Far left above: *A temple wall near Manggis with stone inlay depicting the map of Bali.*
Far left below: *Spare parts dealer in Klungkung enfolds a well-known emblem with undulating volutes of floral tendrils.*
Above: *Utility pole in Gianyar.*
Left: *Outer world of telecommunication has arrived in downtown Klungkung.*

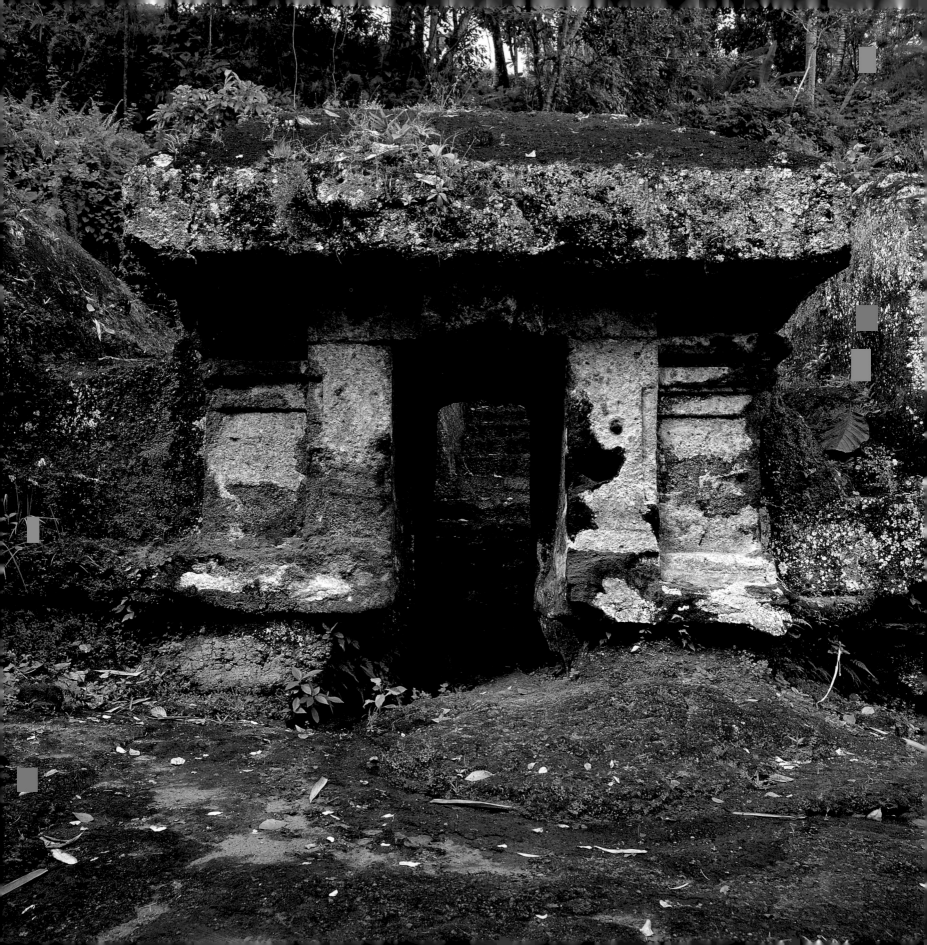

BALINESE TRADITIONS

First rays of morning light shimmer through coconut and banana trees shining down on family compounds alive with activity. Roosters crowing, dogs barking, children and mothers hurrying back from their morning bath at the river, fathers and grandfathers setting out the baskets of fighting cocks...all preparing for a new day. Before the coconut husk fire is lighted to heat water for rice and coffee, an offering must be made. A green leaf of the coconut tree is handily woven into a small *banten* (basket-like tray), then filled with fresh flower petals and a bit of rice. The *banten* is offered with lighted incense and reverence to Batara Brahma, God of Fire. A new morning, another day on Bali begins with activities much the same as those of their ancestors centuries before.

Within these walled compounds live families sharing patriarchal lands. Grandmothers and grandfathers, sons and their families, uncles, aunts and cousins all living a communal life of work and leisure time. Stepping through the entry gate of a compound, one enters into a courtyard with many sleeping pavilions, kitchens, granaries, family temple, gardens and pens for goats, pigs or cows. Placement of buildings is dictated by cardinal points with the most holy place, the family temple, located toward the great mountain where the supreme deities live. Next in importance to the temple is the *uma meten*, the only pavilion with enclosed rooms. *Uma meten* are sleeping pavilions for the head of household or first married son, as well as a place for safekeeping of family heirlooms and valuables. Toward the

sea, the less pure direction, are kitchens, rice granaries and animal pens. Located in a position of honor is the open-air sleeping *bale* (pavilion) of grandparents.

Primitive simplicity is the architecture of the common man on Bali. Theirs is the architecture of time-honored techniques utilizing indigenous materials in resourceful and practical ways. Mud, thatch and bamboo are crafted with a style of natural elegance, a serene beauty that lacks pretension.

Whether in a *pura* (temple), *puri* (palace) or the compound of a common family, traditional architecture accommodates Bali's warm and humid climate with structures designed for living in the out-of-doors. Enclosed rooms are for sleeping while the open-air concept of the Balinese *bale* in court-style settings are gathering places for work and socializing.

Bale are beautifully constructed, raised platforms of mud, brick or stone with coconut-wood posts supporting hardwood or bamboo beams and thickly thatched roofs. Handsomely proportioned *bale* are open on four sides to the cooling breezes. A well-built *bale* is a masterpiece of architectural ingenuity and good taste providing shelter that meets the spiritual and spatial needs of the people.

A vast majority of Balinese live in or near the village of their ancestors. The sharing of community life and responsibility are ingrained and the upholding of traditions mandates living near one's village of origin. Family and community welfare take precedence over individual needs with personal plans or work having little priority if a temple

Left: *Candi Tebing, a temple entry gate in Tegallingah, is believed to be the oldest existing gateway in Bali. The architectural style is of the monumental or Bali Aga period.*
Above: *Lichen and moss covered early stone statue at the temple Pura Batu Karu near the village of Wongaya Gede.*

needs restoration or the head of the *banjar* (political organization of villages) calls a meeting or help is needed to build a neighbor's house.

When planning a new house in Bali, an *undagi* is consulted. The *undagi* (literally meaning "eminent" or "resourceful" person) is an architect/priest who determines the suitability of a site using spiritual concepts of compass directions. Utilizing spiritual axis points and personal measurements of the head-of-household, an *undagi* constructs a plan for general layout and basic dimensions. In the case of plans for a new temple, the *undagi* takes measurements from the body of the priest who is most prominent in the temple. Structures are built imposing the order of human scale and harmony according to the Balinese belief system as well as a spiritual and spatial orientation. Drawings are made by the *undagi* indicating dimensions and layout. Stonemasons, carpenters and roofers then add their own creative touch making on-site decisions during the building process as to how decorative elements are added to harmonize the building with the surroundings. Construction is by hand without the benefit of power tools. Wood or bamboo posts and beams are connected by tongue and groove joinery illustrating the Balinese aesthetic of structural integrity as well as practicality. In keeping with the belief that buildings are living organisms, posts must be installed upright as they grew. The heavier root-end of a post is determined by balancing from the center point or floating the timber in water where the root-end will sink.

Many offerings must be made at each step of the building process to assure appeasement of evil spirits and gods. Once construction is complete, the *undagi* breathes life into the structure reviving materials while family, friends and neighbors join in ceremonies of celebration. The entire building is once again a living organism and part of the cosmos. Their homes and temples are linked to a human being, they are personal and precious.

Absolutely every aspect of life, whether it be the structure of buildings, designs for an offering, components of a painting or master plan of a village is viewed as a living organism having a head, body and feet. This philosophy is a spatial concept that is not only seen in the arts but also in the structure of society. The essence of this philosophy is *tri hita karana*, that everything in the world consists of three components: Soul, physical body, power or ability.

Derived from the concept of *tri hita karana* is *tri angga. Tri angga* designates the physical world into three zones: *nista* (low, impure, foot), *madya* (middle, neutral, body), and *utama* (high, pure, head). To further complicate the concepts of spatial order is the philosophy of cardinal directions (spiritual axes) from the Balinese cosmology *nawa sangah*. There are eight wind directions and one center point called *puseh*. Each of the nine cardinal directions have corresponding colors and deities. Colors are combined to fulfill spiritual requirements in so many aspects of life, including the cuisine. Orientation to spiritual axes rather than directional compass points of north, south, east and west emphasize the Balinese concept of Bali as a microcosm of the Universe and the great mountain, Gunung Agung, as the "navel of the world."

Master plans of villages are organic as they too relate to the body of man and utilize concepts of *nawa sangah*, cardinal directions. Every village has at least three public temples. *Pura puseh*, the temple of origin (deified ancestors), are always located in the most sacred position of *kaja* (toward the great mountain) and are the "head." At the "heart" of the village are the *pura desa* (village temple), *wantilan* (assembly

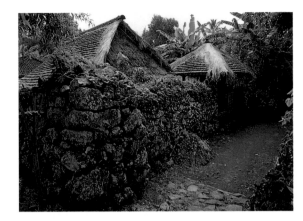

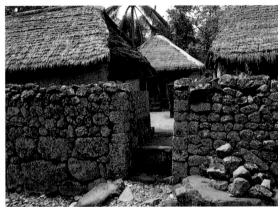

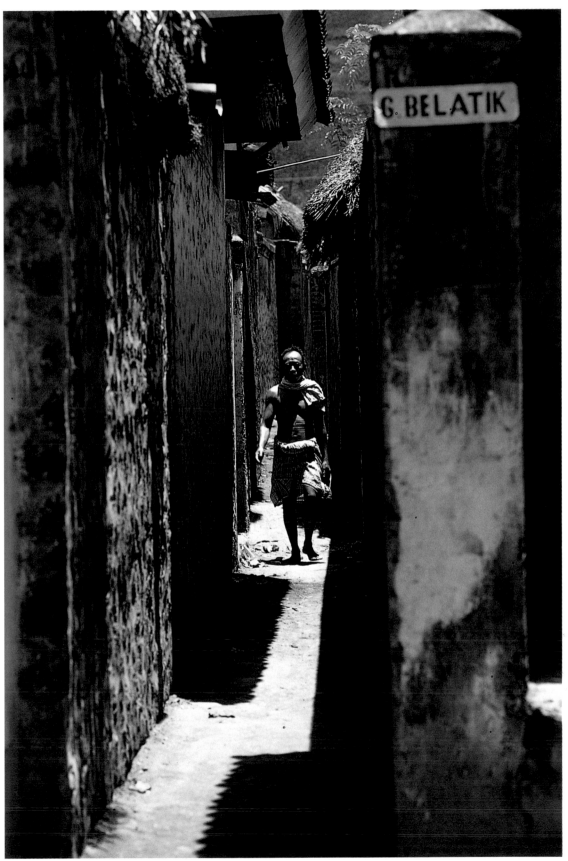

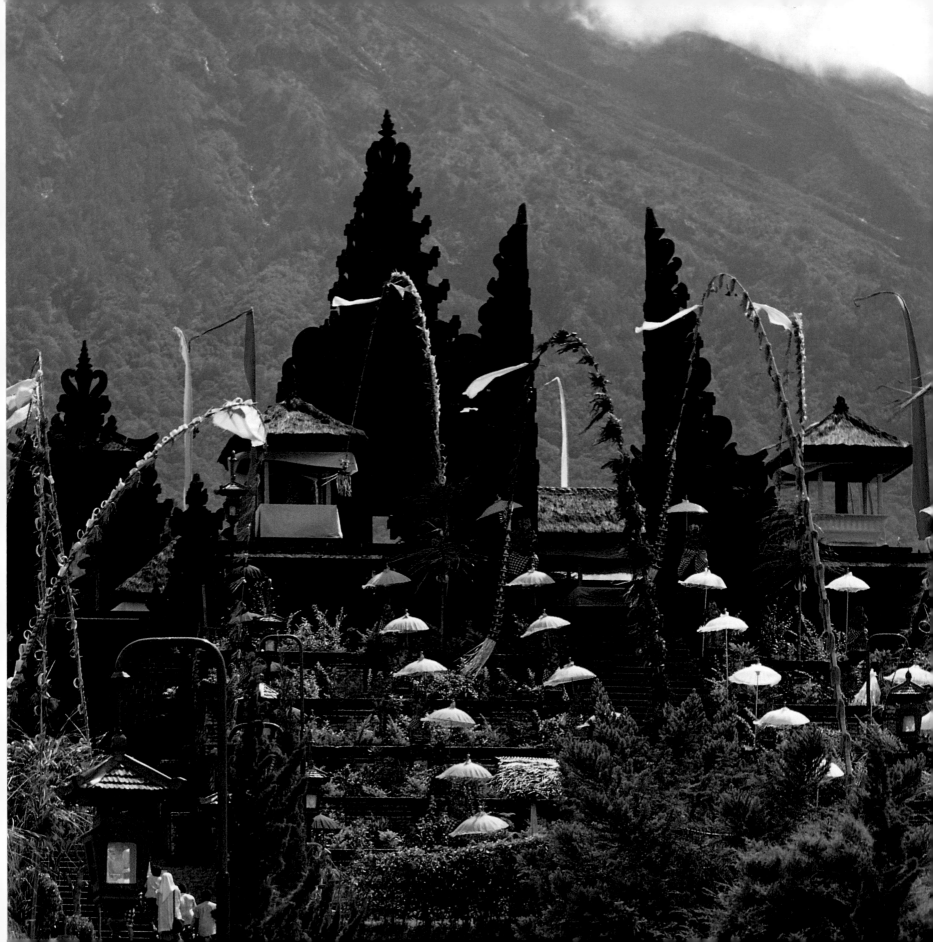

showcase Balinese art. Prince Putra is one of many individuals and groups who are untiringly dedicated to maintaining Balinese traditions.

Artists from the West such as Spies, Dutch painters Bonnet or Hofker, not only brought a new way of thinking regarding subject matter but also brought a concept of art as commercial enterprise. For the first time in their long history, Balinese viewed art for art's sake. Today, entire villages are models of cottage industry engaged in the production of arts and crafts.

Almost any drive through the countryside will lead to small villages where open-air roadside shops are tended by adults and children alike who gaily converse while carving or finishing products for the foreign visitors. The village of Batubulan is known for its skillful stone carvers. Their studios line a busy road just outside of Denpasar where statues of fierce warriors stand guard alongside fanciful stone frogs holding umbrellas saluting traffic as it hurries by. Peliatan, near Ubud, is known as a village of dancers that not only perform at neighboring temple ceremonies but have also traveled around the world to dance. To be born in a particular village may designate one's profession or artistic specialty...if grandfather was a mask maker, his grandsons usually follow his profession. An individual may be sought after because of special expertise within an art, however an artist is not considered a celebrity in the same sense as a noted artist in the West.

Craftsmanship continues to flourish in Bali for there is still a need for stone and wood carvers who can skillfully fulfill the requirements of architectural detail. Constant refurbishing or rebuilding of structures is required due to Bali's hot and hu-

mid equatorial climate. Climatic conditions of this tropical island are not conducive to longevity of materials. Wood structures and ornamentation are in a perpetual state of repair due to the onslaught of wood-boring insects and decay from the combination of high humidity and warm temperatures. Even the soft gray to ocher sandstone called *paras* quarried from river ravines that is widely used as an architectural material as well as for stone carvings is affected by the climate. Highly porous *paras* provides the perfect home for mosses and lichens. The effects of weather and plants upon this soft stone require constant renewal. It is not an unusual sight in a temple to see a stone carver busily carving the most elaborate design, working away on what appears to be an ancient artifact without benefit of design drawings. On Bali, climate and tradition cooperate in maintaining the living arts.

Artists and craftsmen in Bali today are highly-skilled individuals who have mastered their art through the traditions of their forefathers and in many instances work in communal studios. Studios of painters, as within the community of Penestanan, produce paintings in a style compatible with the village tradition. Often many young artists work on the same canvas along with a master as was once common in traditional European atelier.

Although art is now also a commercial venture, there remains a strong recognition that craftsmen, whether woodcarver, stone carver, painter, musician, weaver of fine fabrics or the maker of exquisite offerings for temple...all are "workers" with a talent in service to the gods and community.

PRIMITIVE, ORGANIC ARCHITECTURE

Exposed, unadorned structures of timber, bamboo, stone, mud and thatch exemplifying the Bali Aga style can be seen in villages such as Tenganan, BugBug, Bayung Gede or in the mud-and-thatch compound walls of Balinese families throughout Bali. This honesty of construction reflects the Balinese spirit of practicality and love of natural, organic materials.

Right: *Mud walls, bamboo shake roofs and simple entry gate of this temple in the village of Bayung Gede is of the Bali Aga style architecture.*
Far right above: *A meru shrine within the temple walls at Bayung Gede is built upon the ground rather than on a platform of stones as seen in other Hindu temples on Bali.*
Far right below: *An early candi bentar (temple entry gate) in a mountain village near Kintamani is quite unusual...entrance is through a split-platform pavilion.*

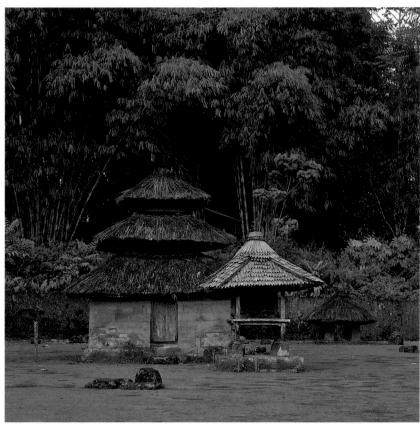

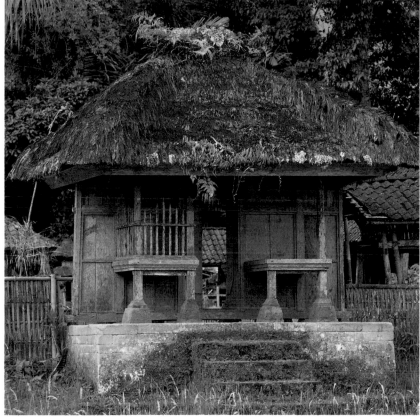

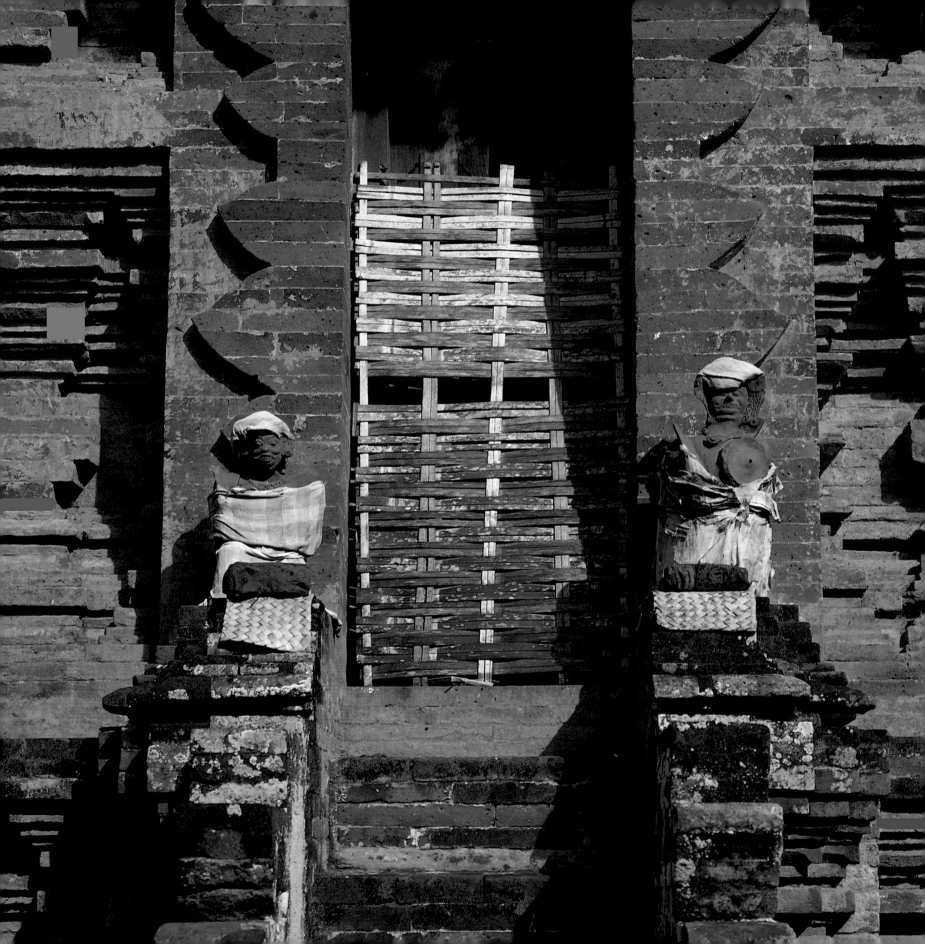

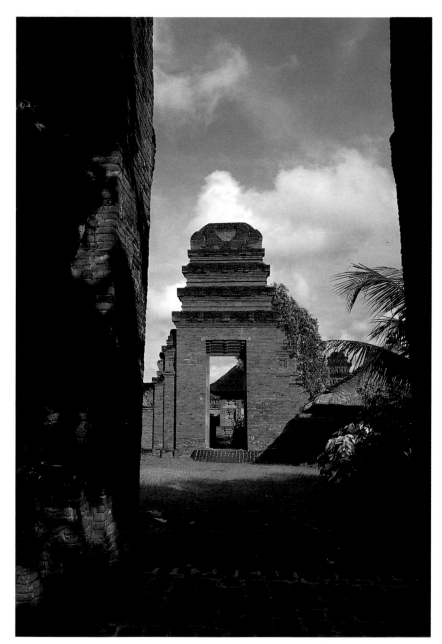

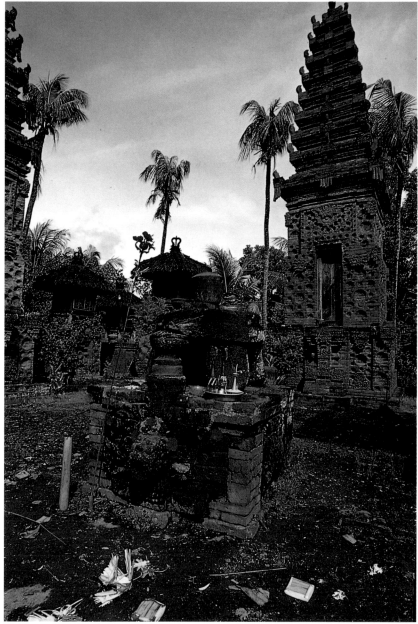

AN INTEGRATED STYLE

Left: *Terra-cotta martial guardians on duty at a doorway of woven bamboo, at Pura Maospait, Gerenceng, in Denpasar.*
Above left: *View through outer gateway toward the inner gate, and to the most sacred area of Pura Maospait.*
Above right: *Megalithic black stone seat or altar, "batu hitam," is placed in front of the exquisitely detailed meru (temple shrine) at the very early Pura Maospait Tonja temple north of Kesiman.*

The Majapahit period gave Bali its "second style" of architecture which is also "the contemporary style." Hindu Javanese concepts were integrated with the animistic traditions of the Bali Aga to form Bali's highly embellished architecture. Themes of this style are earthenware-toned, terra-cotta brick creatively placed in coursings of varied patterns alternating with details in concrete or *paras* stone. These materials form a colorful stage for the drama of multiple rhythms, repeated patterns and multitudes of exquisitely detailed carvings from wood and stone. Richly decorated structures of the Majapahit period were in times past homes for the gods in the *pura* (temple) or homes for royalty in a *puri* (royal palace) but are seen today in varied commercial and residential buildings throughout Bali.

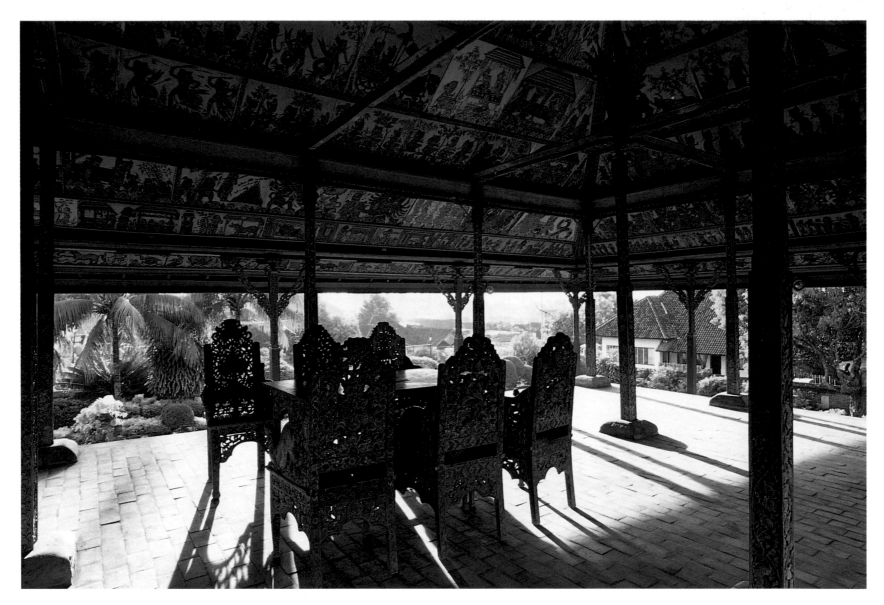

TAMAN GILI — THE MEETING PLACE

Built in 1710, the Taman Gili complex in Klungkung houses the famous courthouse, the Kerta Gosa. A magnificent example of Balinese architecture and Kamasan-style paintings, the Kerta Gosa was initially used as a meeting place for the Raja of Klungkung and his noblemen to discuss matters of importance, to study *lontar* text and to view the surrounding villages. The Kerta Gosa served as the highest court in Bali during the 18th and 19th centuries. Disputes that could not be settled by families or in the village were brought here to be heard.

Above and right: *Kamasan paintings decorate the ceiling with scenes of horrible punishment in the afterlife. Panels tell several stories using characters from the Mahabharata and other well-known Balinese literary favorites. Wayang-style figures offer fair warning to defendants, and reminders to judges, of the karmic implications of infractions of law and social misdemeanor. Benevolence prevails however, for scenes painted at the very top of the ceiling depict complimentary rewards in heaven. Ceiling paintings of the Kerta Gosa, referred to in a lontar book dated 1842, were probably painted about early 18th century, the time the Taman Gili was constructed. The Raja of Klungkung, Dewa Agung, was patron to the village of Kamasan where this style of painting flourished as well as to I Gede Modara, a distinguished painter of Kamasan village accredited with supervision of the paintings of the Kerta Gosa ceilings. The finely carved wooden table and chairs in the Kerta Gosa were replaced in 1920.*

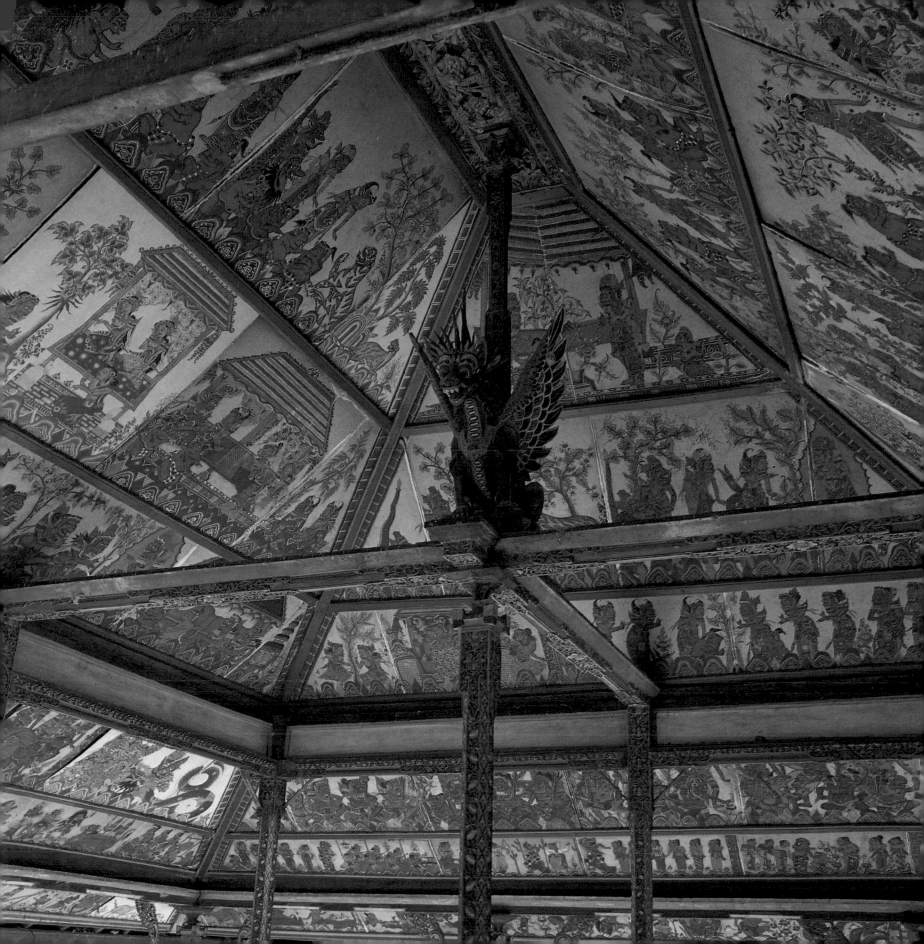

At the center of Taman Gili, Bale Kambang
(Floating Pavilion) sits amidst a lotus pond
adjacent to the Kerta Gosa (Hall of Justice).
This lovely pavilion was once used by the royal
family to receive important guests. The architecture
and the Kamasan-style painted ceilings are similar
to the Kerta Gosa. The Bale Kambang and the Kerta
Gosa are the only buildings remaining of the great
palace of Raja Dewa Agung, Taman Gili. Other
buildings were destroyed by fire during the Dutch-
Balinese conflicts of 1908.

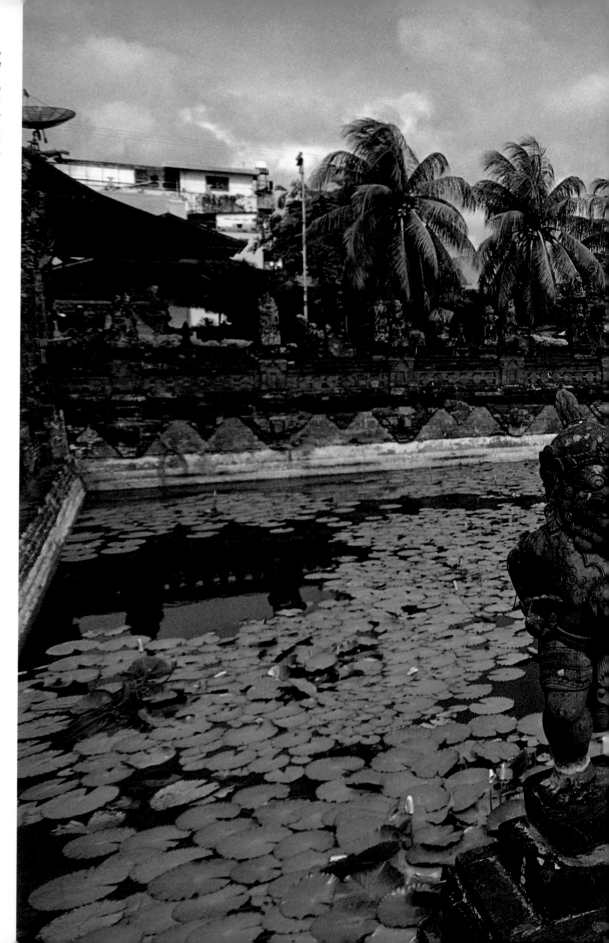

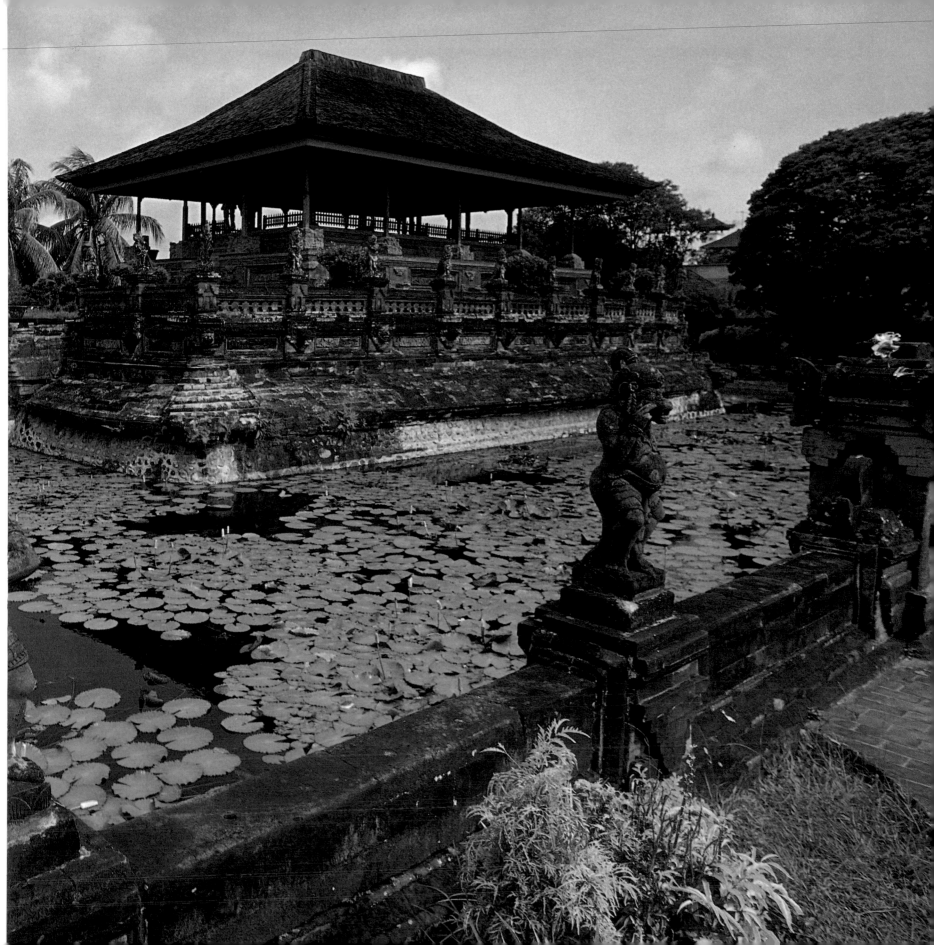

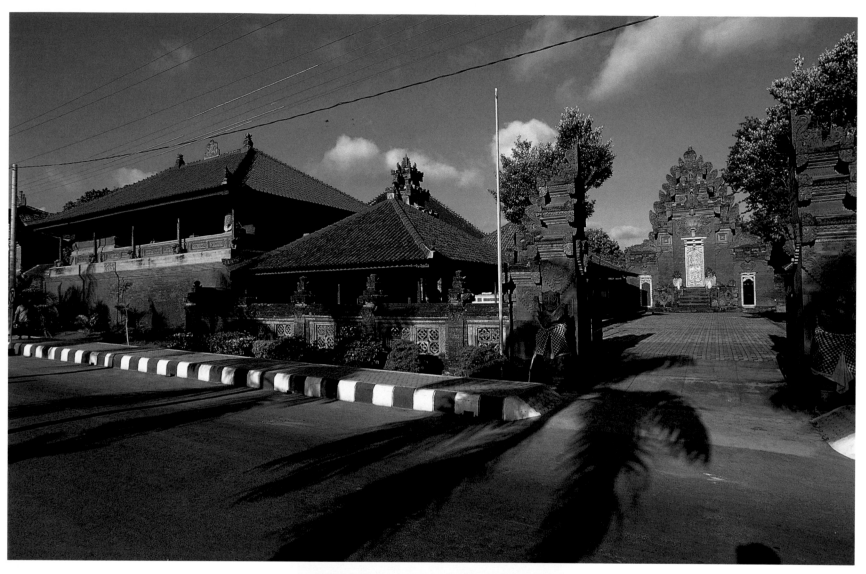

ROYAL PALACE OF GIANYAR

The Puri Agung in Gianyar is a magnificent palace in the traditional Majapahit style. The palace has been home to the rajas of Gianyar and is still occupied by the family of Anak Agung Gede Agung. Puri Agung was originally built around 1771, destroyed during a conflict with Raja Dewa Agung of Klungkung in 1885 then rebuilt. The palace was rebuilt again after an earthquake in 1917.

Above: Street-side view of Puri Agung. Through the split gate and on the left is the open-air Bale Bengong where the princes watch the world outside their court go by.
Right: A beautifully proportioned and detailed Kori Agung gate leads into the inner courtyards of Puri Agung. A fierce stone Bhoma with bulging eyes, long fangs and drooling tongue is traditionally placed above the lintels to scare away evil spirits.

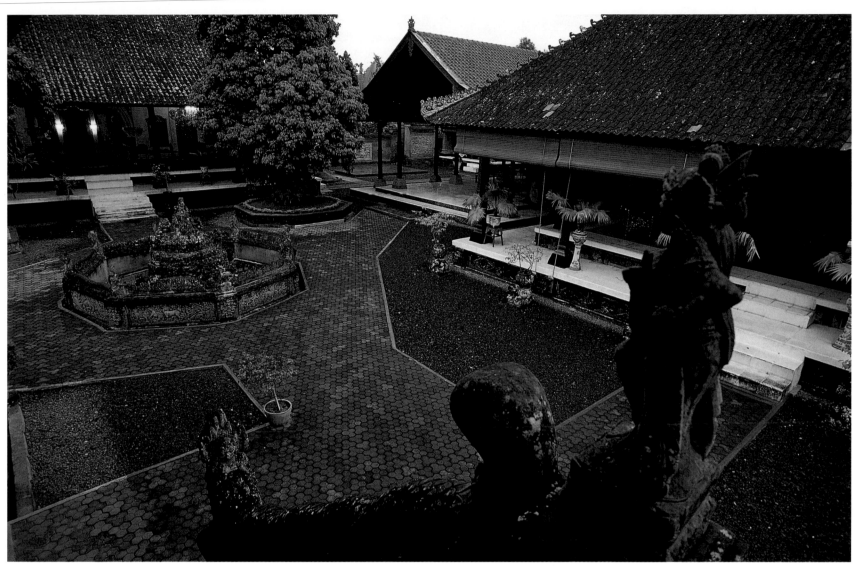

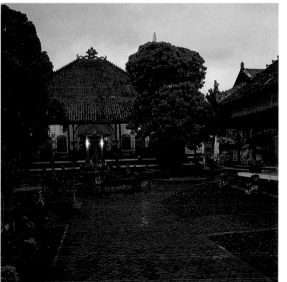

Above: *Modern-day inner courtyard of the Puri Agung is dotted with* bale *(open pavilions) in the traditional Balinese manner of living in out-of-door spaces. The placement of the* bale *in the walled palace compound of a Hindu Balinese raja is planned according to the same laws of spiritual and spatial orientation as the compounds of common families (see Architectural Notebook, page 229).*

Left: *A mature mangosteen (*manggis*) tree graces the inner courtyard, a symbol of the title given to the former Raja Dewa Manggis. The crest of the Rajas of Gianyar is of a mangosteen cut in half, revealing segments of the delicious fruit known as the "Fruit of Queens." It is said the Empress of China sent her fleets to Bali to procure mangosteen to satisfy her longing for this exotic delicacy.*

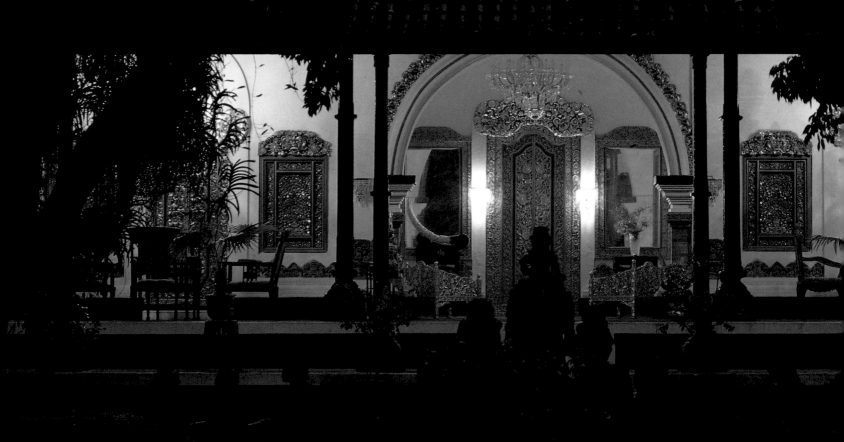

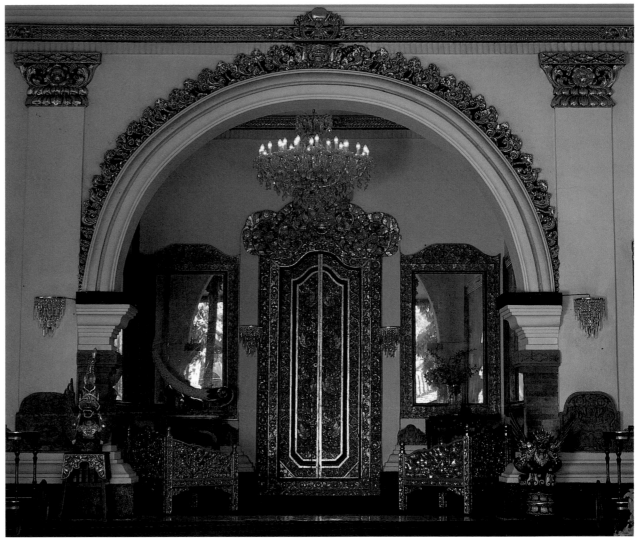

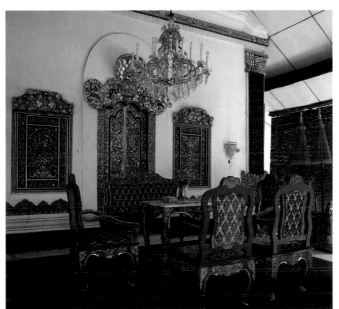

Far left: *Carved and gilded wood in the Puri Agung sparkles in the evening light, providing a glimpse of the splendor in a contemporary puri. The verandah of Bale Gedong, main sleeping bale, is resplendent with opulent details admired by the Balinese.*

Above: *Detail of carved doors, windows and wall decor of the sleeping pavilion in Puri Agung.*

Left: *European-style furniture and crystal chandeliers add an eclectic mix to Balinese court-architecture. Incumbent Anak Agung Gede Agung, who is fluent in many languages, has served as Ambassador to Belgium, France and Austria. His palace home is in the traditional style of Balinese rajas with influences of the outside world.*

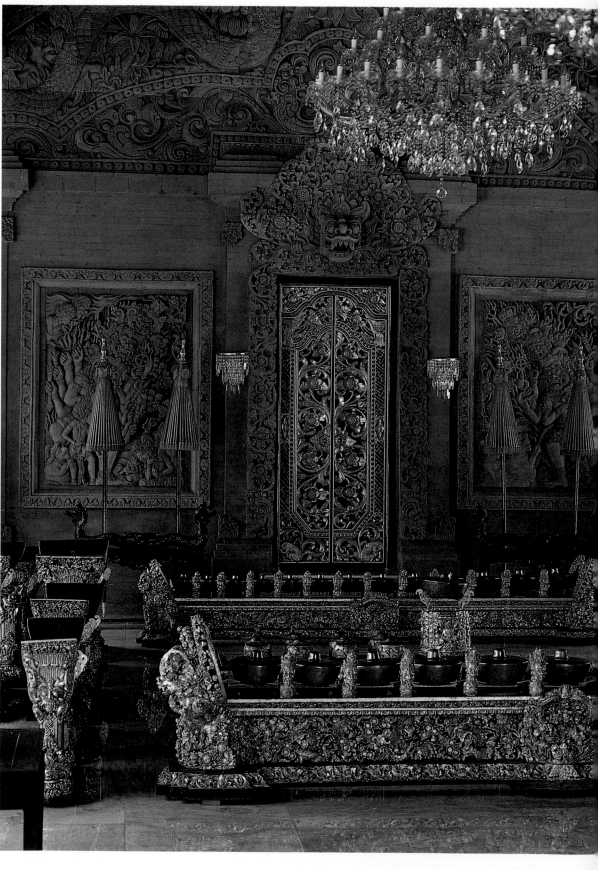

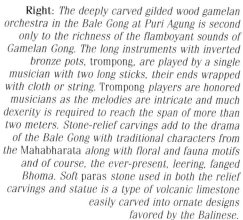

Right: *The deeply carved gilded wood gamelan orchestra in the Bale Gong at Puri Agung is second only to the richness of the flamboyant sounds of* Gamelan Gong. *The long instruments with inverted bronze pots,* trompong, *are played by a single musician with two long sticks, their ends wrapped with cloth or string.* Trompong *players are honored musicians as the melodies are intricate and much dexterity is required to reach the span of more than two meters. Stone-relief carvings add to the drama of the Bale Gong with traditional characters from the* Mahabharata *along with floral and fauna motifs and of course, the ever-present, leering, fanged Bhoma. Soft* paras *stone used in both the relief carvings and statue is a type of volcanic limestone easily carved into ornate designs favored by the Balinese.*

Above: *Crystal chandeliers now light performances of the gamelan orchestra rather than coconut oil lamps of the past. Polychromed and gilded mystical Garuda wood sculptures, carved stone bhomas and crystal chandeliers give testimony to the Balinese acceptance of foreign influence but done in a way to maintain the essence of Bali style.*

Far right above: *The study of Anak Agung Gede Agung at Puri Agung, Gianyar.*

Far right below: *Details of furniture and gamelan instrument, a gangsa. Two* kris *are prized family heirlooms respectfully displayed with honor.*

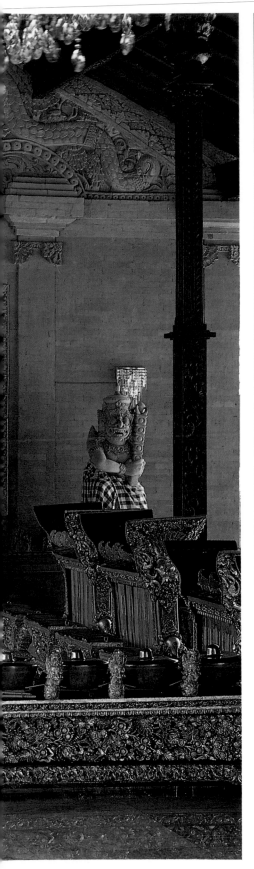

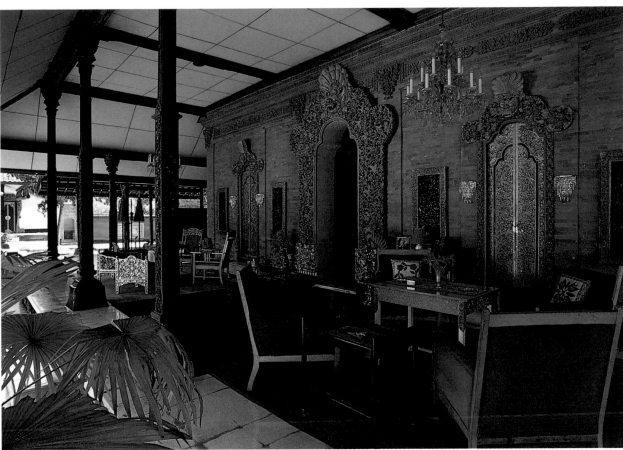

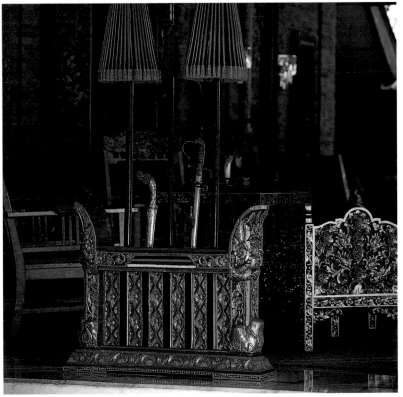

CHINOISERIE BALI STYLE

Painted walls in the Puri Denpasar, Bangli, hint of elegance of courtly days gone by. Exquisitely executed *trompe l'oeil* scrolls, juxtaposed to a traditional Balinese carved and gilded door, depict Chinese-style figures while the motifs tell a story of influence from China.

The palace is now converted into an inn where guests may stay for a very modest rate. The sparsely furnished guest rooms do not relate to the beautifully painted walls of the reception pavilion or the magnificently carved Kori Agung entry gate on the property.

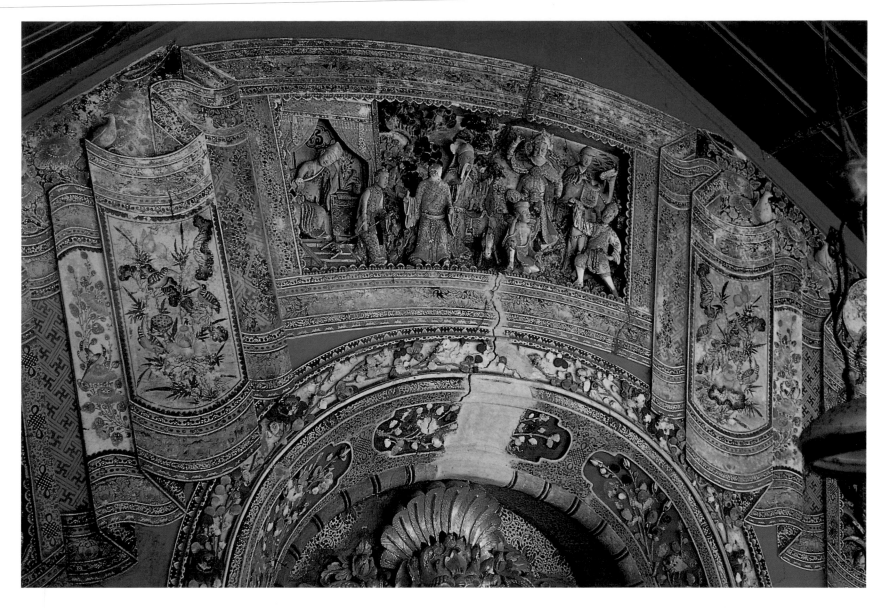

Above: *Detail of Chinoiserie walls over the doorway of the reception pavilion in Puri Denpasar. Trompe l'oeil scroll effect somewhat resembles a tapestry or tile mosaic in the abundance of detail and rich colors. Unfortunately these lovely walls are suffering from the ravages of Bali's tropical climate combined with a certain neglect.*

CARVED PANELS — PURI SIDAN

Intricately carved, polychromed and gilded door and wall panels of this pavilion at Puri Sidan tell Tantri fables. Ancient Tantri stories from Hindu religious writings concerning magic and mysticism are favored themes for paintings and carvings by Balinese artists.

These carved panels are typical of lavish detailing with which artisans on Bali enjoy, whether painting a canvas or sculpting from wood or stone. Design motifs completely fill available space, filling your eye with wonder.

Balinese artists have traditionally thought of themselves as workers or laborers providing a service; the artists were anonymous thus works of art were left unsigned. Artistry is an everyday experience on Bali, a way of life that is not set aside as an exalted work or a position of status.

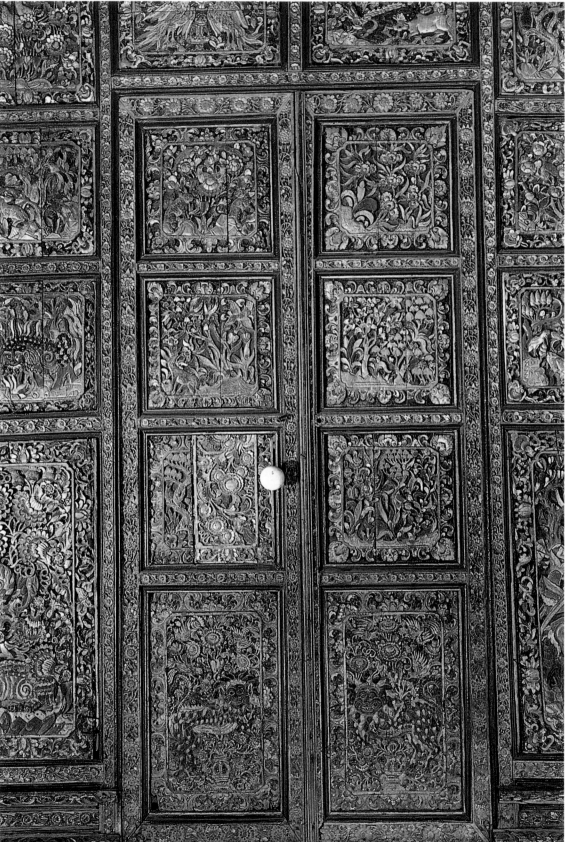

Far right: *Detail of polychromed and gilded woodcarving at Puri Sidan, Sidan.*

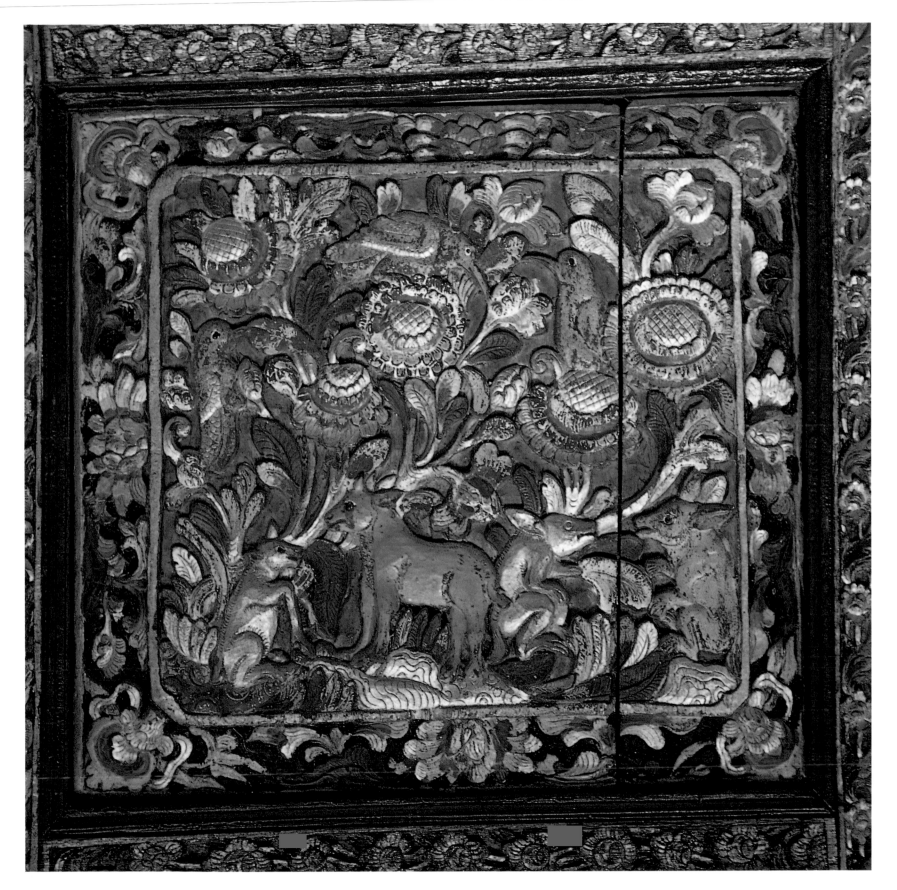

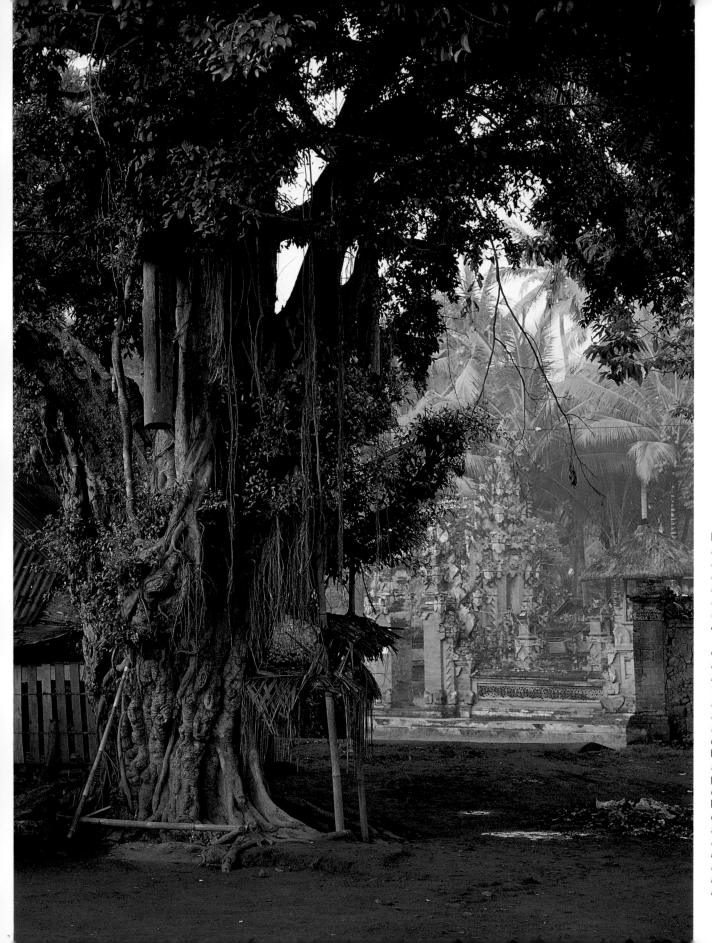

Left: *The* waringin *(banyan) tree is held sacred as a symbol of the family. Mature* waringin *trees have many auxiliary trunks resulting from hair-like shoots from large branching limbs that reach the ground and take root. Nourishment and support are given the old tree from the new "family" of trunks. Traditional dances and other ceremonial events frequently take place beneath the huge cathedral canopy of the tree. This* waringin *tree at a temple in Bedulu also serves as support for the kulkul. Just beyond the tree is the entrance to the middle courtyard of the temple through the* candi bentar *(split gate) and on to the innermost courtyard through the* paduraksa *gate. Both gateways are exemplary of the Majapahit period.*
Right: *Balinese are masters in creating space within open space, simplicity juxtaposed to complexity, tranquillity as a foil to dramatic busyness. A tangle of vines in a tropical forests is given form and focus in this aerie at a hermitage near Payangan.*

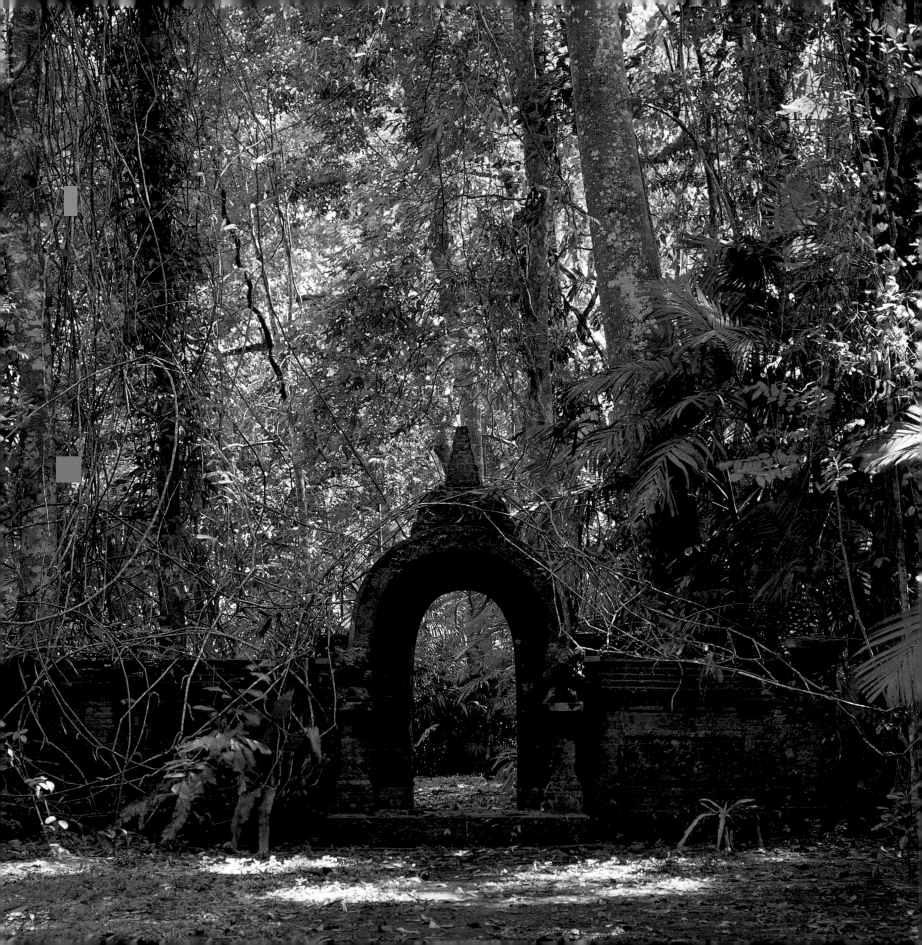

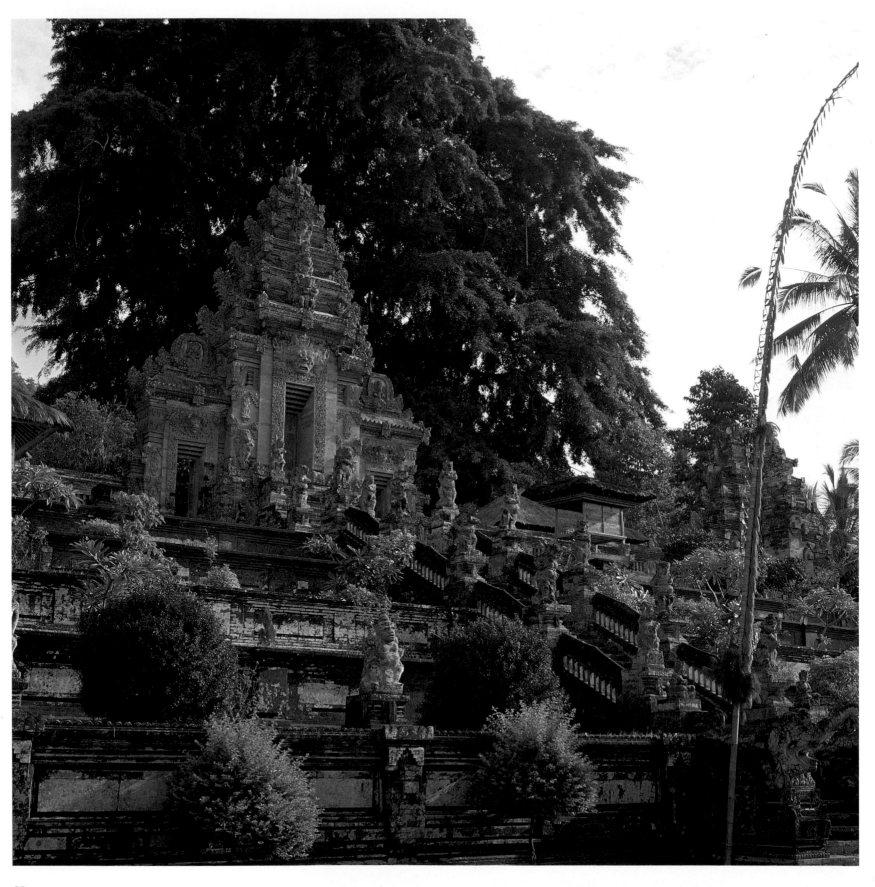

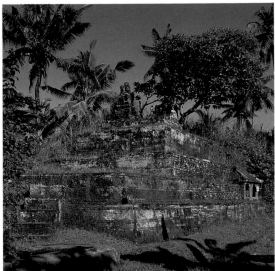

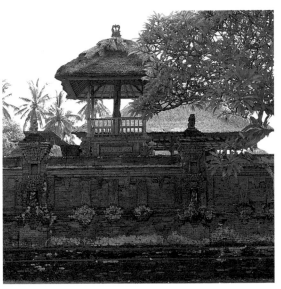

Far left: *Terraced steps lead worshipers past somewhat comical stone statues representing villagers up to the temple, Pura Kehen, in Bangli. Elegant proportions and the fine carvings of this paduraksa (entry gate to inner temple) acclaim Pura Kehen as one of Bali's finest. An old shrine at the foot of the stairs stores a fine collection of bronze plates inscribed with historical data. Records date the temple around A.D. 1204.*

Left: *Orientation of streets in Klungkung are toward the sacred mountain Gunung Agung.*

Above top: *Ancient, tiered stone altar of this temple south of Gianyar probably predates Hindu influence, during the time of the Bali Aga animists.*

Above bottom: *Kulkul tower in Klungkung — a traditional feature of Balinese villages and temples.*

63

ANCIENT SITES

The megalithic structures found in the early temples as well as the carved, stone *candi* (stupas) such as those at Gunung Kawi reflect the Bali Aga or monumental style. Gunung Kawi is a series of nine towers hewn out of solid rock, each inside a carved niche, along with a monastery of cells which are also carved out of rock. Dating from A.D. 1077, the towers serve as royal memorials to Raja Udayana and his family. Bali has many ancient sites of cloisters, *candi* and hewn niches representative of the Bali Aga period. The most notable man-made cave, remarkable for its inner layout as well as its exterior decoration, is the Goa Gajah or "Elephant Cave" near Bedulu. Goa Gajah is thought to have been a hermitage for Buddhist. It dates also from the 11th century and is most likely named for the stone statue of Ganesa inside the great hollowed rock. The exterior of the huge rock is covered with massive stone carvings of stylized rocks, waves, animals, forests and people.

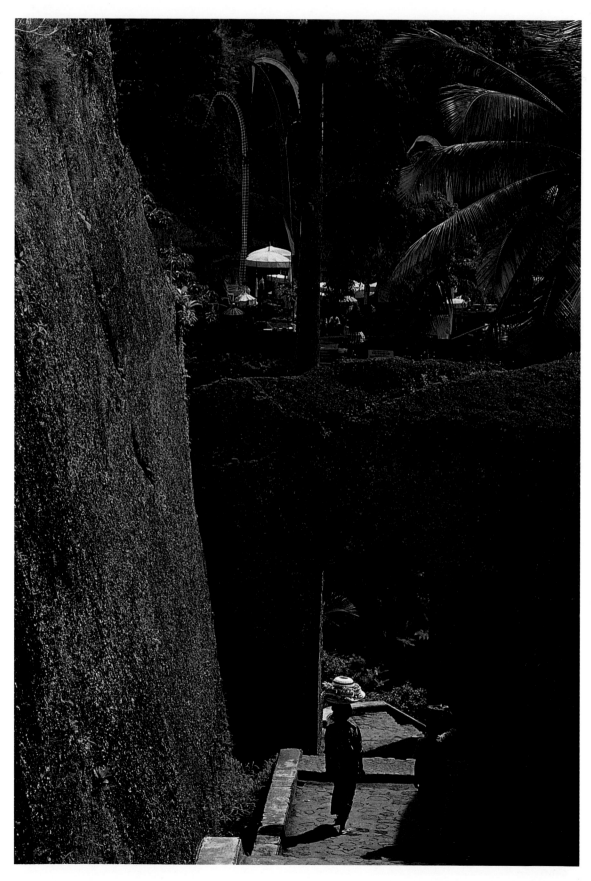

Right: *Winding down through rock-hewn steps at monumental Gunung Kawi, a woman carries offerings to the temple below. Gunung Kawi's appellation "The Mountain of Poets" may actually have its origin in the beautiful landscape rather than the actual complex of* candi, *niches and cells. Dating before the 11th century, this remarkably preserved archaeological site was known by the people of Tampaksiring long before various archaeologists made the area widely known through their discoveries between 1920 and 1949.*

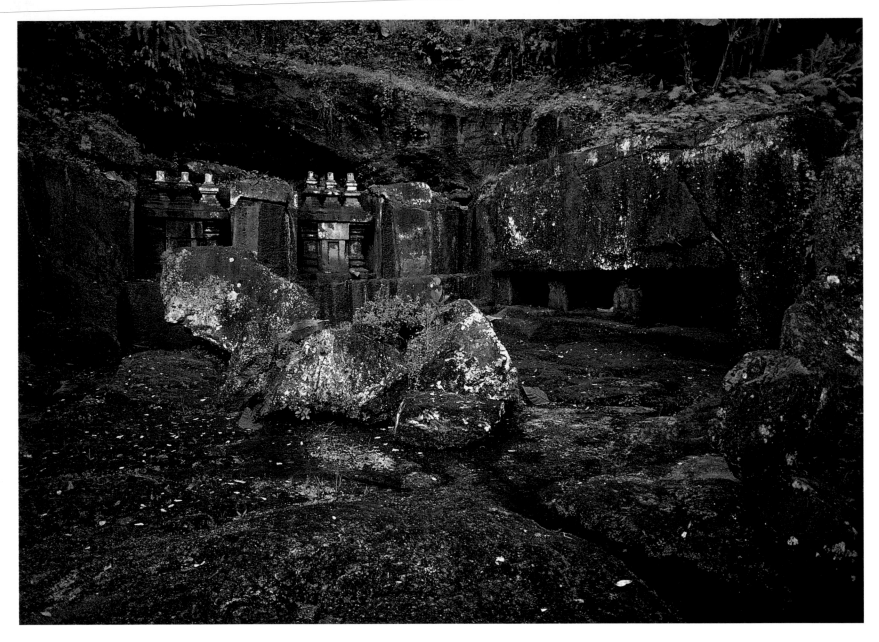

Above: *A sacred grotto in the monumental style of Gunung Kawi, Candi Tebing in Tegallingah was unearthed in the 1950s by the Archaeology Service of Indonesia. Construction of Candi Tebing was apparently interrupted (perhaps due to earthquake) and never completed.*

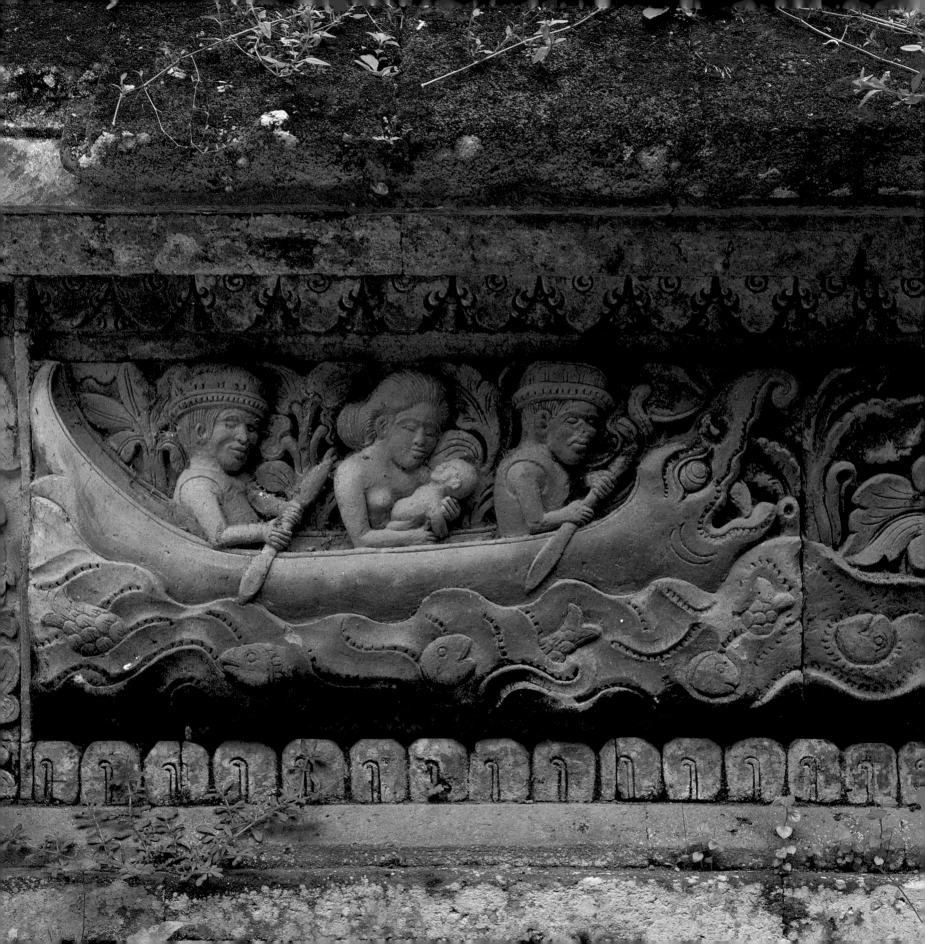

FORMS OF BALI

Sensual, vibrant, startling and often exuberant ornate-ness characterizes the easily recognized forms of Bali. Forms that speak a visual language of a people who adore drama, nature and beauty but perhaps above all refuse to take life too seriously. Drama is a guiding force, the constant element underlying an unaffected grandeur present in fabric designs, wood and stone carvings, architecture, performing arts, paintings and so keenly felt in the music.

Compelling visual traditions were part of the indigenous religion of Bali's original inhabitants, the Bali Aga animists. These artistic traditions formed a basis to interact with the influence of Buddhism, Hinduism and the many other foreign ideas brought to the island during a recorded history of more than a millennium. While the forms of Bali often evoke an image of China, India or Thailand, the resulting adaptation is pure Balinese.

A mild-mannered people who live in harmony with nature is a paradox when examining the contrasts and contradictions in their lifestyle and the design motifs of their arts. Most of the Balinese people lead simple, rural lives yet their arts are voluptuously grand. The people live in homes containing only a bare mini-mum of comfort yet when attending traditional ceremonies they dress in exquisitely designed fabrics with gold and brocade.

The *kamben* (sarong) worn by both men and women is a practical, traditional style of dress

and is a perfect example of the contrasts and contradictions. A most intricately designed textile such as an *ikat, endek* or batik is not sewn into a garment but is simply twisted and tied into a *kamben* using no fasteners such as buttons or snaps. A *kamben* measures one meter by two meters and is stylishly draped in one fashion for men and another for women — and "one size fits all." It is worn to work in the rice fields, to wait tables in a restaurant, or to attend traditional ceremonies. It also serves as a bathrobe or towel to *mandi* at the river, as a cradle for the baby or a scarf for the table. The *kamben* is a totally comfortable and practical garment that requires no elaborate storage closets as a simple shelf stores a vast number to round out a wardrobe.

Creatively draping a single piece of fabric for clothing is in concert with the Balinese manner of ease, practicality, elegance and beauty. The image of exotic, saronged, Balinese women with bare breasts is a scene of the past. This custom was ended by the Dutch claiming army troops were demoralized by viewing such beauty. Older women continue to feel no inhibition in wearing only a sarong and women of all ages within the compound frequently wear sarong and brassiere...black being a highly desired color.

While the mundane parts of life are approached in the most practical way, the spiritual parts of life are very complicated.

Left: *Moving through the sea of life, a wall relief carved in* paras *stone in the Pura Dalem in Negari has bold images rather than intricate carvings.*
Above: *The Balinese sense of humor is subtly cartooned in the* paras *stone statue of a Balinese man dressed in traditional attire...sarong, a saput about the waist and hibiscus flowers placed in the* udeng *or headdress.*

Balinese homes are a study in simplicity while their temples are elaborately decorated with luxurious and fanciful carvings. Ceremonial festivals are staged in these ornately carved temples where dance and drama are presented with an extraordinarily high degree of sophistication.

The beautiful Legong dance is a favored presentation to entertain the gods and exemplifies the Balinese style of contradictions. Legong dancers move in slow, rhythmic movement of the body while the fingers flutter constantly, as do the flowers entwined in the hair falling about the face or the shimmering of the gold leaves of the headdress. Legong costumes are a jewel-toned sarong glittering with gold motifs and layers of patterned fabric trims. The impact on the senses by the vivid imagery of the dancer is further intensified by the crescendo and complex sounds of the gamelan orchestra. Entrancing and mesmerizing are the contrasting components of costume and dance with the added complexity of being staged against an architectural structure rich in ornamentation.

Balinese temple festivals are a magnificent embodiment of the many disciplines that define Balinese forms. Temple celebrations in the humblest of villages encompass dance, drama, artistic offerings, music and architecture. The temple festival not only embodies the design themes of their arts but the heart of their culture.

The visual, musical, and performance arts, as well as architecture, possess layer upon layer of patterns and rhythmic themes. A "busyness" to the eye as well as to the ear and to the feelings. In a word, "busyness" most accurately describes the style of Bali and in particular the ornate style of south Bali where the largest portion of the population live. Anthropologist, Margaret Mead, conducted extensive research on the Balinese personality and culture in the 1930s. She wrote of the "incredible busyness of Bali" when describing the lifestyle of the people. Today this busyness is still pervasive in the industrious attitudes exhibited in everyday activities and is a major component of the arts.

Artistic busyness seen in the Balinese style of layer upon layer of patterns, textures, and colors is reminiscent — and at the same time in contradiction — of the serenely peaceful rice field landscapes. Continuous patterns and rhythmic themes exhibited in the ritual arts of ceremonial pageantry are illustrated in nature in the *sawah*. Textured green and brown rice terraces step up and down the slopes of Bali forming a life-sized model of a topographical map. Each terrace is grooved to the movement of slope and each succeeding step reverberates the rhythm. Rhythmic patterns of this incredibly beautiful landscape have been sculpted for centuries by a people who have repeated the same continuous design elements in their arts.

Rythmn, drama, nature and beauty are a basic sum total of themes present in Bali's style. To these elements must be added tradition. *Agama, adat, budaya* (religion, laws and culture) are three words endemic to the Balinese. Honoring of these traditional tenets of their society give structure to their art forms.

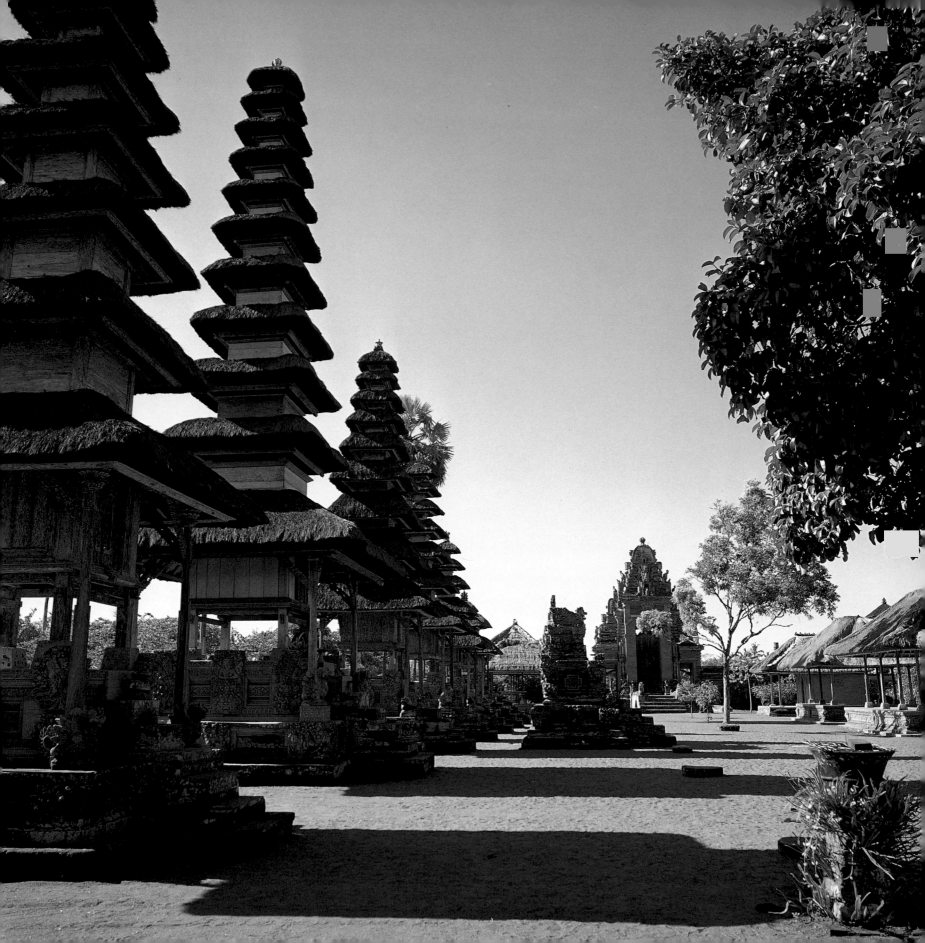

Left: *Pura Taman Ayun is considered one of Bali's most beautiful temples. The temple was built in 1634 as a family temple for the Raja of Mengwi and is still maintained by decendants of the royal family. The inner courtyard of Pura Taman Ayun has many* meru *with finely carved stone base. The* paduraksa *entry gate is of the Majapahit period.*

Right: *Serene moats and an abundance of flowering, fragrant trees surround Pura Taman Ayun lending the place a tranquil, meditative atmosphere.*

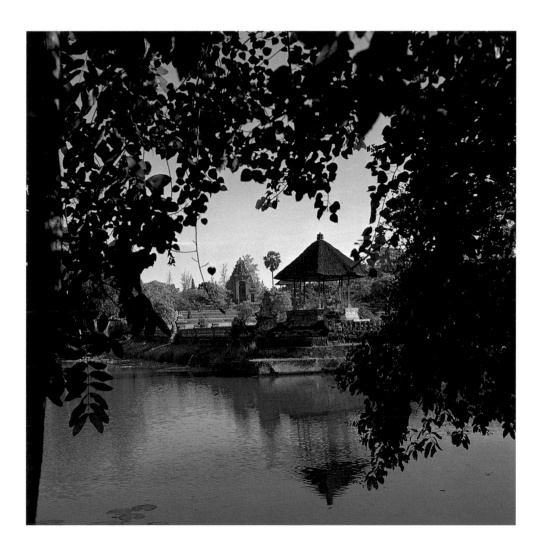

FORMS OF BALI — TOWERING MERU SHRINES

Balinese temples are sacred plots of land bordered by low walls and roofed by the sky above. Many shrines are scattered about the inner courtyards including graceful *meru* shrines. A widely recognized Balinese form, *meru* are pagoda-like structures always built with uneven numbers of sugar-palm fiber roofs that diminish in size as they step higher. A *meru* of eleven roofs is a resting place for the supreme god, Sanghyang Widi. The name, *meru,* is derived from the Cosmic Mountain, Mahameru, the axis of the Universe.

BALINESE RELIGIOUS FORMS AND CEREMONIES

Temple ceremonies are a staged embodiment, a coming together of the many disciplines that define Balinese forms. Celebrations honoring the gods or ancestors are divine pageants expressing artistic dedication through every aspect of their creative abilities. Ceremonies are regular events providing incentive for the community to design and create offerings; to observe or perform traditional music, dance, shadow plays, and drama; to prepare and partake of delicacies of the cuisine; and through divine worship of the forces of nature, restore magical health to the village. Balinese celebrations are not solemn events but joyous occasions. Religious ceremonies are not a time to humble oneself but a time to welcome the gods and to make them happy with beautiful sights, smells and sounds.

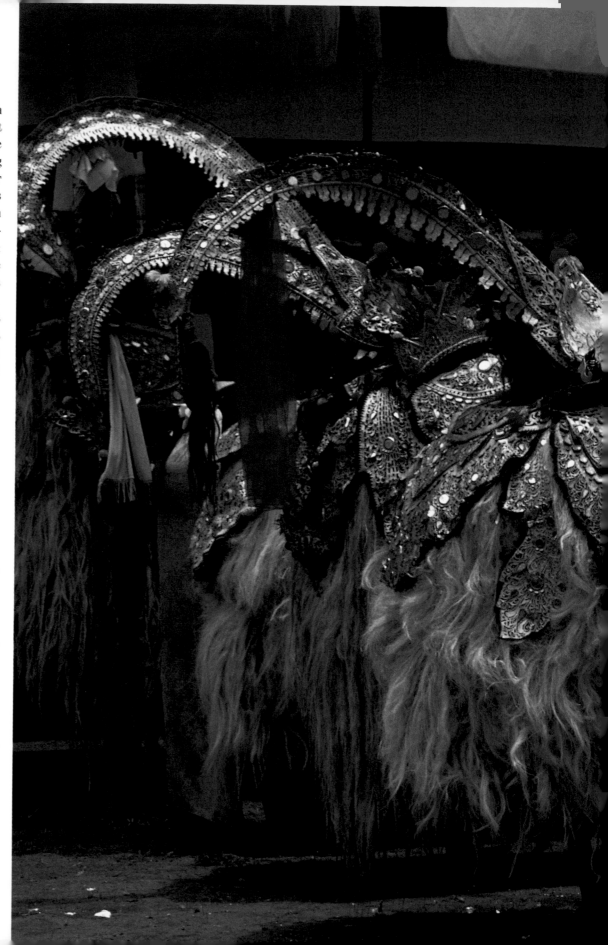

(Preceding left page)
Top and bottom left: *Roadside shrines are often simple bamboo platforms with carved statues, usually gaily decorated. Lower picture is of a shrine amidst root-hairs of a banyan tree that have been dyed red for an additional touch of color.*
Right: *Image of Betara Ding Dong, god of fertility. The event involves an uproarious, ribald ritual of fertility in which a Ding Dong couple with huge genitals are mated.*
(Preceding right page)
Top left: *Shrines at a temple ceremony, Pura Taman Pule, Mas.*
Top right: *A priest places offerings of fresh flowers during the temple ceremony.*
Bottom left: *Villagers ride to the sea for a special ceremony in the back of a truck.*
Bottom right: *Children join a temple procession in the village of Ubud.*
This page, right: *The mythical, lovable, supernatural Barong is an important part of temple ceremony performances. The mask and costume are treated with respect as they are considered to contain magic.*

74

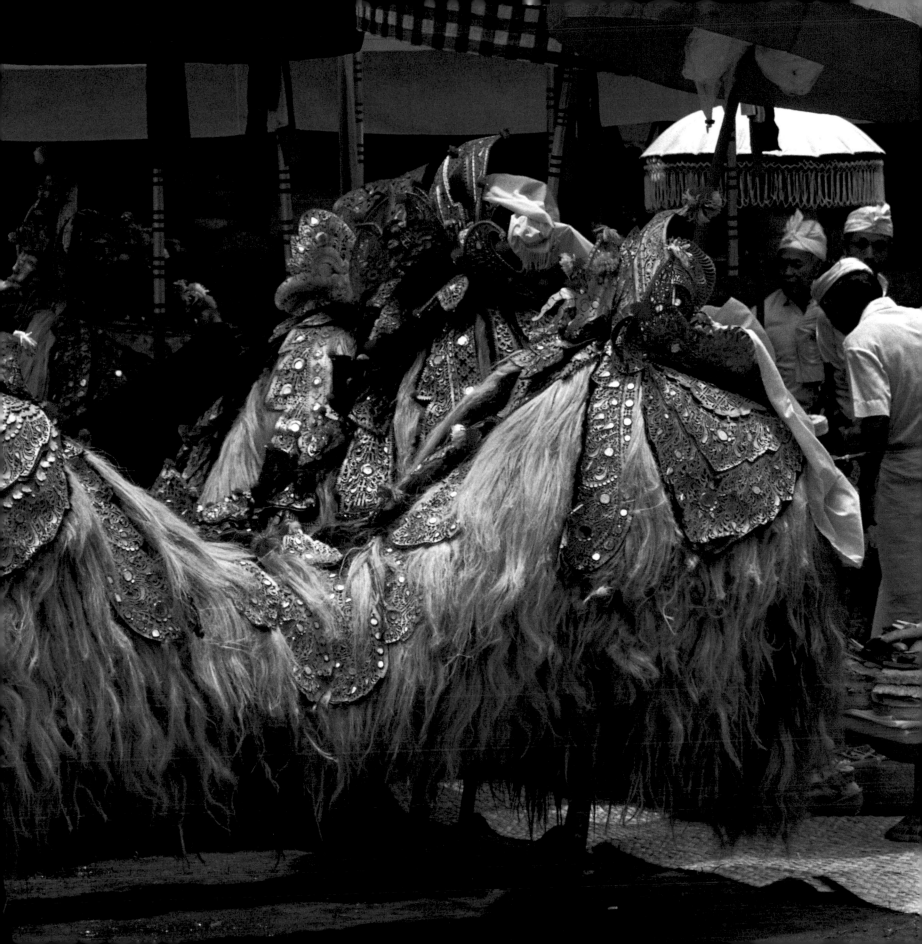

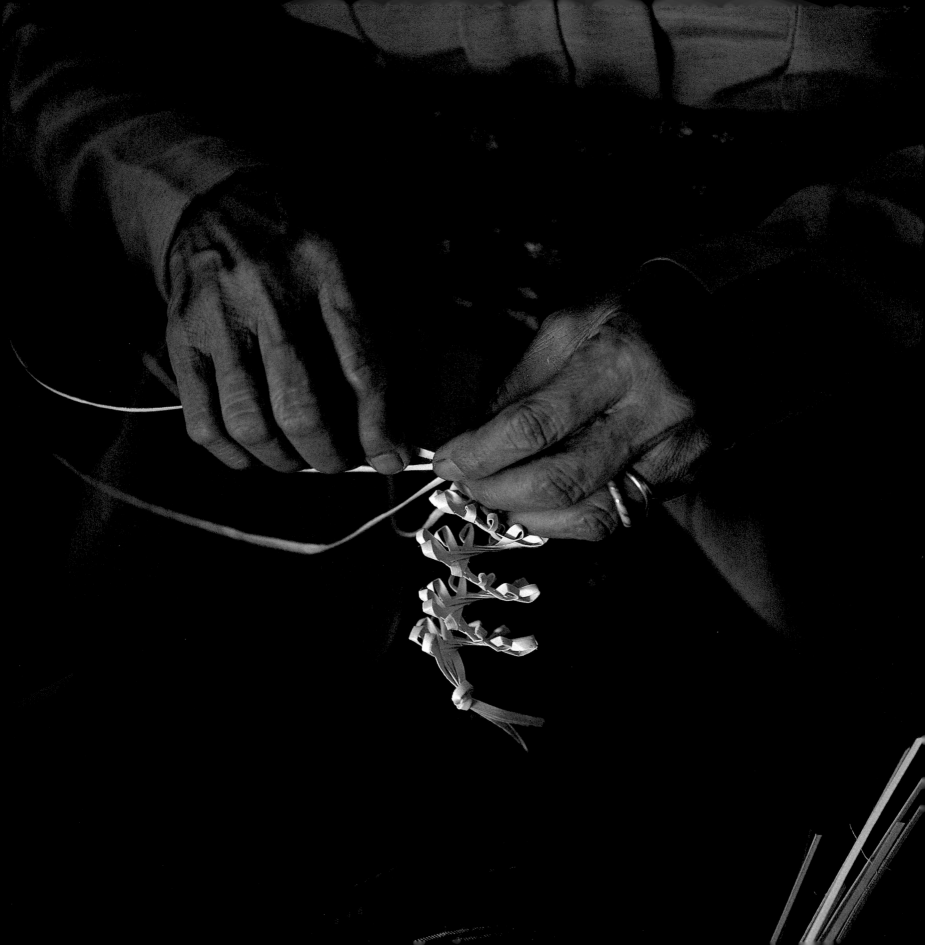

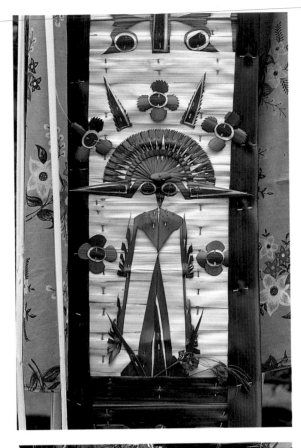

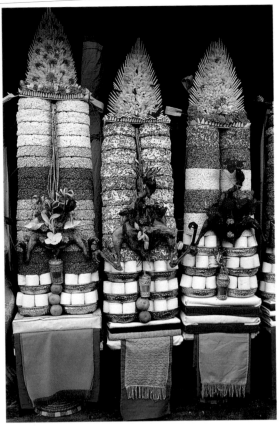

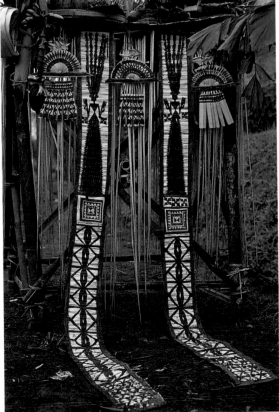

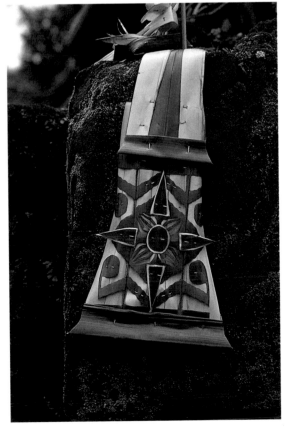

THE ART OF THE OFFERING

Rice is the main food crop on Bali so it is no surprise that forms seen in the style are derived from the fields, the plant and the fruit it bears. A design element evolving from the rice oriented culture and much loved by the Balinese is the *tjili*. *Tjili* are graphic images of the "rice mother."

Top left: *Lamaks are woven for special ceremonies using combinations of mature, green palm leaves and immature, white palm leaves. White leaves are often stained with dyes to achieve colored patterns. Religious symbols such as the* tjili, *wayang figures, or geometric patterns are used in* lamak *design.*
Top center: *Colored rice cake offerings are abstract* tjili *designs...fan-shaped crown, a body of rice cakes and a skirt.*
Top right: Tjili *drawing with palm-leaf detail decorates rice cake offerings. Offerings of Chinese coins,* pis bolong, *are fashioned about a mirror, also hung in long strands.*
Bottom left and right: Lamak *runners vary in size from quite short to many meters in length.*
Far left: *Much of a woman's time is given to the artistic expression of design and construction of perishable, delicately cut, palm-leaf decorations and offerings creating transitory art forms of brief but incredible beauty.*

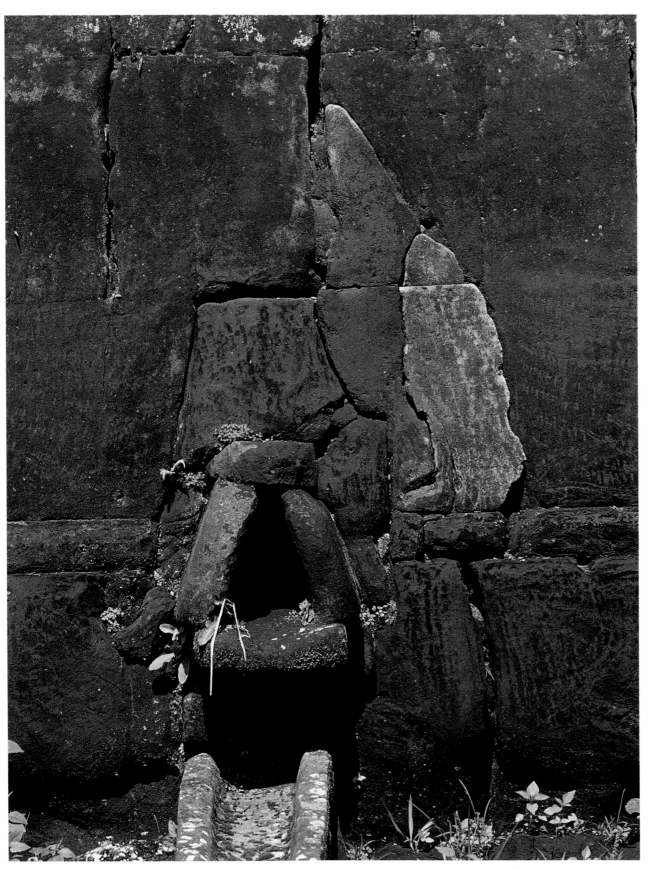

WALLS — PATTERNS AND RHYTHMS

Rather than erecting a building to enclose space, Balinese build walls. The wall as an architectural element is a fine example of the philosophy of complexity and contradiction prevalent in their arts...there is a blank wall but it contains a gate, spaces are closed yet open, once inside the gate there is interplay of space.

Walls are built of brick, stone or mud and frequently are a combination of these materials. Designs of walls feature rhythmic patterns developed by the use of multi-depth courses. Within these patterns of brick coursings, a mystical animal carved of stone or a jutting piece of cement formed to a geometric shape of religious significance is often capriciously placed. An unexpected change of direction of brick coursings is another method of achieving diverse and varied interest. Rhythmic patterns with that unexpected interruption to relieve monotony and provoke a smile are a favored element in architectural walls as well as in other arts.

Left: *A mud wall has a channel to divert heavy rainwater from a compound.*
Right top: *A kitchen wall is vented by brick patterning.*
Right center: *Wind holes in the wall of a temple in Krobokan.*
Right bottom: *Designed to permit the flow of air, this three dimensional brick pattern appears to be a precursor of modern visual artworks.*

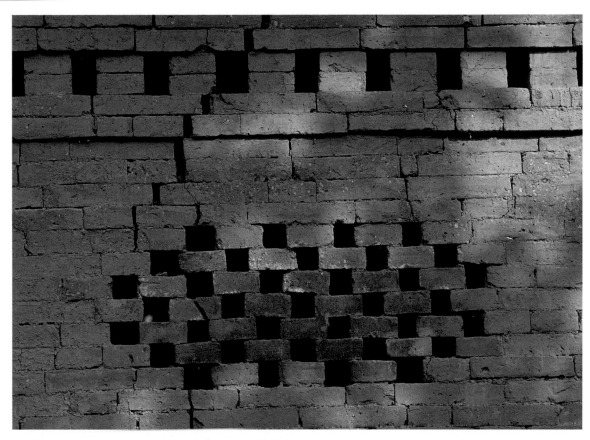

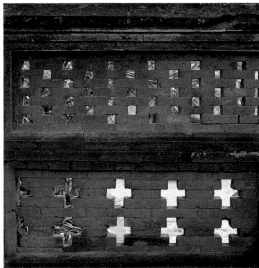

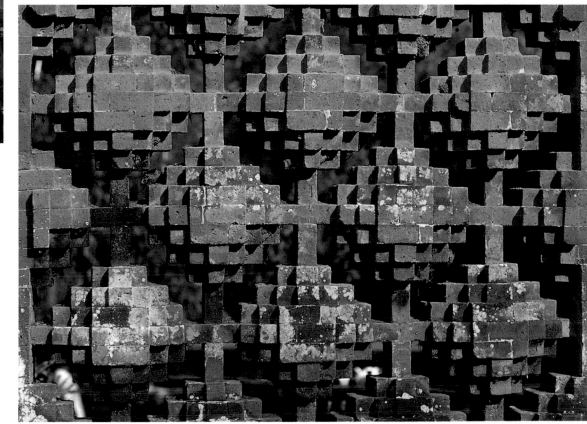

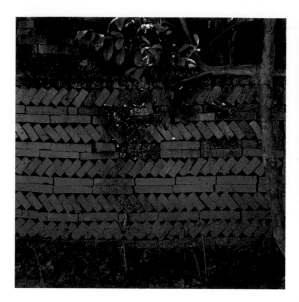

Clockwise (from top to bottom): *Stacked bricks form a wall with geometric interest; compound mud wall in the Bali Aga village of Tenganan; stone foundation and exterior mud wall of building in the Karangasem area; mud wall of building using the popolan technique (popolan are round mud balls with mud mortar; they are usually similiar in size and shape as the stones used for the base); mud bricks stacked to dry.*

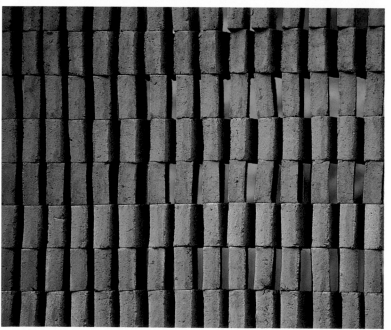

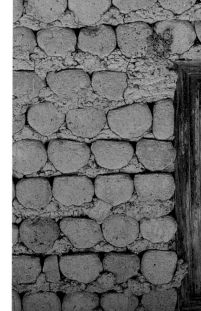

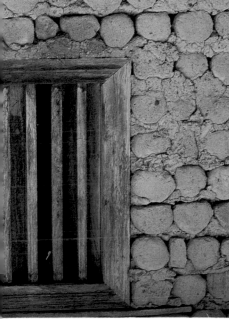

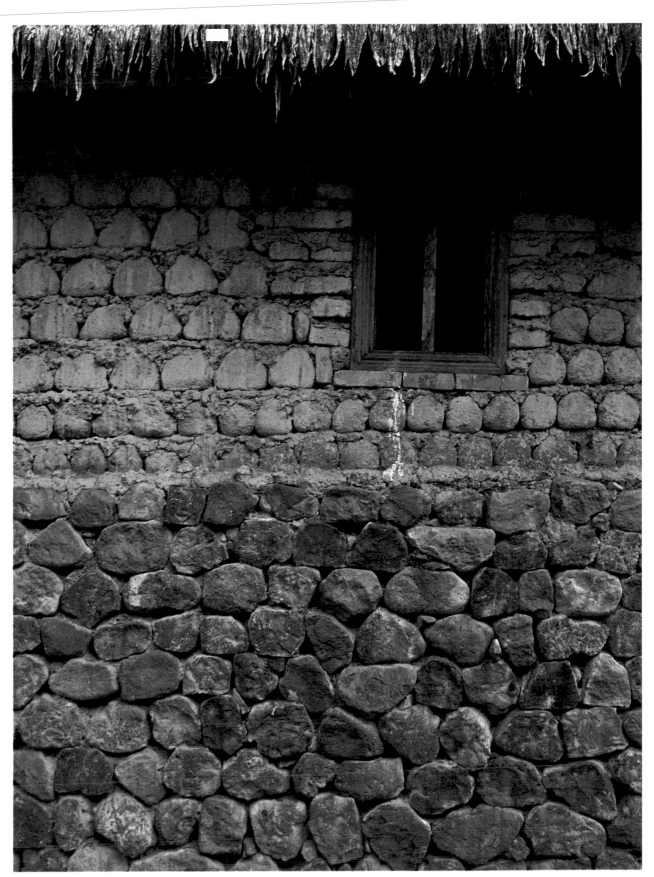

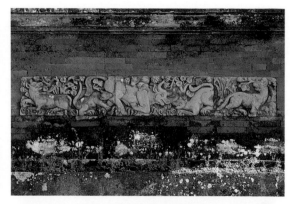

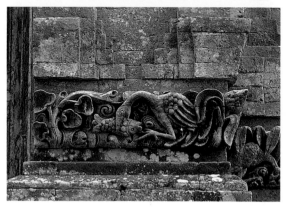

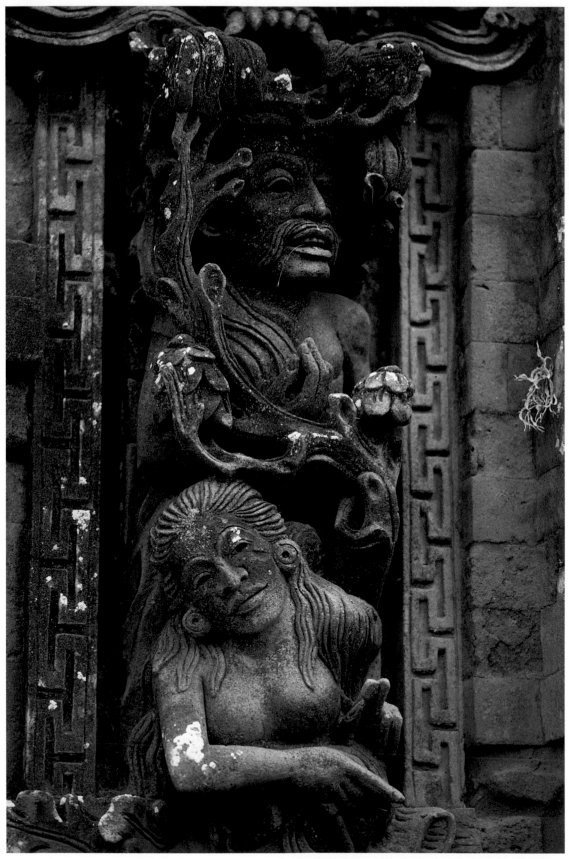

WALL RELIEFS

Bali's profusion of stone carvings is staggering. Temple walls and gates are a jungle of carved motifs of flora, fauna, whimsical characters, mythical figures plus all the stone statues guarding every gate.

An abundance of soft, volcanic sandstone, *paras*, has provided Balinese stonecarvers the medium for their artistic expression. Through the ages, Bali's volcanoes have spewed a mineral rich ash that is responsible for the lush vegetation as well as compacting in some areas into a stone "tuff" that is as soft as wood when first quarried. *Paras* hardens with age, however its porous surface is a perfect home for lichen, ferns and mosses so that within a very short period of time, the newest of carvings has an age-old appearance.

Left: *Balinese would describe this* paras *carving of a man and woman entwined with vines, leaves and tendrils as "romantis." Carving is on a gateway to a temple in Tabanan.*
Above: *Reliefs on the wall of a Pura Dalem temple are probably stories from the Tantri.*
Right: Paras *and brick reliefs on the wall of a temple in Negari worked with many of the traditional motifs shown in the Architectural Notebook section. The scene of a gamelan orchestra features a Kebyar duduk dancer center stage.*

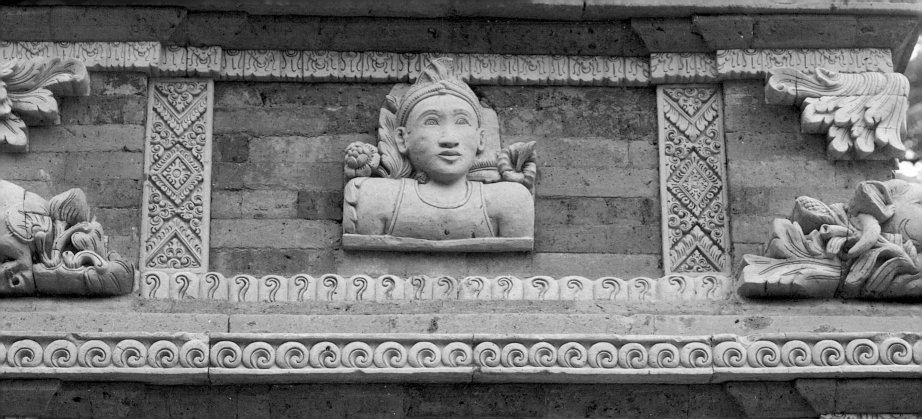
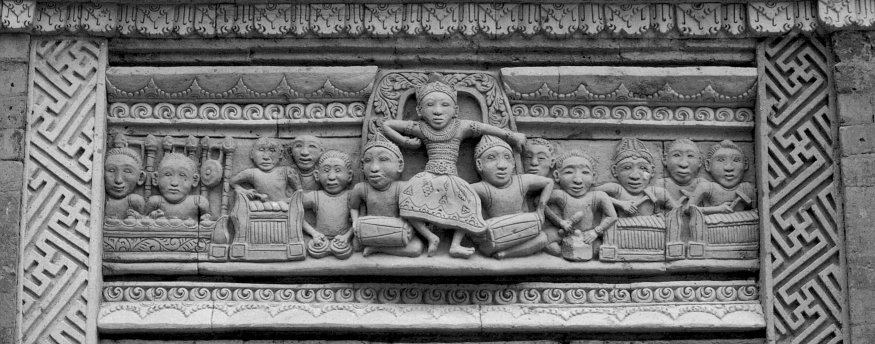

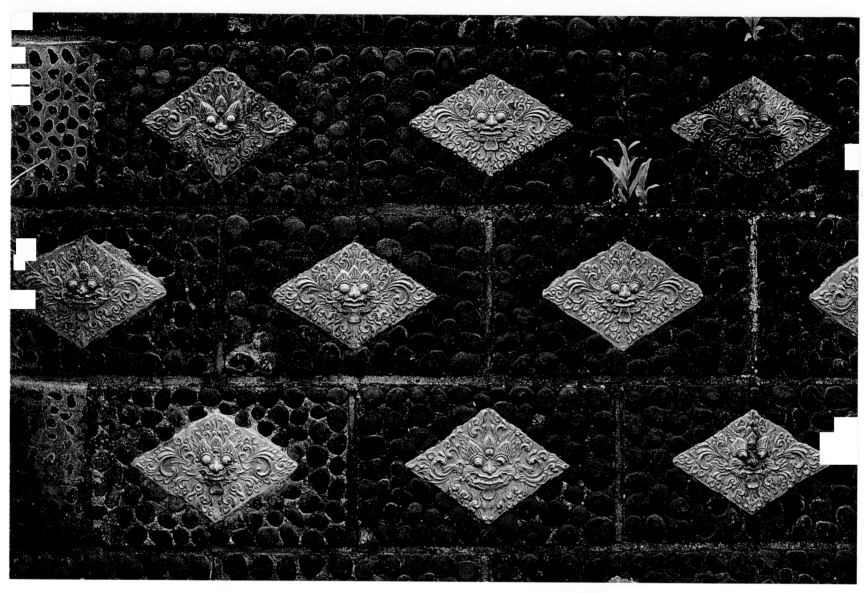

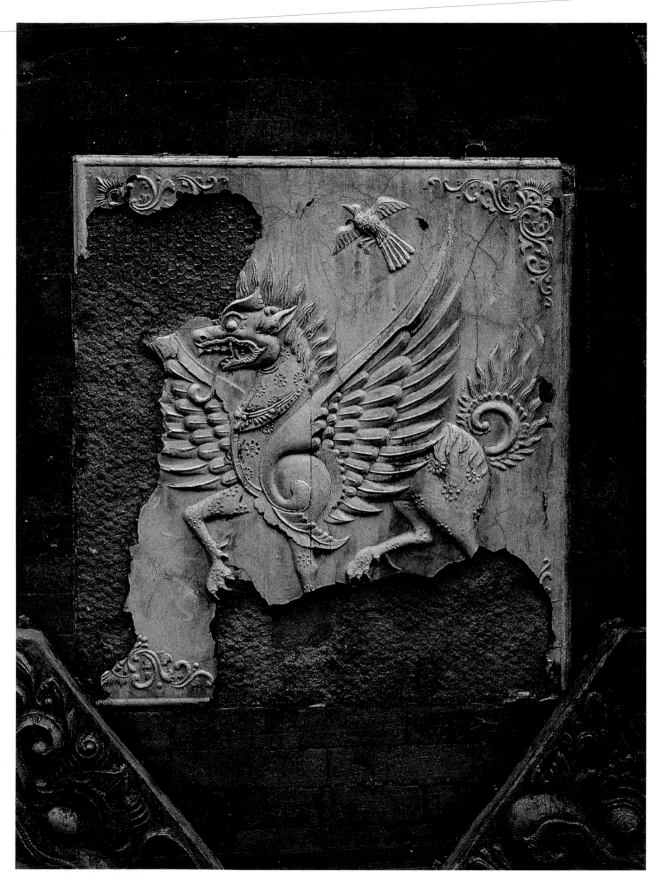

Bali's stone carvings of fierce faces, bulging eyes, fearsome fangs of mythical creatures all softened and framed by delicate floral designs astound and bewilder.

Far left above: *Wall of black stone bricks are inset with individually carved* paras *stone-shaped diamonds with figure of Bhoma.*

Far left below: *Facade of palace wall at Puri Karangasem.*

Left: *Detail of plaster tile on the wall of Puri Karangasem.*

SENSUOUS SCULPTURE IN WOOD

Woodcarvings of talented Balinese artists are flowing, alive forms that have dynamics, and often reflect Balinese humor or animistic content. Unfortunately, much of the woodcraft bought for foreign export do not represent the rare quality available on Bali. Carvings shown are from the Bali Museum in Denpasar and from the village of Nyuhkuning.

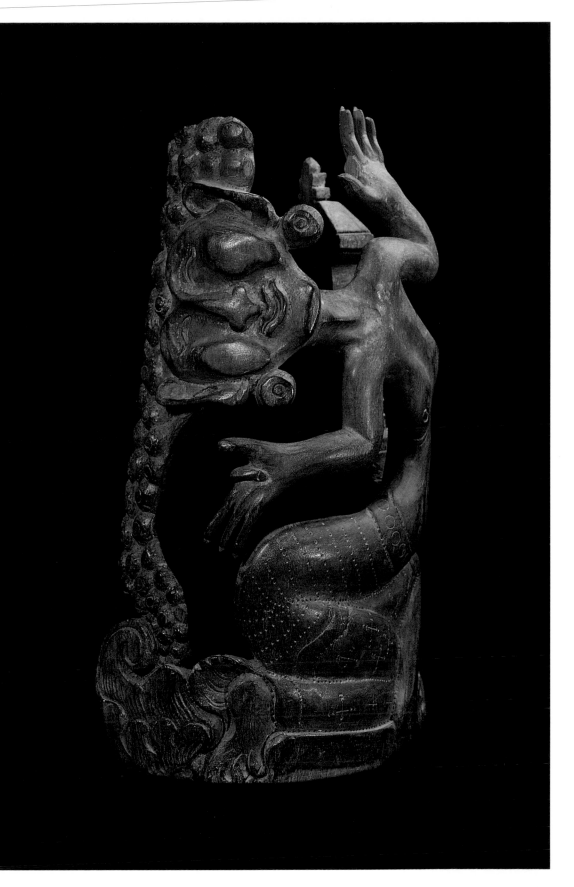

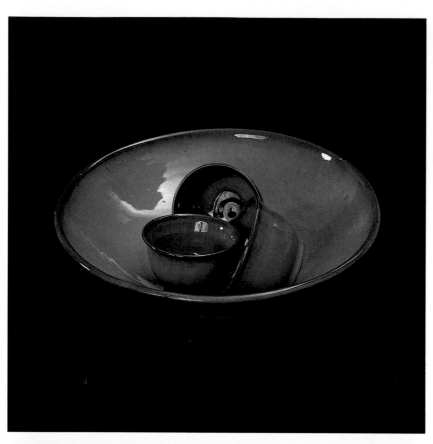
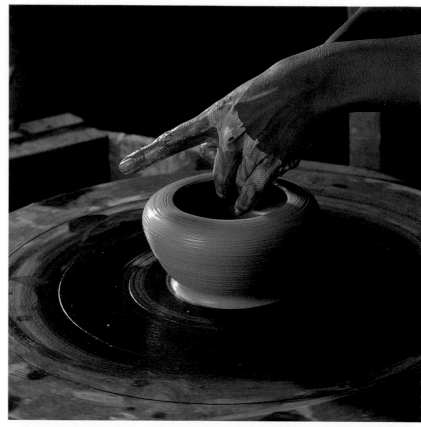

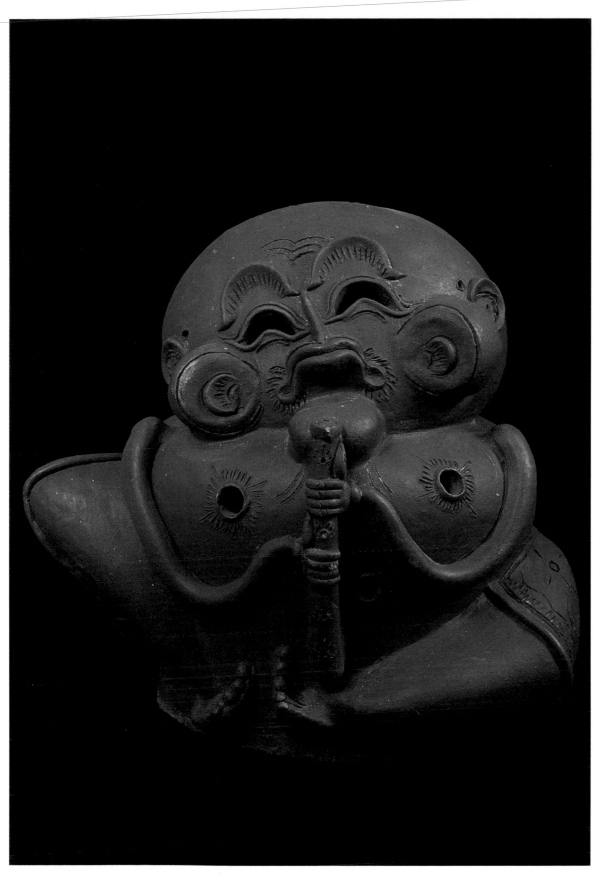

BALINESE POTTERY

Interest in working with glazed pottery is a growing art form on Bali. Balinese craftspeople are accepting ideas from abroad, then interpreting forms within their traditional style. Favored glazes are shades of cerulean to cobalt blue (as shown on opposite page, top left). Balinese creativity, dexterity and craftsmanship will assure this growing cottage industry success.

Unglazed, red clay pottery is utilized throughout Bali as containers in the home, decoration in architecture, offerings in temple and cremation ceremonies and as work vessels. This commonly used unglazed pottery is usually fired at low temperatures and considered quite disposable. Pottery of this type has been unearthed in archaeological sites dating from 300 B.C.

The stylized flute player on this page is a cartooned image developed by Kay It of Tabanan in the 1970s. This style is very popular for garden light fixtures.

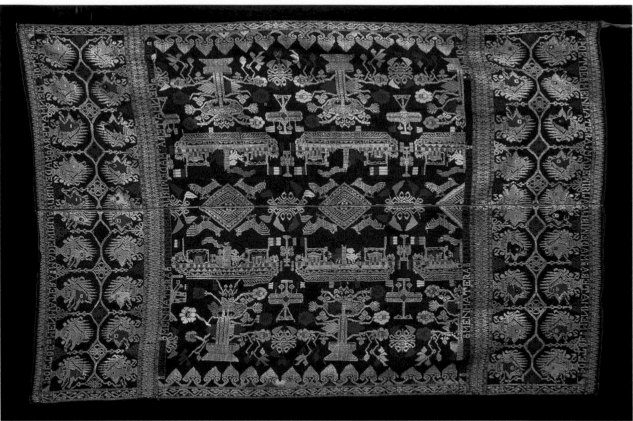

TEXTILE ARTS OF BALI

Sumptuous colorations are interwoven with religious symbolism in the tradition of textile arts on Bali. Balinese style of "busyness" noted in other arts is also carried out in textile designs. Like carved-stone reliefs, textile patterns fill every available space of a cloth.

Above: Geringsing *offers magical protection as well as community identity for the Bali Aga village of Tenganan, one of three places in the world known for weaving this double* ikat *fabric. Double* ikat *weave is the result of a difficult and time-consuming technique of resist dyeing both warp and weft threads before weaving. Bundles of un-dyed thread tied in a design-specific manner are dipped into a dye solution. Tied areas resist absorption of dye; through multiple tieing and dyeing a pattern of varying hues and intensities is achieved.*

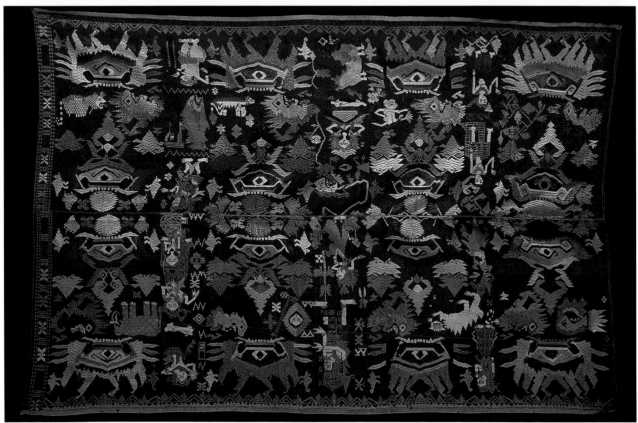

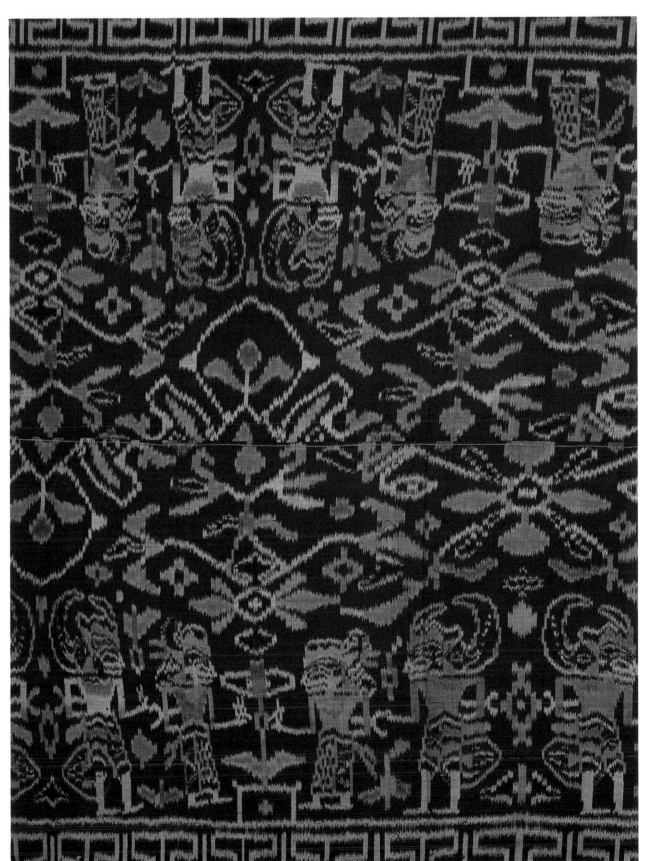

Left and above left: *Glittering* songket *weaves make splendid costumes for weddings, nobility or theatrical performances. They are a traditional weave of Bali and Western Indonesian islands closely associated with early royal court life. Delicately embroidered and figured* songket *is accomplished by additional weft threads woven into a base material to achieve patterning. Supplementary weft threads are frequently gold or silver.*

Above: *Songket fabric design of gold threads on silk is similar to those frequently worn by brides for their wedding ceremony. Ceremonial dress consists of lengths of cloth tightly wrapped in sarong style and fastened with pins or broaches rather than being made into a sewn garment.*

Right: Endek *textiles are woven using the simple backstrap loom, the* cagcag, *and are weft* ikat *fabrics compared to the double* ikat geringsing *(weft and warp* ikat*) of Tenganan. Weft* ikat *patterns are the result of resist dyeing techniques on only the weft threads. Wayang figures of the Ramayana stories are often woven into* endek *fabric. Limitations of width are imposed by the* cagcag *loom requiring fabric panels to be sewn together for certain applications.*

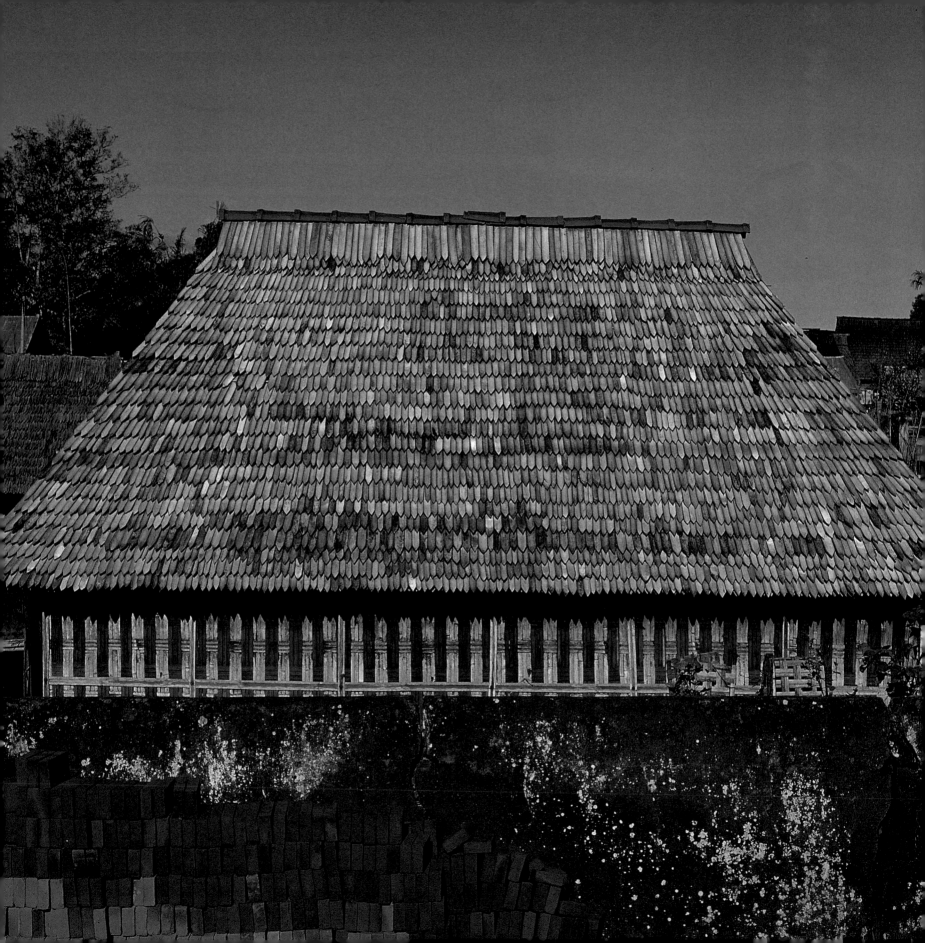

BAMBOO CULTURE

Upon entering a dense grove of bamboo, there is an immediate awareness of enchantment. Here the hot, equatorial sun is filtered by a thick umbrella of interlacing branches gently swaying with the breeze and a dark coolness caresses the skin. The buzzing song of crickets is soothed by the calming sound of nearby river waters as a golden light reflects from the giant arching stems. One does not have to be Balinese to feel the presence of magic in such a grove.

Many Balinese believe there is a magic in bamboo; it is certain the resourceful and varied uses of this material is magical. There is no doubt the remarkable lifestyle of Bali would have developed quite differently without the presence of this single plant.

The role of bamboo in the culture today is as important as ever in the long history of Bali. Sacred *lontar* (palm-leaf) Hindu manuscripts from about A.D. 1100 describe construction methods utilizing bamboo. Many species of bamboo are found throughout the island providing different sizes and qualities for the varied uses. A culture exists here that has grown out of the availability of bamboo and is now dependent upon bamboo as a material and method of construction in architecture and engineering, furniture and furnishings, work tools, utensils, medicine, cuisine, musical instruments and vast numbers of utilitarian products.

Bamboo is actually a giant treelike grass, a member of the botanical species Bambusoideae, and is of the most primitive family of grasses. Bamboo as a species is adaptable, can survive adverse conditions and has a curious characteristic.

Irregardless of geographic location, bamboo of the same species will flower and produce seeds at the same time as if there is an internal or external time-clock of knowing.

According to beliefs regarding aspects of magic, bamboo is not encouraged to grow within the walls of a family compound. In fact, should it sprout by itself it may be allowed to stay or a person adept in handling the mystical qualities of bamboo may be asked to remove the plant. Bamboo is cut and harvested only on certain auspicious days for the evil spirit, Lemedi, lives within bamboo and must be dealt with carefully. A common belief is that health problems may occur for a family should the roots of bamboo grow beneath the sleeping house or *bale*. However it is considered very good luck if *tebu,* sugar cane, which is also a grass, sprouts within the walls of the family temple and it is left to grow there.

Young shoots of bamboo are a delicious delicacy although the fine hairs surrounding them are a slow-to-act poison. Like tiger's whiskers or slivers of glass, the fine hairs are virtually undetectable. Considerable care is required in cleaning the young shoots in preparation for cooking.

The gay and lighthearted Balinese love riddles; the following is a well-known one:

Ape dicerike majempong digedene magambahan? Answer = *tiing.* (What is it that when it is small wears a ponytail and after it is old spreads wide = bamboo).

These ponytail-like shoots appear from underground rhizomes and become the stem or more accurately the culm.

Left: *A new bamboo shake roof of golden hues begins its weathering process to silvery-gray tones. Walls are woven bamboo.*
Above: *Exterior of kitchen in Bayung Gede has woven bamboo walls and bamboo shingled roof.*

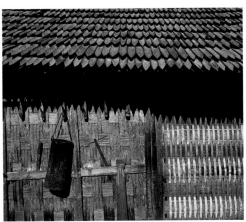

Fibers in this hollow culm run in one direction lengthwise and are intersected occasionally by a node which is a ring or joint of hard fibers. The inherent qualities of bamboo's unique construction result in a flexible, lightweight, easily split but strong wood with incredible tensile strength.

Bamboo as a material and as a tool is so very important to the cultural style of the Balinese. From life to death they rely on and are dependent upon its uses. Life begins when the umbilical cord of a newborn is cut with a sharp knife made from bamboo called a *sembilu* and after a lifetime of bamboo being used daily in innumerable ways, it ends with a cremation ritual in which bamboo plays a huge role. Cremation rituals include a tall tower, made from bamboo; a woven bamboo-like basket as a wrapping for the body called a *wadah*; bamboo platforms for the procession; bamboo decorations in the fashioning of offerings — even the musical instruments played during the cremation are made of bamboo. *Gambang*, similar to a xylophone with bamboo keys, are played along with the gongs and other percussion instruments.

On Bali, if a tool is required, a vessel needed, a game to be invented, a cow or goat or chicken to pen up, bamboo is the essential choice. Bamboo is incredibly important in all activities whether work or play, in the arts or religious events. It is not only an available material but a material with a broad spectrum of essential qualities that can be counted upon to solve everyday utilitarian needs.

From most vantage points, the mountains of Bali are a dramatic part of the magnificent landscape; however Bali is not so much a mountainous island as it is an island of steep river ravines. Rivers flowing from the mountains have cut vast deep gorges in the soft limestone as they flow to the sea. Land in these deep ravines is difficult to cultivate and yet three of the four plants on which life in Bali largely subsist are found here: bananas, coconut and bamboo. Rice is the fourth plant on which Balinese substantially rely; however rice requires extensive cultivation while the other three grow with free abandon in the lush ravines. Bamboo requires no cultivation and grows rapidly to enormous heights with some species actually growing as much as one meter per day. Bamboo flourishes in the cool and shaded river ravines where its growth is uninhibited.

Rice fields are edged by a fringe of graceful coconut trees marching down and through bamboo groves into the river ravines. Coconut trees have almost as much importance to the culture of Bali as bamboo. Coconut trees are treasured for their beautification of the tropical landscape while providing natural shelter from the midday sun or downpour of rain. The fruit of the coconut is a ready source for thirst-quenching milk in a naturally recyclable container. These valuable attributes are only the beginning of a far from complete list of essential uses, such as: the meat of the nut is used extensively in the cuisine; oil derived from the meat is used for cooking and for lamplight; husks of the nut are dried for firewood; shells of the nut are shaped into implements for cooking, and processed to make charcoal for cooking fires. Fronds are woven into baskets of all sizes and shapes including weaving small containers in which rice-sweets are placed for steaming. The stems of fronds become firewood or the spine on which *alang-alang* grass is wrapped to make shingles for thatch roofs. There is an endless list of how each part of the

tree and its fruit are used in a myriad of ways; perhaps the most visual and spectacular being the use of the tall, cylindrical trunk of the coconut tree as posts in buildings. With all the multitudinous ways the coconut tree is creatively utilized, bamboo is used even more extensively.

Large diameter bamboo called *petung* has the strength of steel but is relatively light in weight. Being light in weight, *petung* is manageable without heavy equipment in the harvesting as well as transporting to market. Manageability is a key element in the widespread use of bamboo. Location of bamboo groves or building sites are frequently accessible only by footpaths so it is a common sight to see large bamboo poles being transported from grove to construction on the shoulders of a small Balinese man. *Petung* bamboo is used as posts and beams in buildings, lashed together to form bridges, joined together for water pipe and in the manufacture of large-scale, bamboo furniture for the international markets.

Petung bamboo is used as a structural material while bamboo *ampel, santong* or *hyas* are split and woven into mats to form airy walls called *bedeg.* Like a a tightly woven basket, *bedeg* walls have a mellow, warm color and natural texture. *Bedeg* has become a favored wall material in the homes of foreign visitors on Bali. This same quality of bamboo is also finely woven into hats and umbrellas for protection from the weather, to make baskets of every description for work and storage, and in the making of offerings and decorations.

Visiting any village market is a treat in discovery of how the Balinese use bamboo in every imaginable way. Square baskets with a matching square lid frequently used to carry produce to market are called *sok* while other variously shaped baskets are *keben* and used for storage of anything and everything. Large, flat trays of bamboo are used for sorting and sifting rice as well as the tiny but red-hot green peppers called *cabe,* or garlic, onions and other foodstuffs requiring cleaning of debris. Woven trays are also used in winnowing rice by tossing the rice into the air so the wind catches the chaff and blows it away. *Pengukusan,* conical shaped sieves of bamboo used for steaming rice, are sold at market or small shops everywhere.

Everywhere in Bali one may hear an early morning sound of a distant *kulkul* played in staccato rhythm calling villagers for a meeting or to pass news of importance — a practical and efficient present-day communication system in a land where the telephone is not common. Most family compounds have a *kulkul* made from a hollow cylinder of bamboo which is frequently decorated in whimsical motifs and hung in a central location. Melodius tones of a bamboo *kulkul* are alarm systems within the family compound or a call for help to neighbors. Small hotels and homestays in Bali hang bamboo *kulkul* from the verandah of each room for the convenience of guests who wish to call for room service.

The Environmental Bamboo Foundation headquartered in Ubud is spreading a message, not only by *kulkul* but through the world over networking, about the miracles of bamboo. It is their intent to enlighten people everywhere about the many benefits of bamboo in considerations of world ecology and industry.

Balinese have known for centuries the multiple applications of this most beautiful plant and have utilized the resource in developing their culture. The bamboo culture of Bali is authentic, an inherent element in their style.

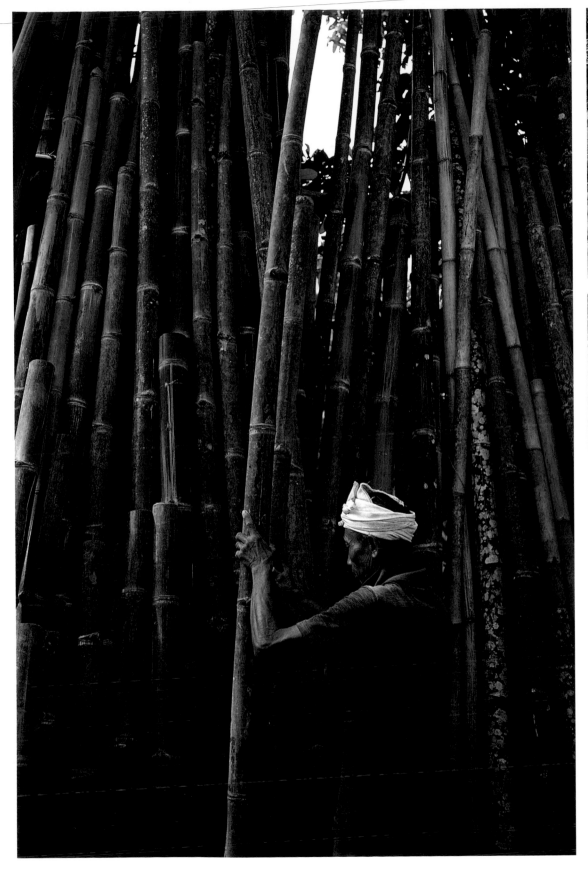

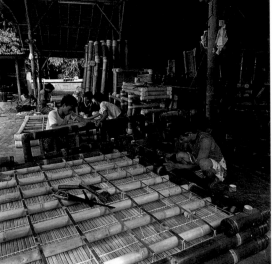

HOME FURNISHINGS FROM BAMBOO

Bamboo is used extensively not only as structural posts and beams in architecture but in furniture manufacturing. Bali exports bamboo furniture to destinations throughout the world.

Left: *Grading and selecting petung bamboo.*
Above top: *Certain villages specialize in the manufacture of bamboo furniture.*
Above bottom: *Pentagon bamboo table is in the home of Amir Rabik, Ubud.*
Following pages: *Moss and lichen covered bamboo-shake roof in the mountain area of Kintamani.*

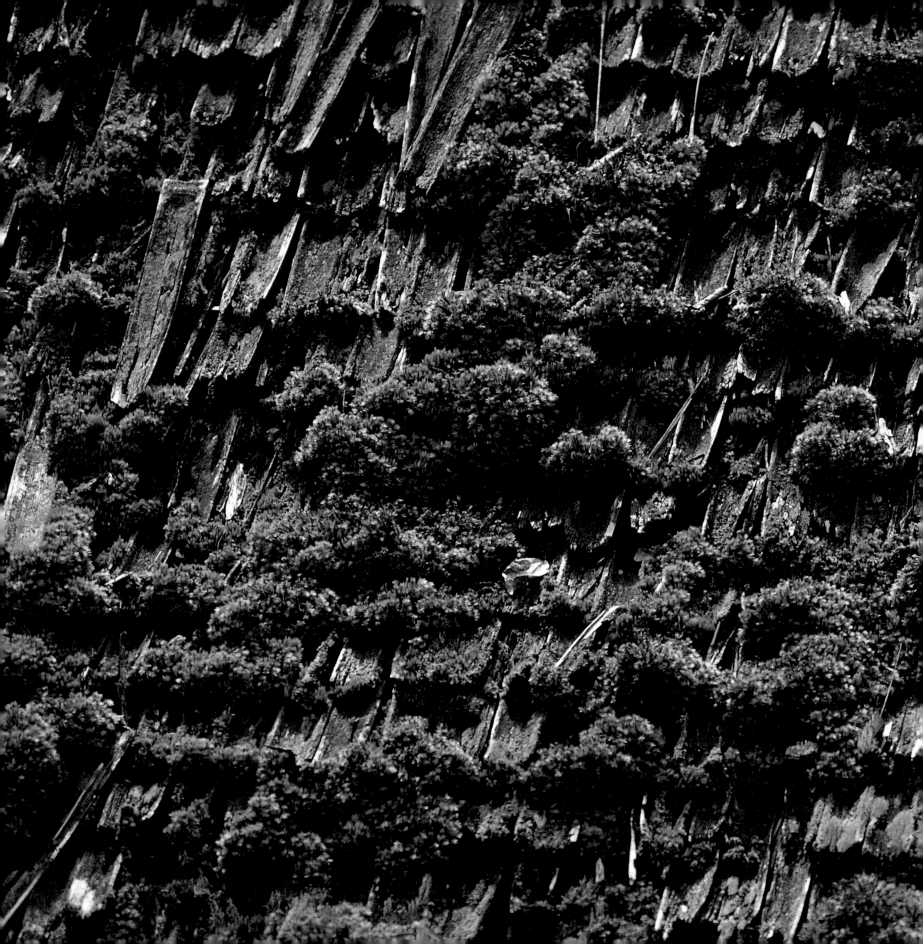

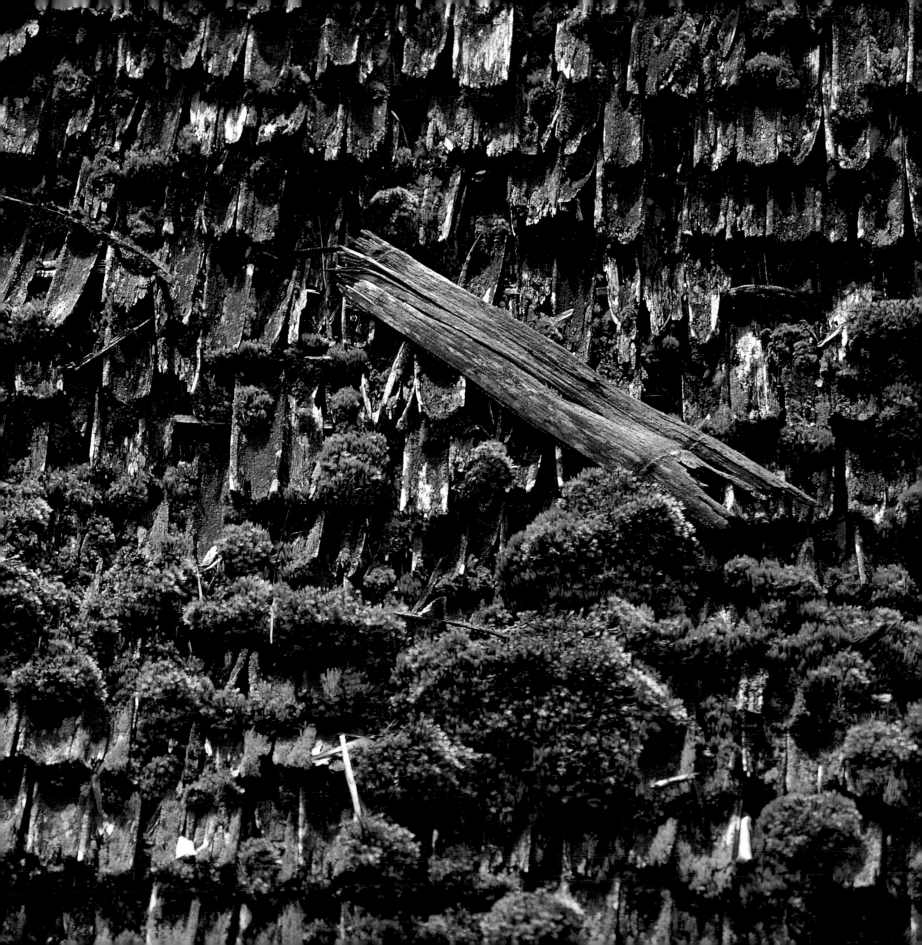

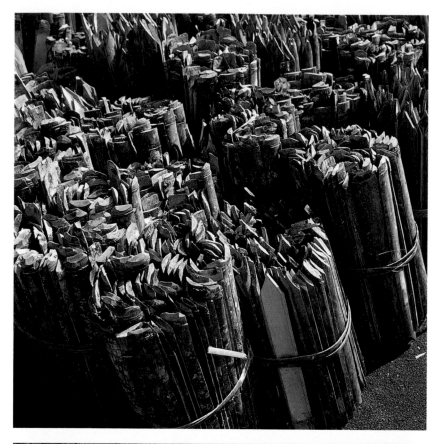
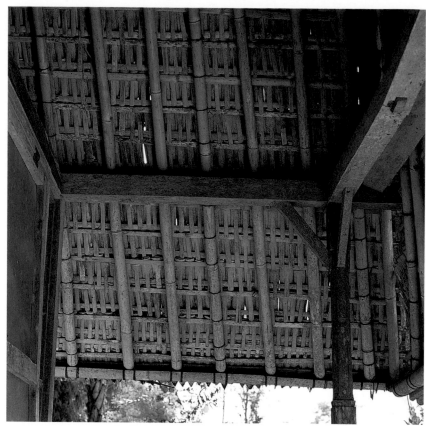
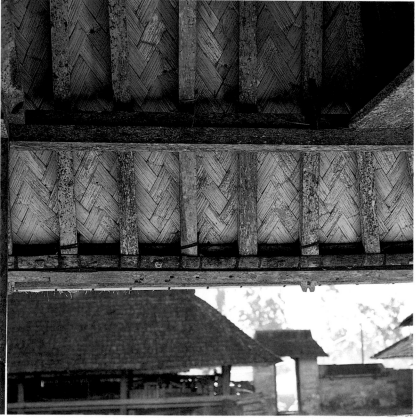
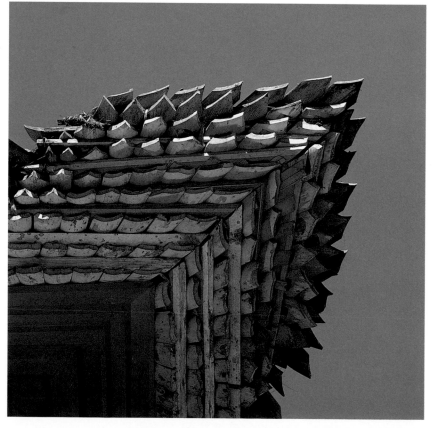

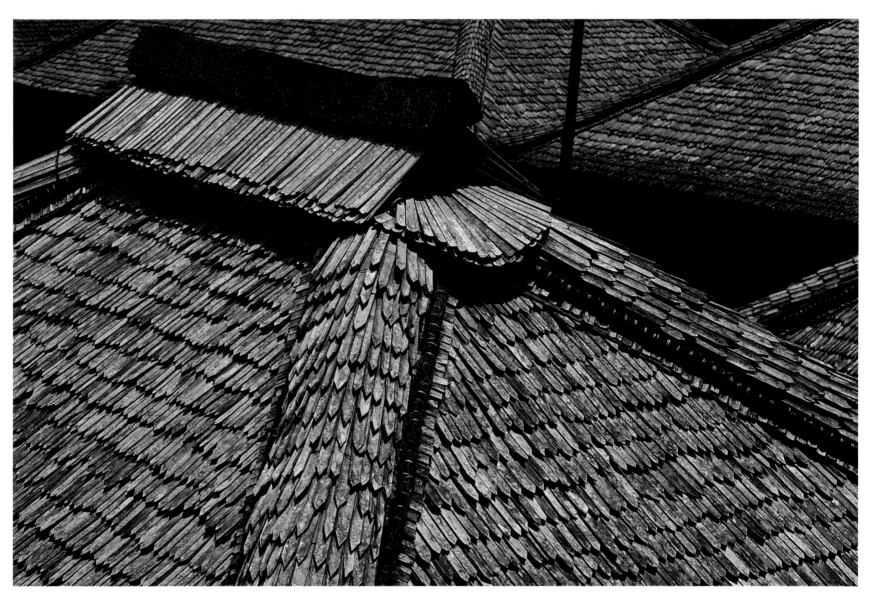

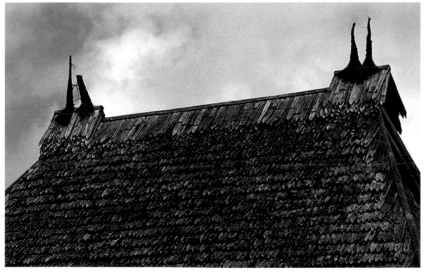

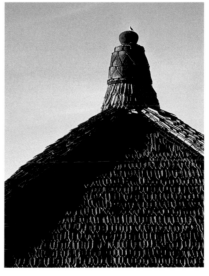

GEOMETRIC PATTERNS OF SPLIT BAMBOO

Tiles of bamboo as roofing and side-wall materials are an imaginative and practical application of split bamboo. Handsome, rustic textures are achieved with design motifs of geometric patterns. Roof construction utilizing bamboo tiles is frequently seen in the mountain villages of north Bali where the climate is cooler and drier.

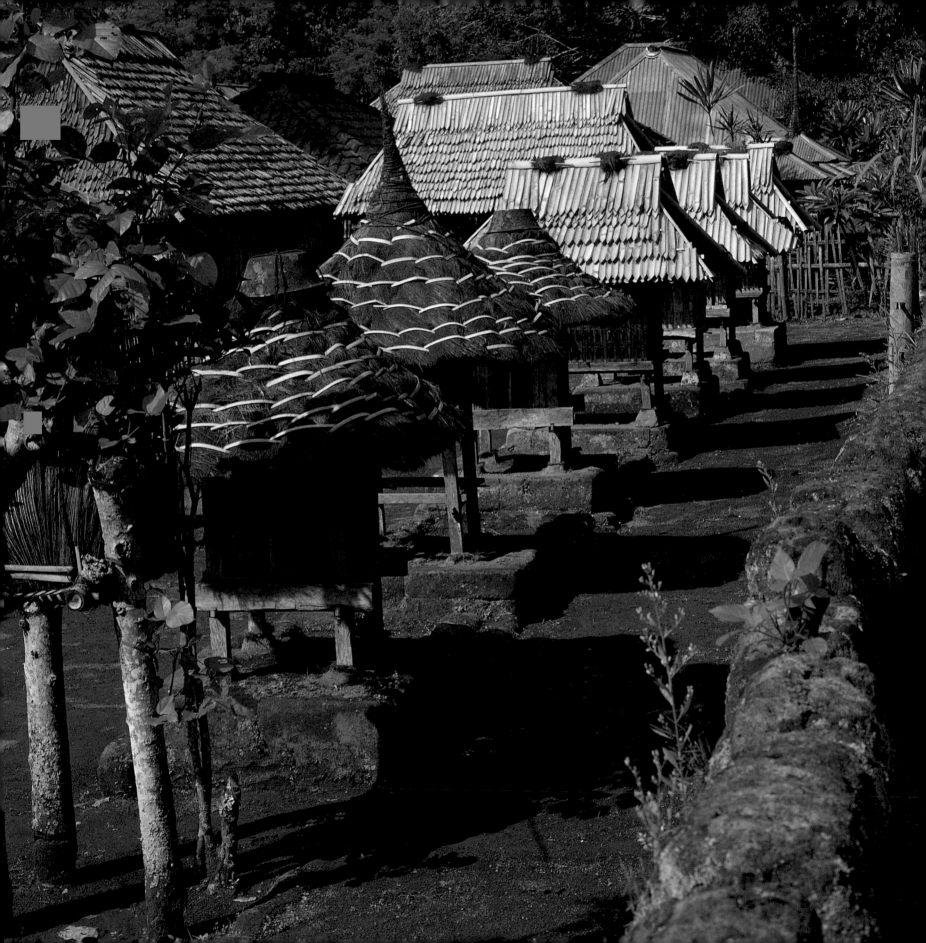

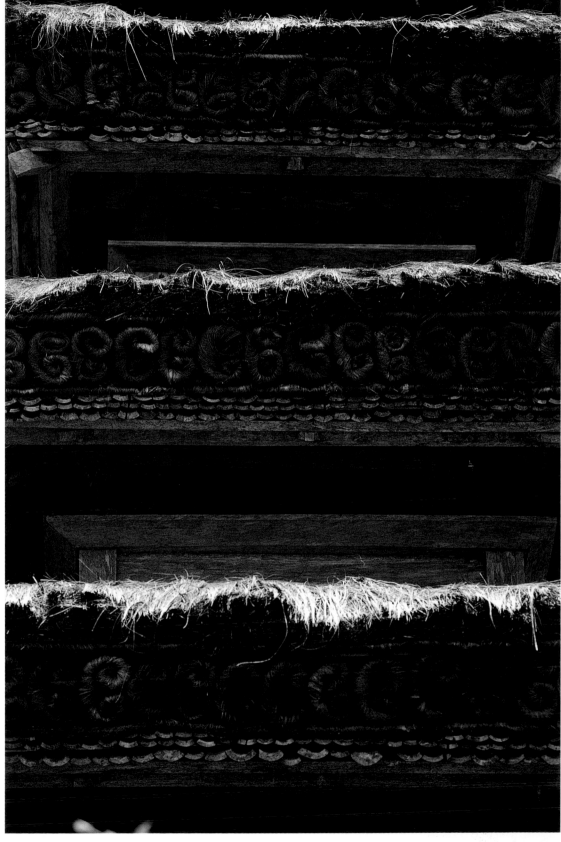

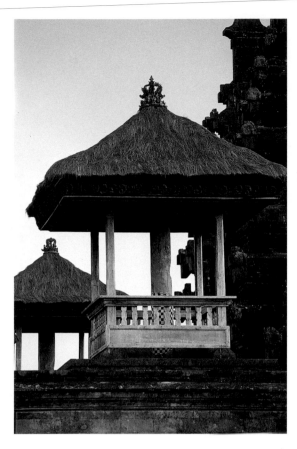

THATCHED ROOFS OF BAMBOO AND PALM FIBER

A temple in the Kintamani area undeniably attests to the practical and aesthetic use of organic materials on Bali. Shrine roofs of bamboo and palm fiber plaited with strips of bamboo are enclosed by a mud wall. The aesthetically pleasing roofs can last as long as twenty-five years enduring tropical rains of the monsoon and provides cool insulation.

Above: *Wooden signal drum in a kulkul tower is topped with lovely palm-fiber roof and a crown,* karang murdha.
Right: ljuk *palm fiber (fibers from the sugar palm tree) are twisted and curled for decorative effect on roofs of shrines.*

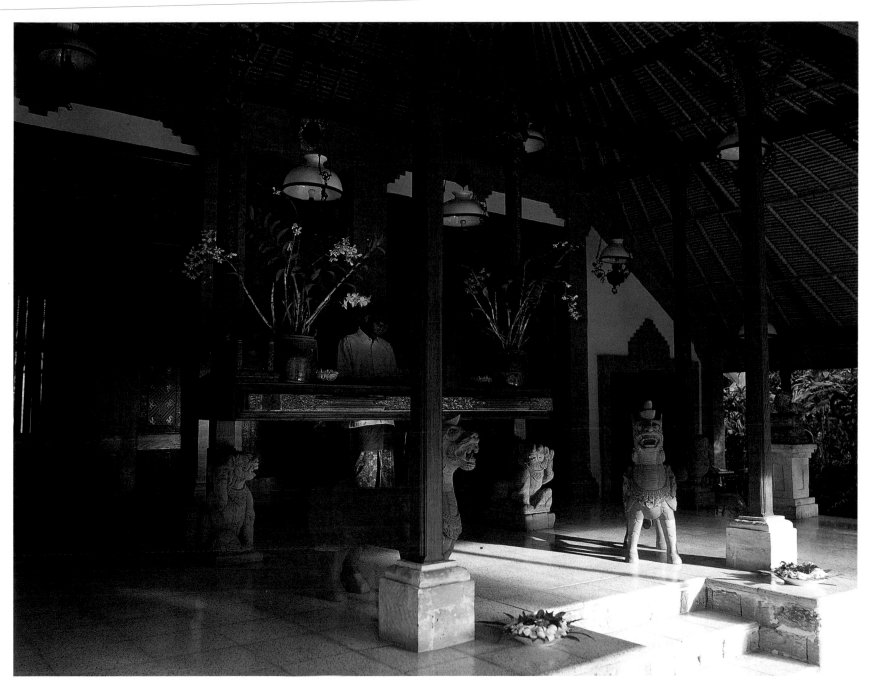

GRACEFUL BAMBOO AND ALANG-ALANG GRASS ROOF

The Balinese love of drama and ingenious use of available, natural materials is expressed in the beautiful bamboo and *alang-alang* thatch roofs. Sewn onto six to eight foot lengths of bamboo or coconut fronds, the *alang-alang* are placed close together like shingles and lashed to the bamboo skeleton of the roof structure using cords of sugar-palm fiber. Uncomplicated to construct, this sophisticated but simple roofing technique results in an incredibly elegant interior ceiling of patterned bamboo.

Above: *Reception area of the Tandjung Sari Hotel in Sanur is graced with traditional architectural details including a magnificent bamboo and* alang-alang *grass roof.*
Left: *Offerings of fresh flowers are placed each day in this tree shrine at the beachside pavilion of the Tandjung Sari Hotel.*

107

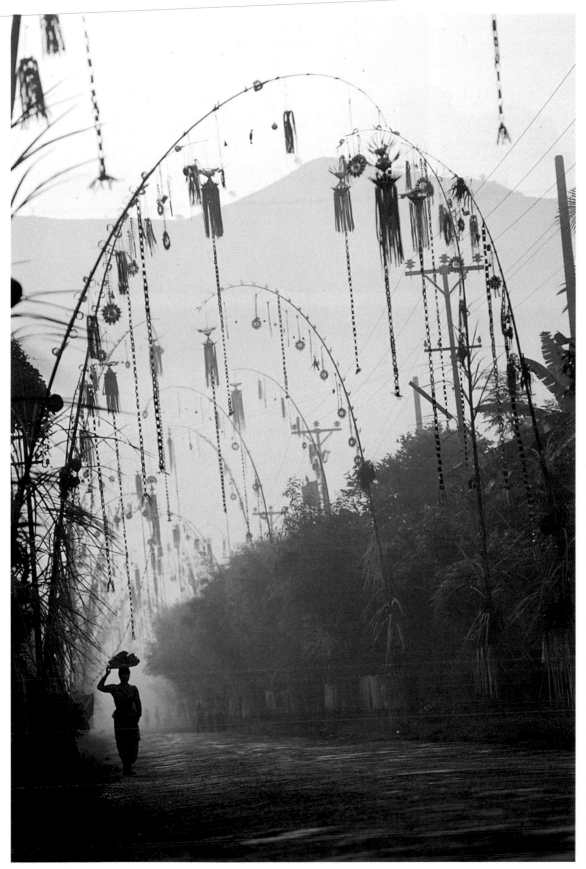

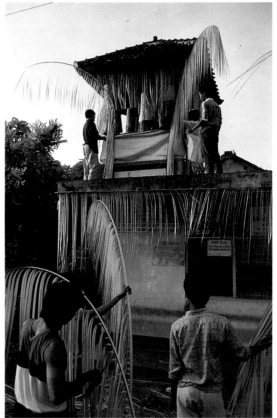

A VARIEGATED USE

Balinese creatively use available, organic materials to meet practical needs as well as for decorative purposes in every aspect of their lives. The availability, abundance and flexibility of bamboo has provided the staple of invention.

Far left: *A freshly planted* sawah *will soon need the bamboo wind chimes when maturing, plump heads of rice becomes a favorite food of birds.*
Left: *Arching bamboo decorations,* penjors, *gaily decorate a village lane on an early misty morning. Penjors are skillfully constructed and erected on auspicious holy days as a special offering to welcome deified ancestors and gods to the family compound temple or village temples. Penjors symbolize the high mountains, rivers of water and fruits of the fields that give life to the Balinese. Constructing a penjor is a project happily assumed by men and boys of a household in friendly competition with neighbors. A long bamboo pole supports a variety of materials that are readily at hand such as decorative foliage, fruits, flowers and bundles of rice.*
Above: *Young coconut palm fronds are used to decorate a* kulkul *tower for a celebration.*

109

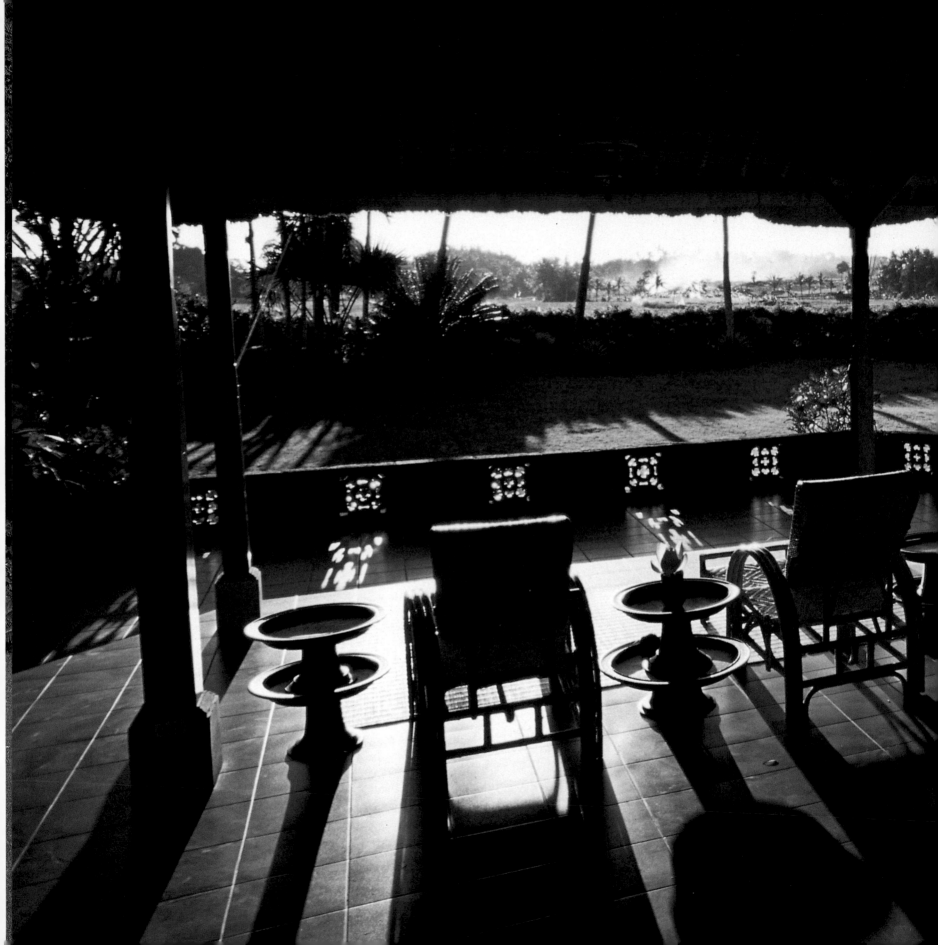

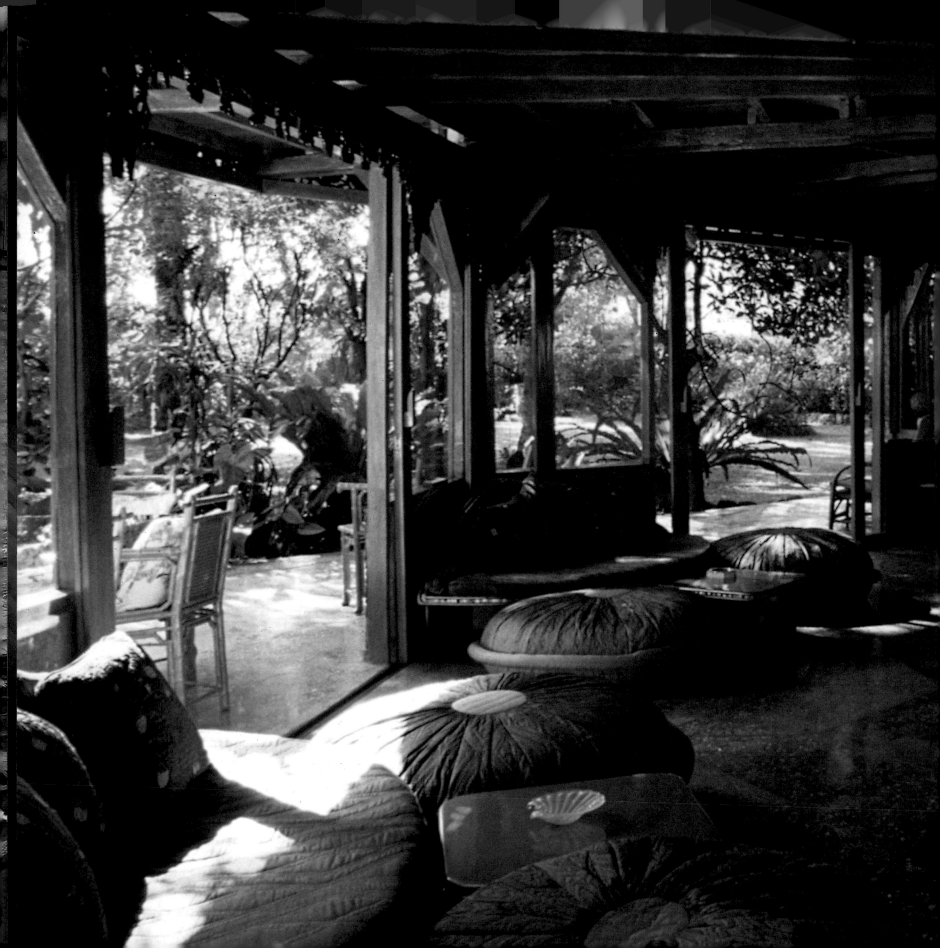

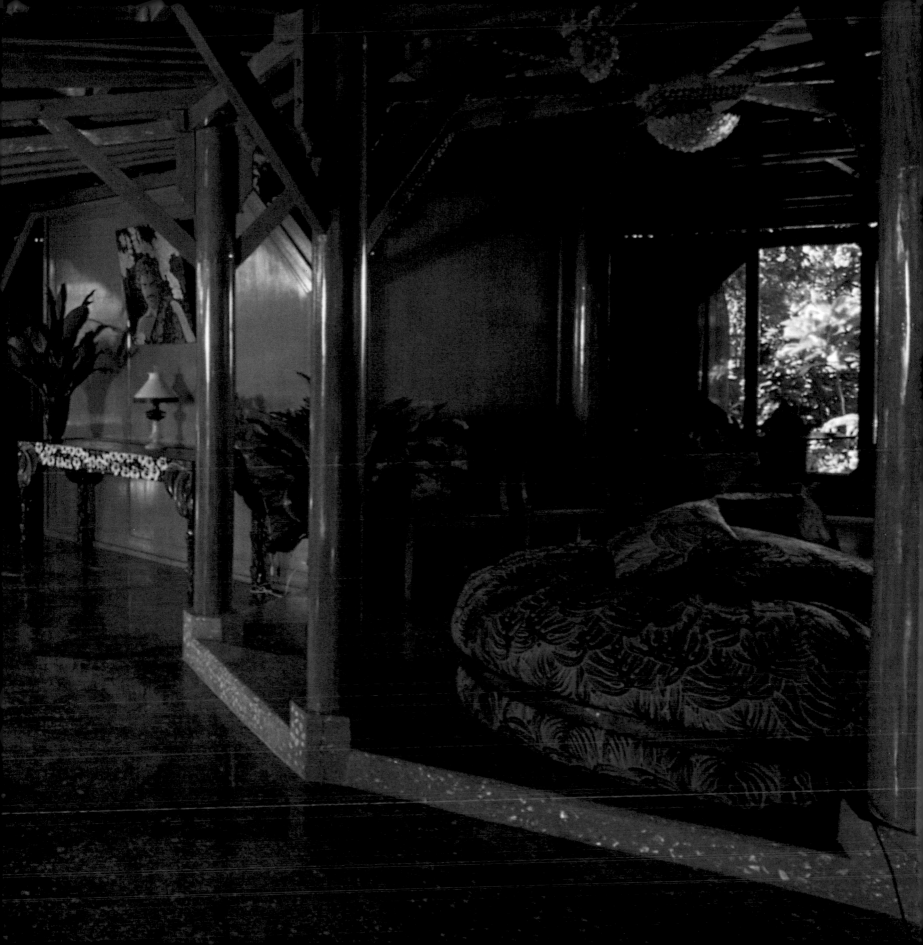

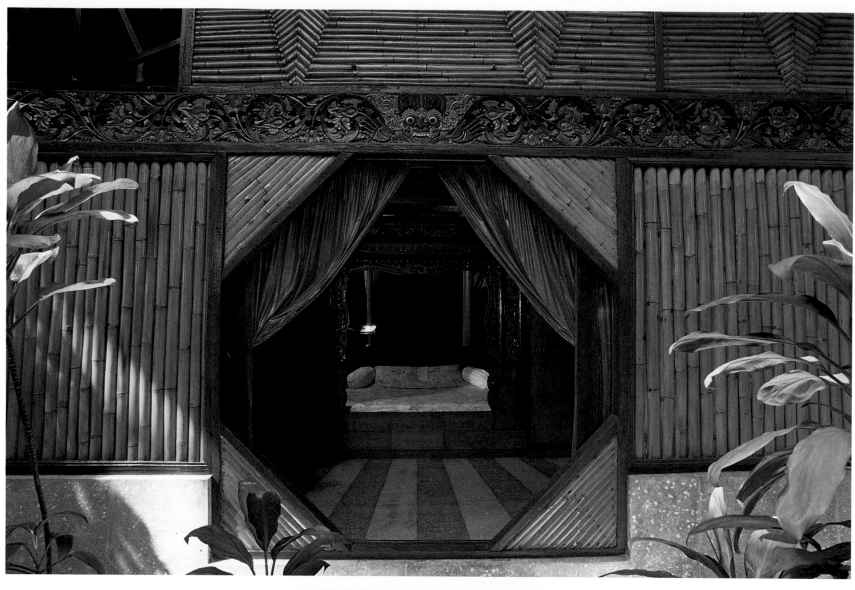

Above: *Polychromed and carved floral frieze,
with Bhoma over doorway for protection,
extends around the exterior of the octagonal-
shaped main house. Bamboo used here is in its
natural colors in contrast to the red aniline
dyed bamboo elsewhere.*
Right: *A view from the outside into
Milo's master bathroom.*

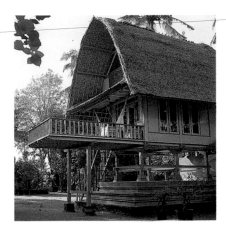

RICE BARN HOUSES

Designs of rice granaries vary from village to village but never fail to delight the eye with tall, steep *alang-alang* grass and bamboo thatched roofs.

The architectural style of rice barns has been widely adapted for homestays and private houses for tourists. Dotting the rice field landscapes, these two-story structures have thatched roofs, woven bamboo walls and window openings with small diameter bamboo as screens. Split bamboo blinds are the only protection from blowing rain on the open-verandah living space of these rice barns cum home. Visitors find these structures charming; however Balinese feel they are not really suitable for housing other than for storing rice.

Above: *A converted* lumbung, *rice barn, for guest at Milo's house in Seminyak, south Bali.*
Right: *Strong pigment colors of Milo's rice barn are like those seen in houses, temples and shrines in the mountainous areas of north Bali.*

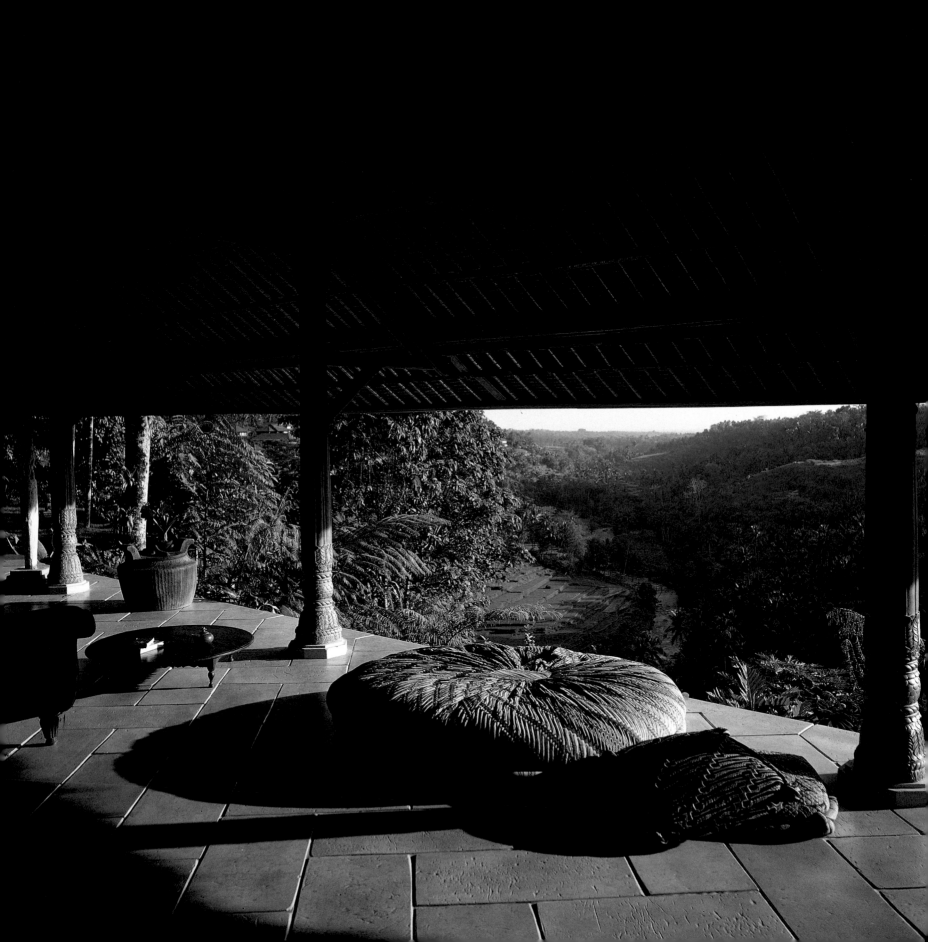

BALI TIME — A TIME OF ADAPTATIONS

Considering the many elements that define the style of a culture or have contributed to the development, on Bali none may be more significant than the basic factor of time. Bali style's intricate and multi-layered elements are as free as the Bali breeze of constraints dictated by time. Slow and deliberate movements of dance, hours-long shadow puppet plays, handworked batik and woven fabric designs, ornately carved statues and frieze are examples of artistic expression allowed to blossom in an atmosphere unencumbered by Western values of time.

Time is of little importance to the Balinese and perhaps because of this, they are blessed with the precious gift of an abundance of leisure time. This island of artistic people have managed to design their daily lives of necessary work to incorporate creative interests as an extension of religious ideals. Balinese Hinduism celebrates artistry as a gift within everyone (not distinguished for a few) and defines the passing of time as eternal cycles. Time on Bali is circular, gauged by a gentle flowing of cycles: cycles of life...as in the planting and harvesting of rice, the waning and waxing of the moon or as in their ideology of birth-death-rebirth. Bali time is harmonized with nature resulting in the Balinese sense of creativity unfettered by linear concepts of time. There are no scheduled beginnings and endings as in the linear time concepts of the West. Artistic expression is given unconditional liberty within the principle of *desa-kala-patra* (space-time situation or place-period-condition). Recognition of this tenet supports acceptance of outer influences as they may interact at any particular time or place without jeopardizing the Balinese identity.

Time as a linear concept and its lack of importance on Bali is well-defined upon asking a Balinese how old a temple might be. It is not unusual to be confronted with a blank expression and a question in answer to the question "why do you wish to know this?" The temple has existed just as it is today since any living person can remember. The age of the temple is probably unknown for the date the cornerstone was laid was not recorded. Antiquity is respected but is not the gauge in terms of evaluation. Refinement of carvings or the balance and harmony with nature are features to be admired rather than the age of a building or the status of the architect.

Temples are for the most part the same as they have been for centuries with restoration work as perpetual as the seasons of dryness and monsoon. Tradition has determined the style and traditions honored do not change for the sake of new fads. This is not to say an individual stone carver or mason fails to add his personal creative touch when restoring a structure. Without plans or pictures of previous designs, craftsmen are free to innovate within the context of traditional designs. Upholding tradition is given priority and adaptations are selectively incorporated to existing design rather than a completely new style emerging.

There is a classic quality to the style of Bali, a timelessness exemplified in all of the arts but this is particularly true

Left: *Classic timelessness of Balinese architecture interpreted for living today is expressed in the home of M.A. Dion in Kedewatan. Views are of* sawah *and the Ayung River.*
Above: *The swimming pool of M.A. Dion's residence is flanked by Balinese ceremonial banners.*

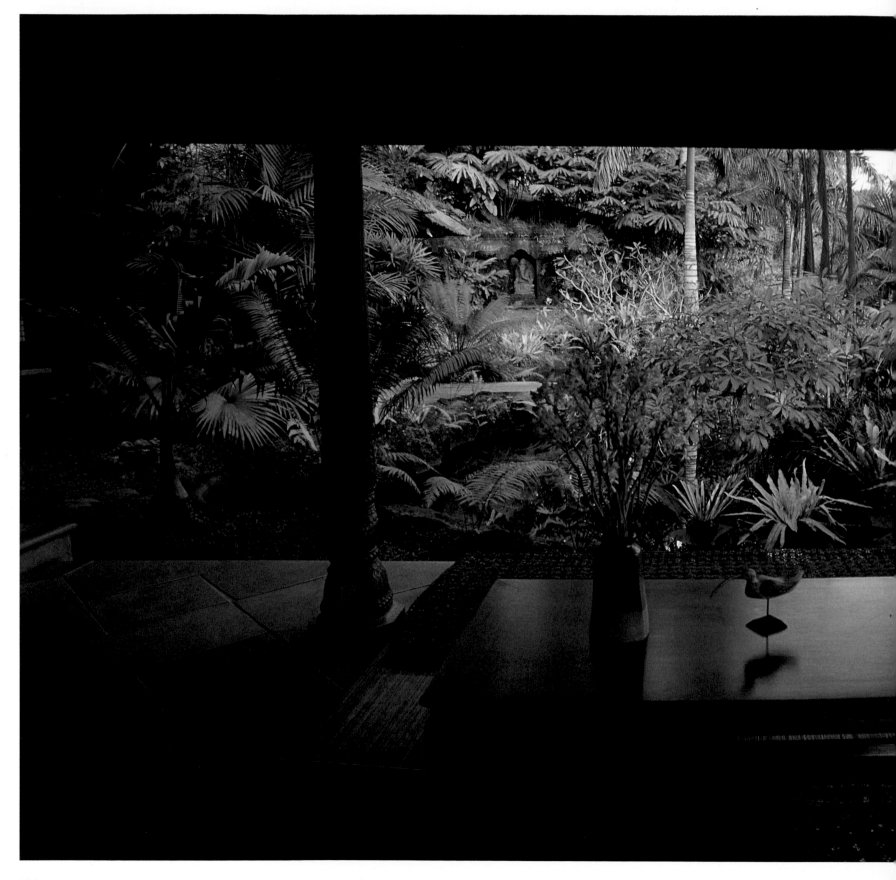

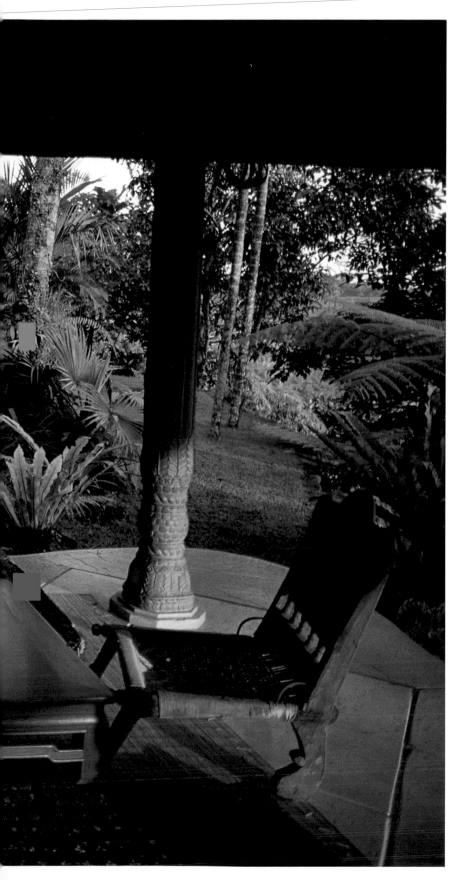

of the architecture. It is quite remarkable that a country with such a long history has only two notable architectural styles — the Bali Aga and the Majapahit styles. The Bali Aga style is one of primitive austerity without embellishment. Materials gathered from the land are used without a camouflage of man-made materials revealing their natural beauty and honoring the animist beliefs of the Bali Aga society. The supporting, skeletal structure of buildings is exposed; posts and beams are visually and honestly expressed as are the joints between posts and beams which are left uncovered. "Truth of construction" as advocated by many modern, international architects has been the design ethic on Bali for centuries.

The longevity of the two established styles of architecture has created a timeless perspective to the whole island. The age of a building is difficult to distinguish because a 10- or 50-year-old building appears much the same as a centuries-old building for there is a dedication to traditional forms. The classic, unadorned *bale*, *lumbung* or *wantilan* structures of the Bali Aga style may have been recently built but are timeless in appearance.

The Majapahit style, the more contemporary of the two styles, has been in vogue for more than 400 years and represents Bali Time in another important way. Not only have the design motifs been faithfully reproduced for the past 400 years but the time consuming, hand-carved details largely covering the facades of Majapahit-styled buildings represent the Balinese philosophy of time. Time required to carve sinuous whorls of tendrils, vines, flora and fauna entwining mystical figures on Majapahit *candi bentar* is not of the essence. More important than time required is the quality or spirit of the work. So, "Bali Time" is two-fold: timelessness created by a steadfastness to style and culture, and the availability of time to pursue artistic endeavor.

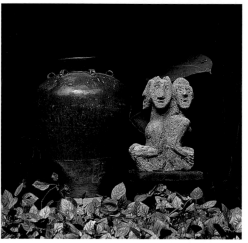

Many resort hotels in south Bali provide visitors a neo-classic, Bali-style vacation. *Candi bentar*, the split gate designs of temples, are constructed in the Majapahit style with vermilion brick voluptuously overlaid with sculpted stone greeting guests entering the hotel grounds. Open-air dining pavilions are reminiscent of village *wantilan* (pre-Majapahit style) with carved posts and beams supporting soaring bamboo and thatch roof. Entry doors to guest rooms are narrow wood panels with profusely carved, floral and fauna motifs, polychromed and gilded. Adaptations utilized in resort architecture are directly related to elements of design and materials of the two architectural periods in honor of Balinese tradition. Contemporary governmental buildings are lavishly coated with classic Majaphahit design elements but sadly, often lack scale and proportion. The Bali Museum and Art Center of Denpassar are fine examples of the Majapahit style adapted for public use.

The early, pre-Majapahit architectural style of the *lumbung* (see page 123), has emerged as an adaptation in the Balinese version of bed and breakfast. *Losmen*, or homestays, offer foreign visitors an opportunity to experience the timelessness of Balinese architecture while living close to nature in charming dwellings with thatched roofs. Breakfasts of banana pancakes and exotic fruits are served on the open-air verandah where blinds of slatted bamboo are lowered to block the soaking, horizontal monsoons or hot midday sun. Verandahs are the living rooms of this adapted style of architecture as they are in traditional Balinese homes. An enclosed sleeping room off the verandah has walls of woven *bedeg* and window screens of bamboo. Up narrow stairs, like a steep little chicken ladder, is another sleeping room where the exposed, underside of the roof provides a handsome ceiling of bamboo and thatch. Garden bathrooms with stone walls and exotic foliage are roofed by the sky ...a supreme pleasure by day and starlit night. Kitchens are generally a room attached to the rear of the house and often placed in a separate pavilion.

Adapted use of the *lumbung* as structures for living rather than rice storage can be pinpointed to a beginning in the 1920s with the arrival of Europeans. These globetrotters were sophisticated travelers who frequently stayed for extended periods of time and desired a close experience with Balinese culture. The *lumbung* answered their needs then as it does for current visitors. The adapted style is a fresh interpretation yet timeless in its classic approach to traditional Balinese architectural methods of exposing structure and honestly expressing organic materials. In the tradition of Balinese living, natural materials, textures and colors create harmony with nature resulting in calm and relaxing environments in housing for foreigners.

Many Balinese today continue to live in family compounds in very sparse conditions utilizing the traditional spatial concepts derived from Hindu principles. Materials of concrete block, stucco and tile are replacing bamboo and thatch in compounds of families who now reach out for what they perceive as modernized living.

Artist Walter Spies' home is still standing as part of the Hotel Tjampuhan in Ubud and has been a model for a style of

home built for foreign visitors. Spies (previously mentioned regarding his role in the traditions of Bali) had lived in Russia and Europe but found himself longing for adventure, to live where he could "feel and know what real life is." In 1923 he sailed away from Hamburg and jumped ship in Java. He was in the heart of the Dutch East Indies, where he kept busy working as pianist in a Chinese cinema accompanying silent films, giving piano lessons to other Russian emigres and painting. While living in the Sultans' *kraton* in Yogyakarta he made a holiday visit to Bali and became spellbound with the mysterious people, their colorful music, dance and magnificent natural world. Spies moved to Bali in 1927 and became fast friends with Prince Tjokorde Gede Agung Sukawati of Ubud. The Sukawati family offered Spies land to build a house and studio on their property overlooking the beautiful ravine of the Campuan River near Ubud. His home soon became a destination for other European travelers, an oasis of hospitality and culture for those making the "grand tour." A favored stopover for a wide assortment of international travelers and artists, his guest book was signed by celebrities of the times such as Charlie Chaplin, Barbara Hutton, Vicki Baum, Noel Coward and Margaret Mead.

A visit to Spies' Campuan home in 1936 was described by Louise G. Koke in her book *Our Hotel in Bali* — "a dark brown, two-storey house clung to the side of a steep ravine. Dense foliage screened it from the road and made a secret stillness. Below the house an oval swimming pool lay half hidden among the trees, fed by bamboo pipe from a hillside spring. The house was decorated with Balinese paintings and antique carvings. One of Mr. Spies' own paintings, a forest scene in great detail with great shafts of light casting long shadows, hung in the living room. There was a grand piano as well — a remarkable thing to find in such a place. At night the wooded slope would be mysteriously lit by burning wicks set in hanging coconut shells. Metal threads in the servant's garments would shimmer in the warm glow. The air would be a little heavy with burning incense, and with the odour of coconut oil in freshly washed and anointed hair. That was an impression to take away." (*Our Hotel in Bali* relates Louise Koke's personal story she and her husband, Bob, encountered in building the first hotel on Kuta beach in 1936.)

Ms Koke's description is not romanticized beyond the realness of Bali for she could easily be describing a home of a foreigner living on the island today.

Following in Walter Spies footsteps, many writers, musicians and painters adopted Bali as a second home and begun the architectural and visual art adaptations we see today.

The tourist meccas of Kuta, Sanur and Ubud reflect a modern-day Bali that is quickly dispelled by short walks from traveled byways. Motorcycles might be parked in the lanes and a television on the verandah of an open *bale* but beyond these diversions to a contemporary world, there exists a way of life that steps back in time. Centered and striving for balance, the Balinese live a style of perpetual, ongoing commitment to tradition creating the atmosphere of timelessness; not a fossilized culture stuck in the past, but a society willing to adapt new ideas with a continual returning to ways defined by their ancestors.

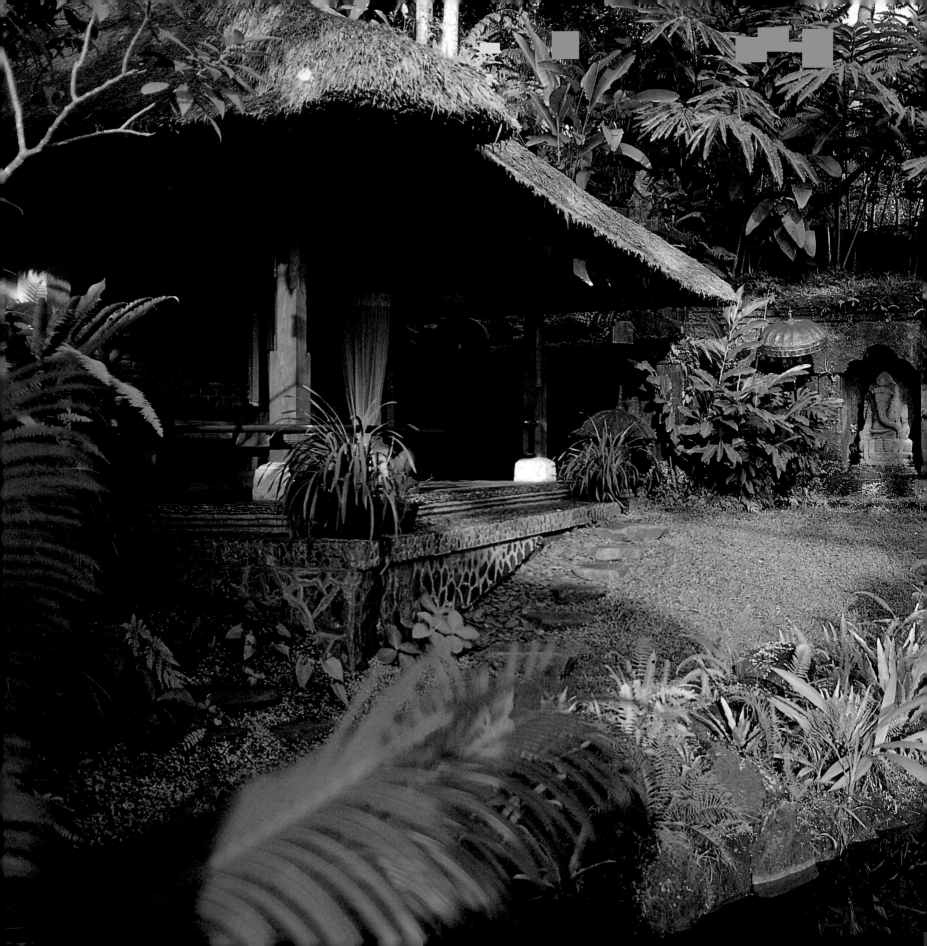

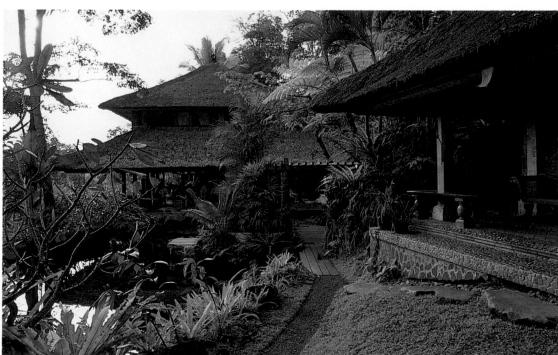

CLASSIC AND TIMELESS PAVILIONS

The compound of M.A. Dion's home is a series of pavilions set into a garden landscape that meanders along a steep ravine of the Ayung River. The organic nature of architectural materials and open verandahs blends each pavilion into the site. The design and site planning are classic and timeless. The view from the terrace leads to distant *sawah* fields dotted with banana and coconut trees.

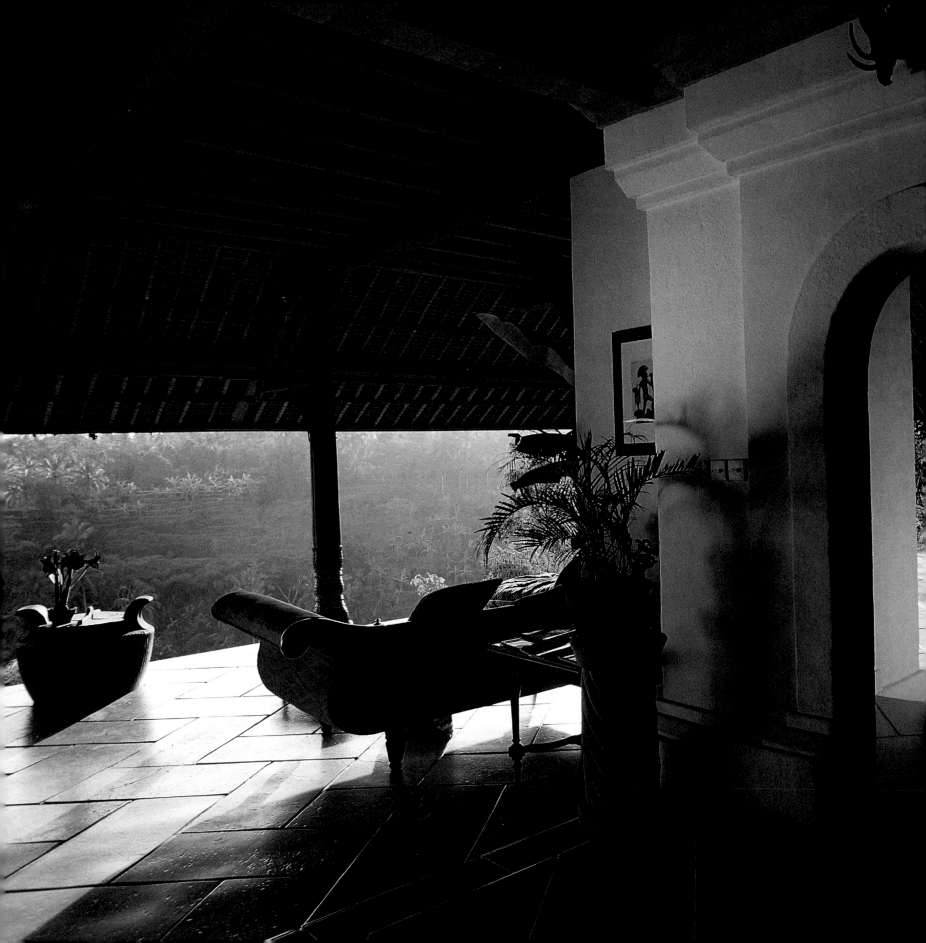

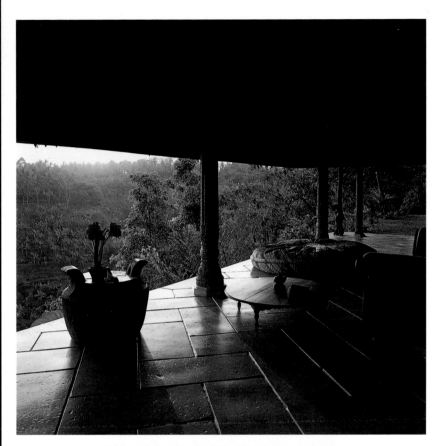

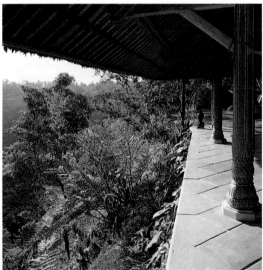

Left: *The warm tones of the bamboo and thatch roof are a perfect foil to the white stucco walls of the sleeping room in the Dion's residence main pavilion.*

Above: *The finely carved wood posts and beams in the main pavilion entice the eyes to study the exquisite architectural detailing. The pouf is made with quilted batik fabric from Java while the large storage container is of wood, probably for storing rice.*

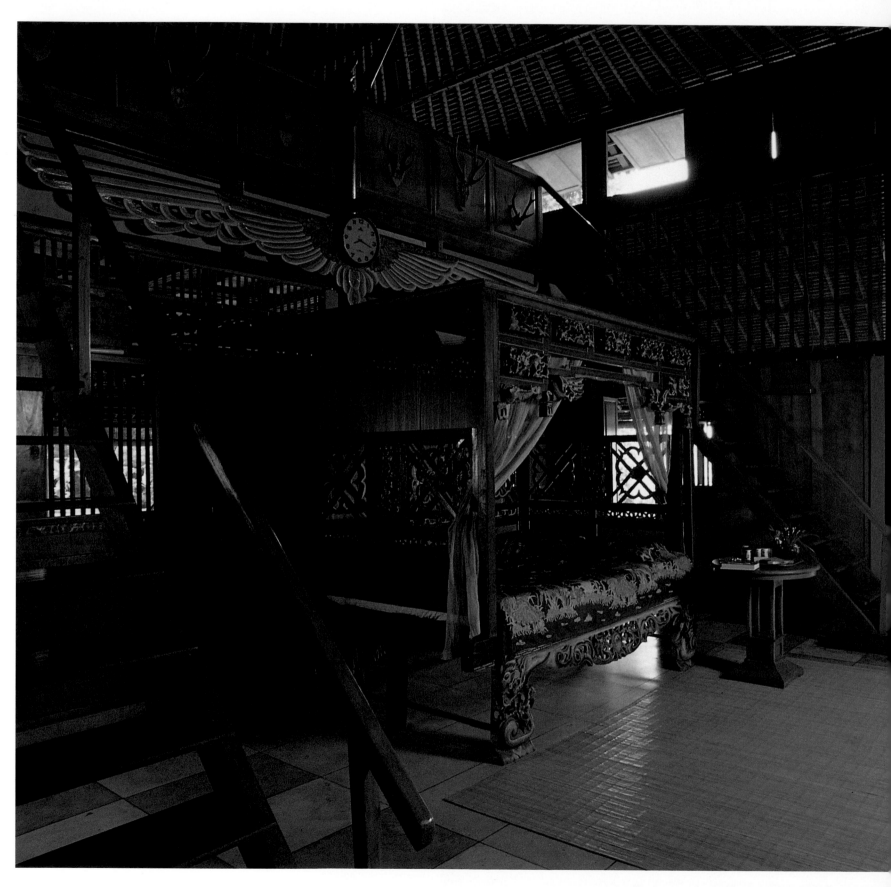

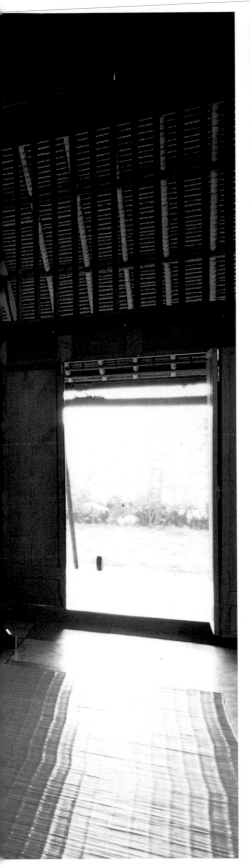

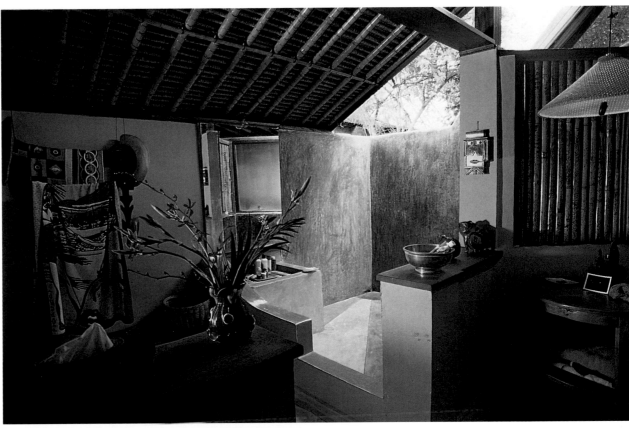

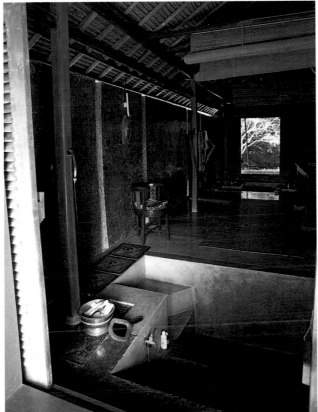

A HOUSE IN SEMINYAK

Seminyak is a village by the sea, not far from the busy vacation town of Kuta, where many foreigners live and work. Aurora's home in Seminyak has distant views of rice fields yet is very near the beach.

Far left: *The interior view of Aurora's main house pavilion. Exuberantly carved and polychromed wood of clock frame and bed offer spirited fun to this bamboo and wood pavilion with very high ceilings. A clerestory opens to fresh breezes and views of rice fields from the loft. Wood posts are from the trunk of coconut trees.*
Above: *Shower of a bathroom in the guest pavilion at Aurora's compound is open-air. Bamboo is used as a privacy grill at window.*
Left: *Aurora's bathroom just off the bedroom in the main pavilion has a combination of stone and marble. Bathtub is polished concrete.*

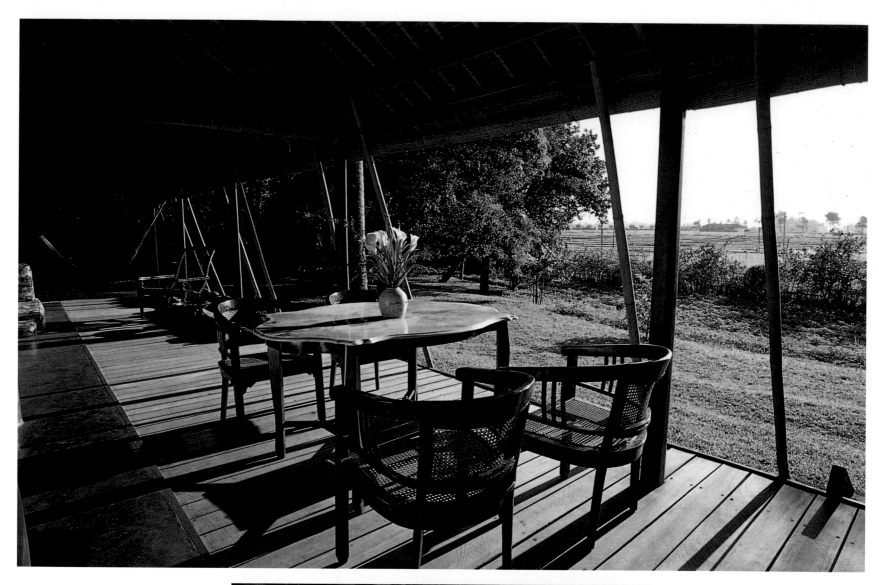

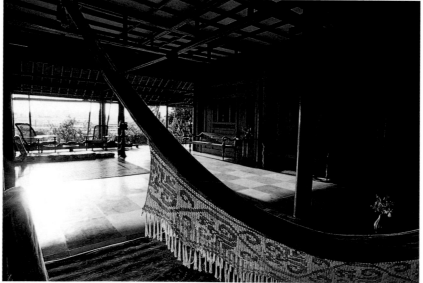

Above: *The terrace of Aurora's main house. Split bamboo roll-up shades, kere, shield the sitting area from rain and filter the afternoon sun.*
Right: *Cotton-crocheted hammock is a fabric version of lacy carved wood walls.*
Far right: *Detail picture of the grill-worked walls of a sleeping room in the main pavilion of Aurora's compound. The grillwork uses many decorative motifs traditional to Bali.*

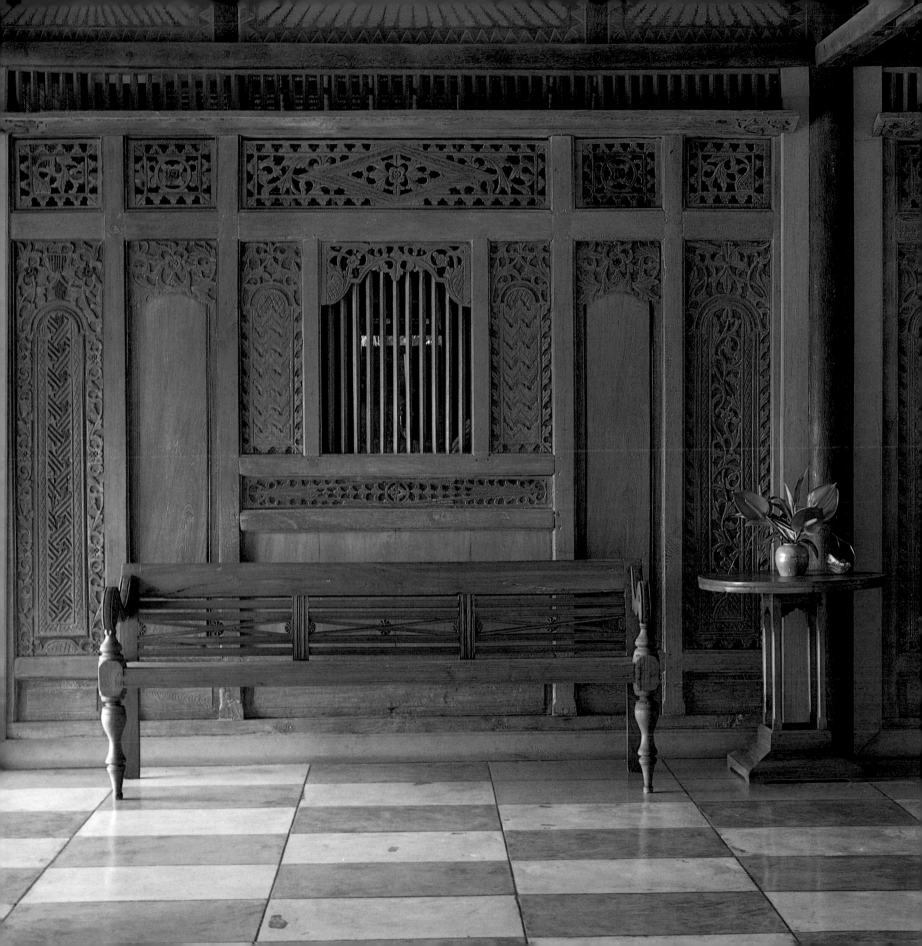

Right and far right above: *Charming tranquillity prevails in this timeless setting with its natural, organic blending of gardens and architecture. The handsome, primitive chaise longue on the verandah of the main pavilion at Aurora's house perfectly complements the timelessness of the atmosphere.*
Above: *Detail of carved paras stone inset on a mud wall.*
Far right below: *An unfortunate crack results in a stunning, dovetailed repair that adds an elegant design to a primitive chaise longue at Aurora's house.*

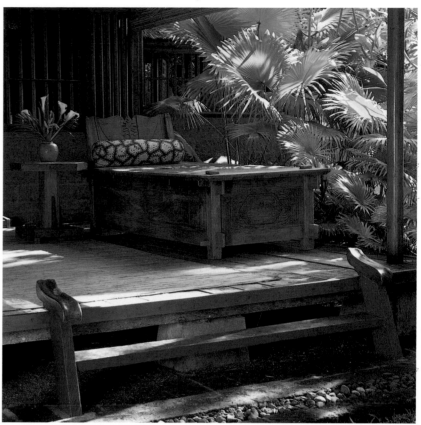

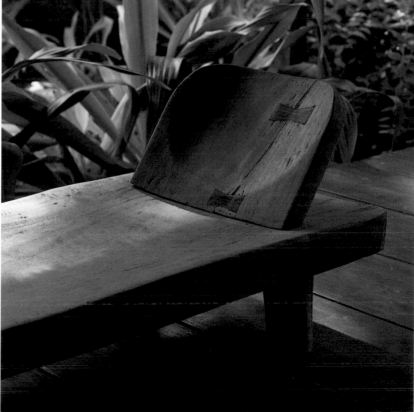

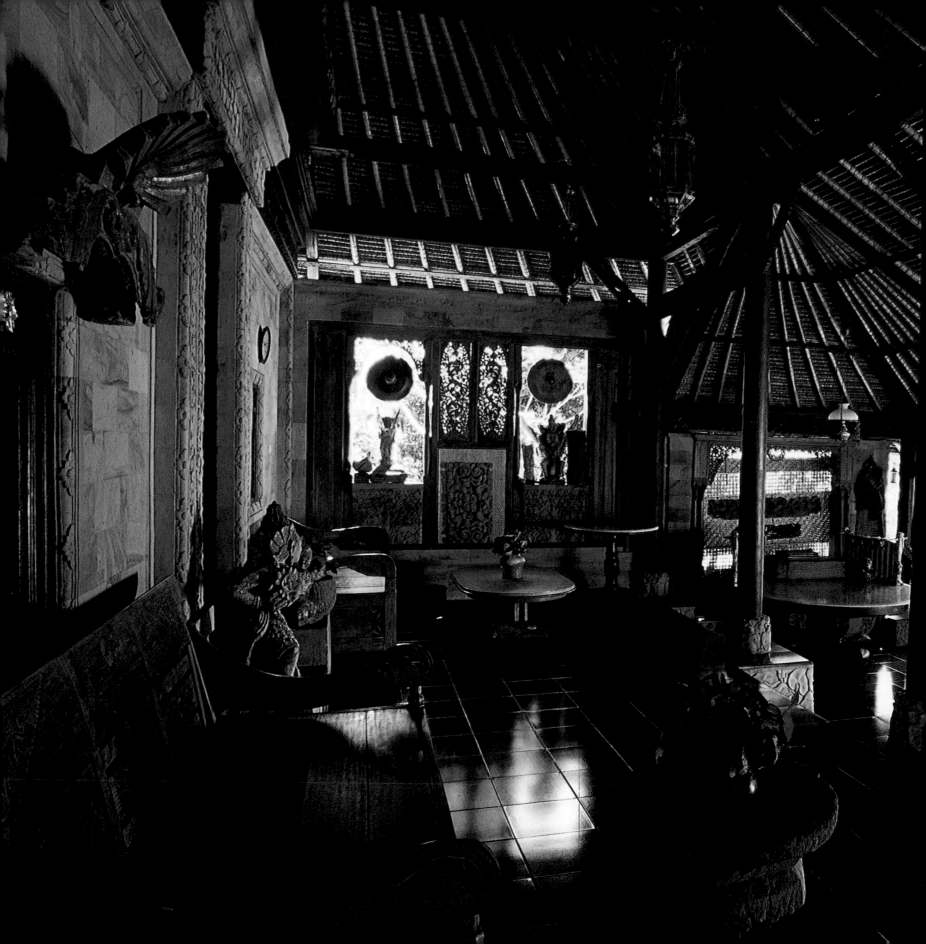

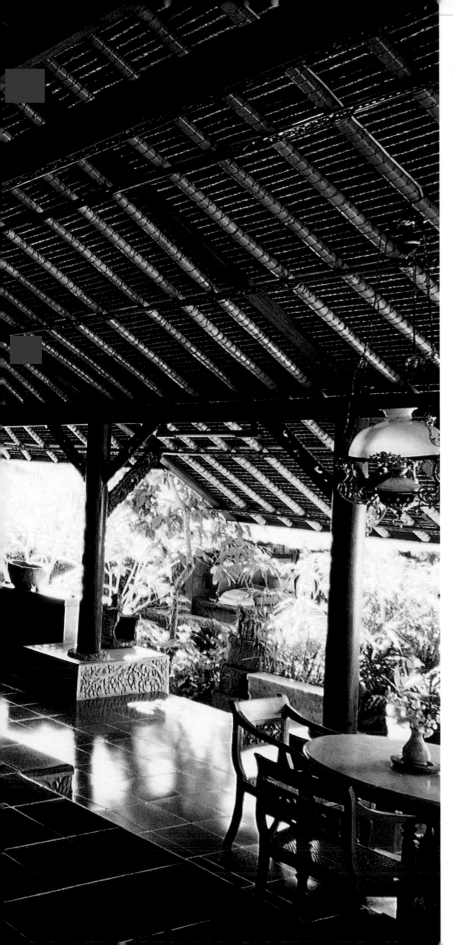

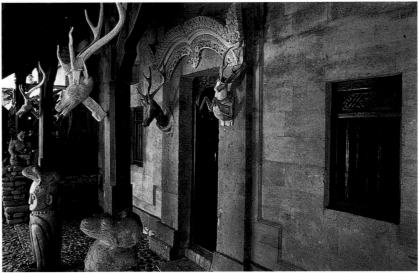

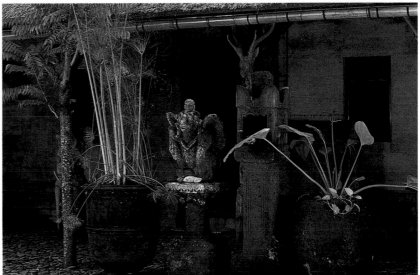

CLASSIC BALINESE ARCHITECTURAL ELEMENTS

Soaring bamboo ceilings, *paras* stone carvings, coconut tree posts and open-air verandahs are graciously combined here in a pavilion at the home of Ida Bagus Putu Suartha, Ubud. The oil lamps with iron filigree and white globes (main picture, at center) were developed during the time of Dutch colonization of Java.

Above top: *Pure whimsy. Carved wood images of mounted big game and* paras *stone statues support posts. Walls of this pavilion are quarried blocks of* paras.
Above bottom: *A stone shrine for daily offerings and a stone statue of a child riding the back of a mythical bird stand between terra-cotta water garden jardinieres.*

A HARMONY OF BALI STYLE AND FOREIGN INFLUENCE

Sanur is a seaside community on the southeast shore of Bali, not far from the main city of Denpasar or the tourist mecca of Kuta. Sanur's white sand beaches and calm surf have attracted elite hotels and permanent foreign residents yet the Balinese living in Sanur continue to live a traditional lifestyle. Modern-day commerce is carried out in Sanur blending with the age-old rituals of Balinese custom. Homes of foreign residents in Sanur also combine the traditional with contemporary lifestyles.

Left: *A very old frangipani tree carpets the lawn of a garden with fragrant blossoms at the seaside home of Frank Morgan in Sanur. Just through the trees can be seen the outline of the main pavilion of "Wantilan Lama."*

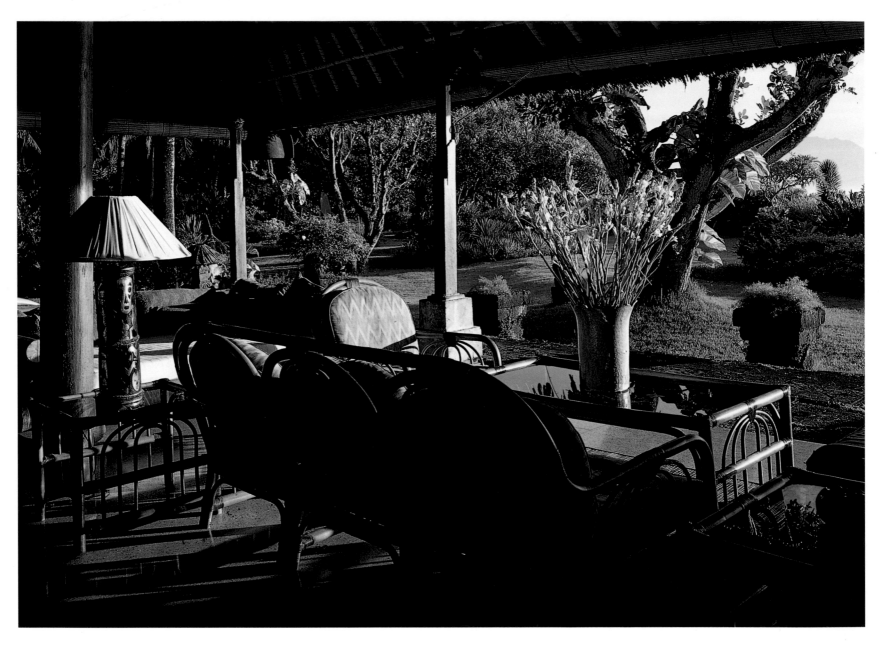

Above: *The living room of the main pavilion "Wantilan Lama" of Frank Morgan's home in Sanur is furnished with comfortable bamboo made on Bali. Cushion fabric is a traditional* endek *textile.*

Right: *The upstairs living area at "Wantilan Lama" looks toward the holy mountain, Gunung Agung. The covered dish of carved wood and a flying duck of rattan transporting a goddess are examples of Balinese handicraft.*

Following left page: *Fresh and charming sitting area in the main pavilion. Coconut palm posts support a large, double-tiered bamboo thatch roof. A clerestory is opened between tiers of the roof providing cooling ventilation.*

Following right page: *Carved and polychromed wood figures of Rama and Sita from the* Ramayana *stories stand on the verandah of the main pavilion. The window has a nicely carved wooden frame.*

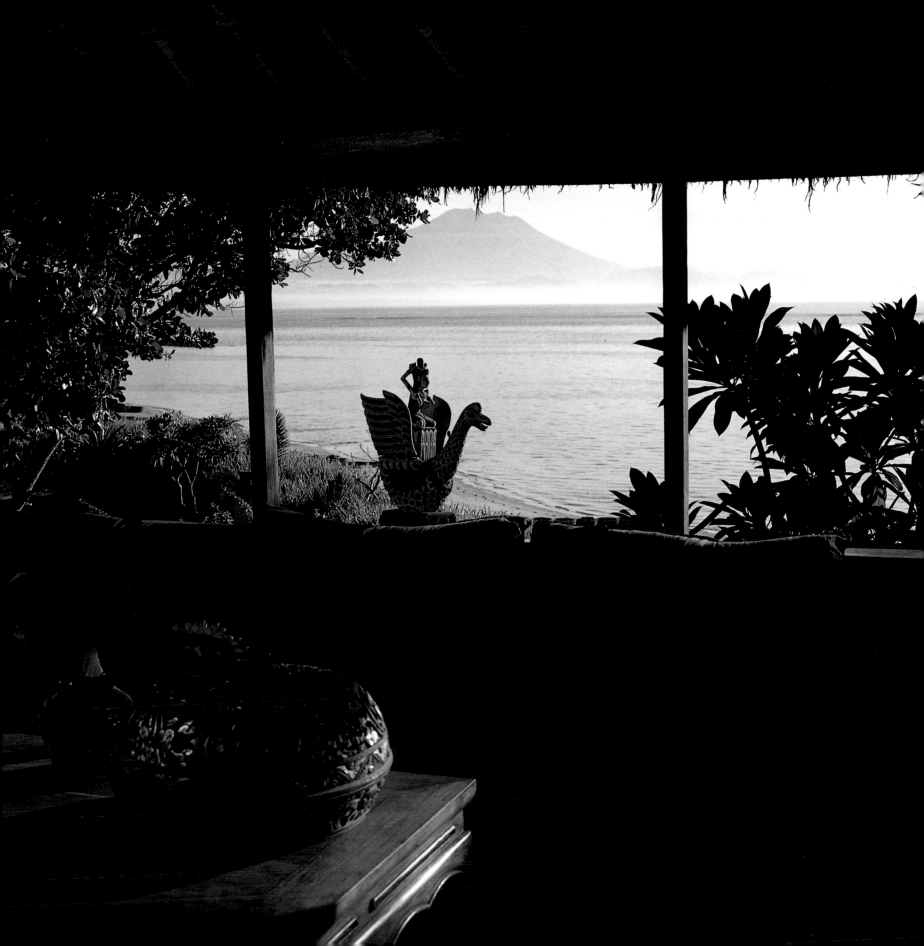

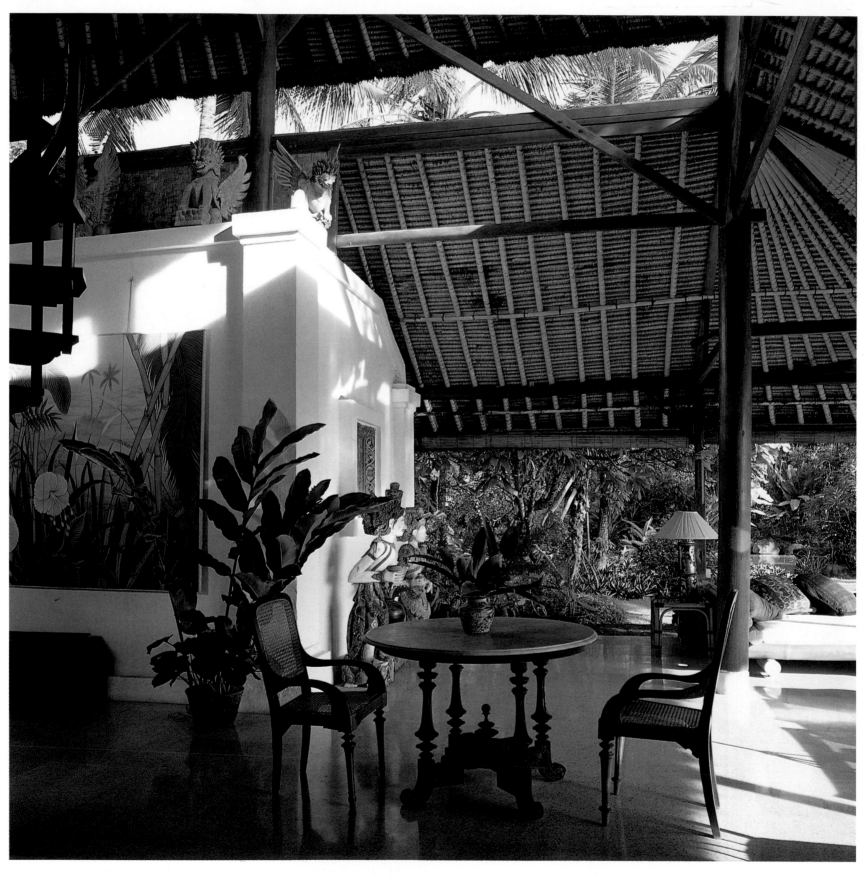

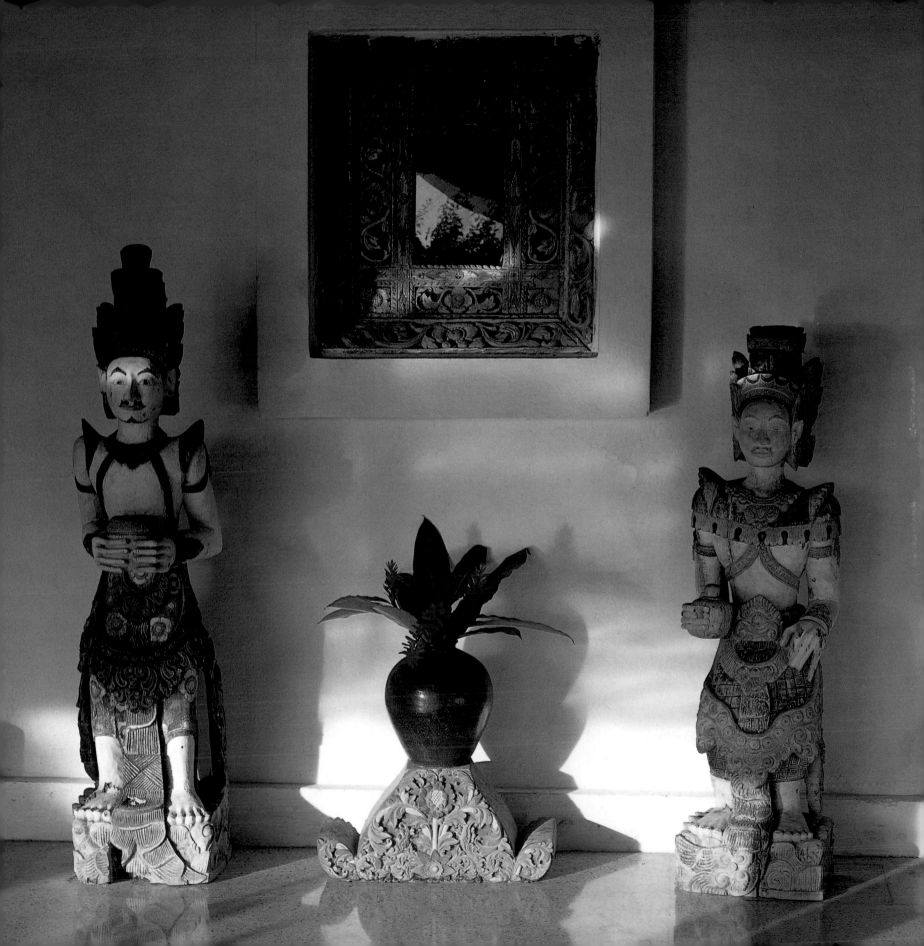

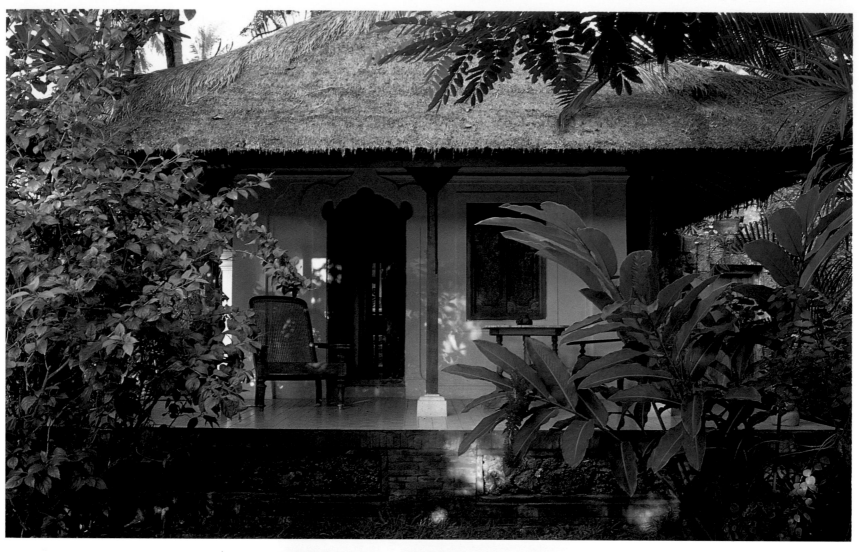

The Frog Pavilion at Frank Morgan's home is a delightful guesthouse with traditional Balinese architectural features. Above is a sitting porch with lovely carved door and window shutters. To the right is a terrace for breakfast in the garden.

Above: *Built in the shape of the traditional rice barn (*lumbung*), "Ade's Lumbung" at Frank Morgan's home in Sanur is a guest pavilion with garden privacy and a view of the sea. The first floor has an open verandah for the living room and a closed sleeping room. Upstairs is accessed by a ladder to another sleeping room.*

Left: *Evening time at the main pavilion "Wantilan Lama" of the Morgan home. This view clearly shows the double-tiered* alang-alang *thatch roof.*

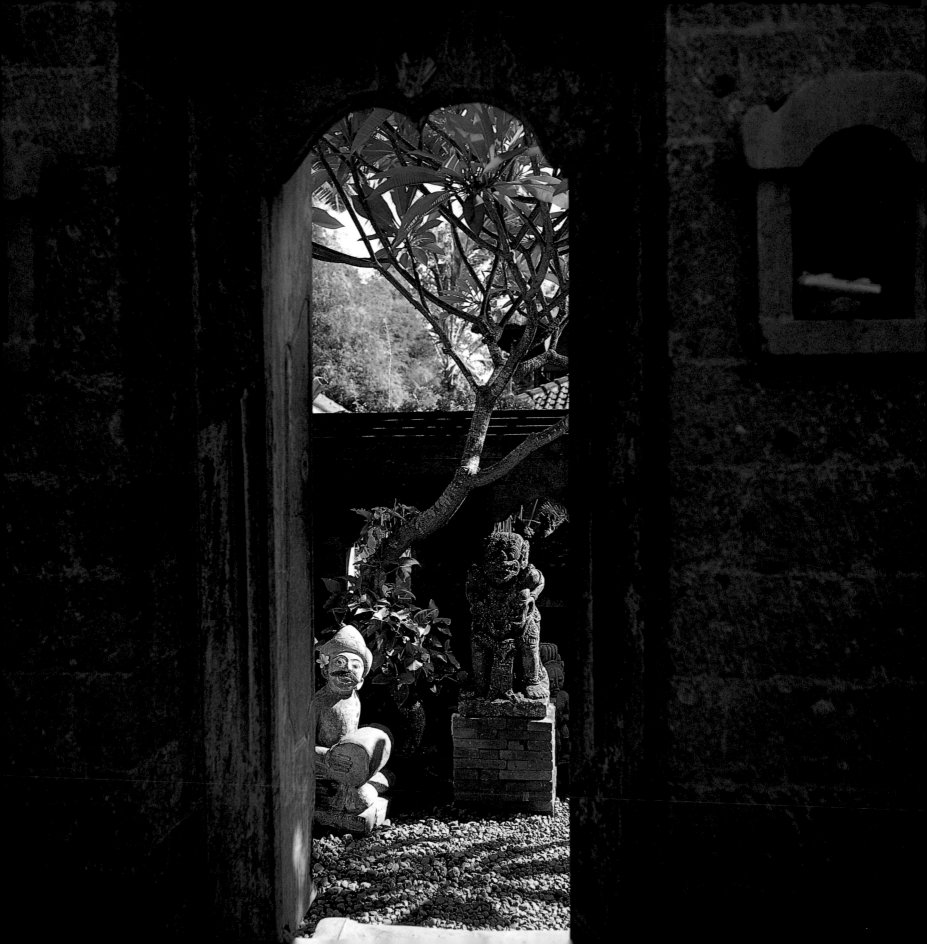

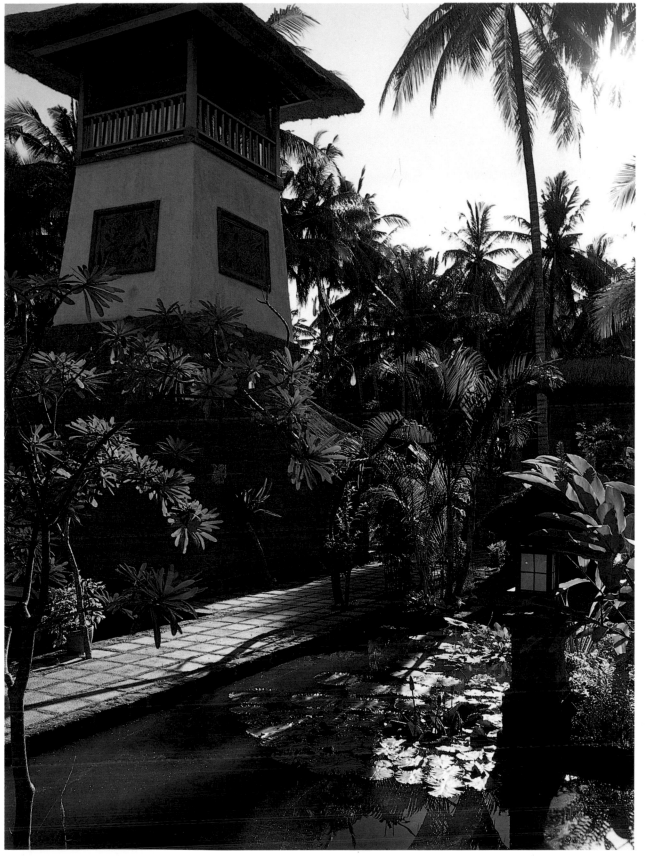

COMBINED OFFICE
AND HOME

Paras stone statues of a gamelan drummer and a warrior welcome visitors to Wijaya Tribhuwana International offices at Villa Bebek, Sanur. The old doorway is a fine example of carved and gilded wood with sections once painted a lovely blue-green. Niche in the wall is for daily offerings.

Left: *Water tower at the Villa Bebek assures gravity fed water to the pavilions. Carved* paras *stone reliefs set into tower walls and colored balustrade add interest to an otherwise strictly utilitarian conveyance.* Above: *Detail of* paras *stone relief and a view of the swimming pool area at Villa Bebek.*

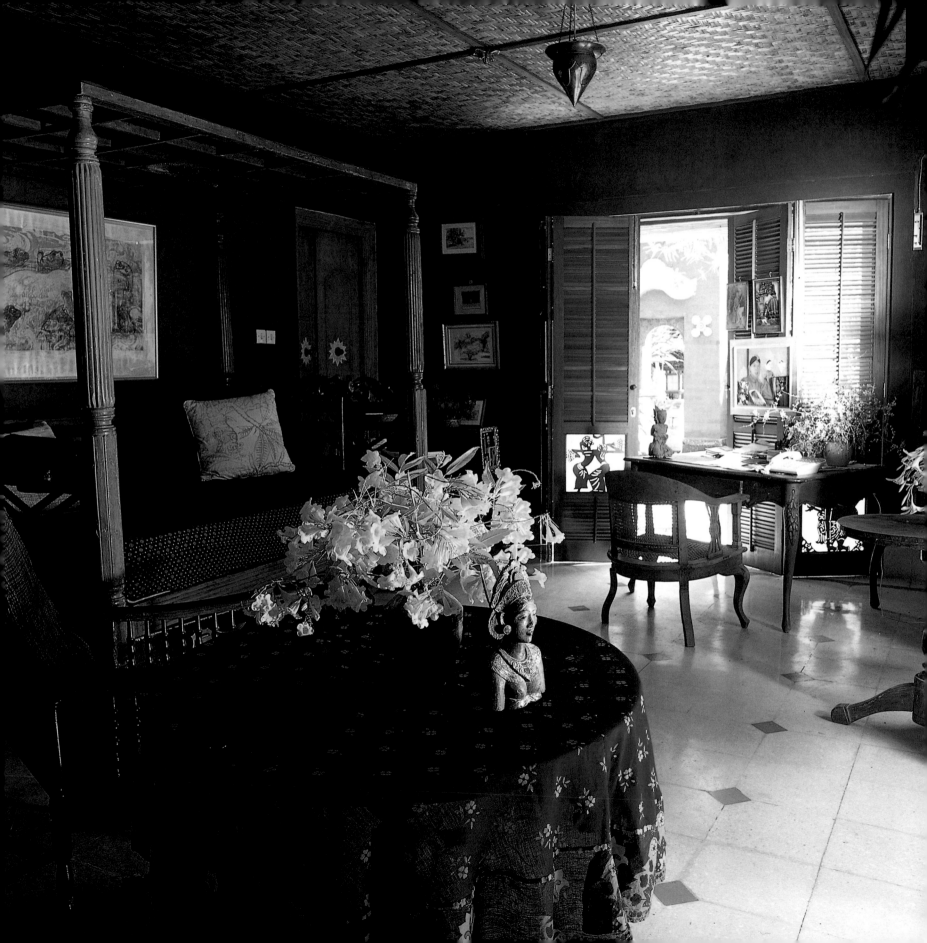

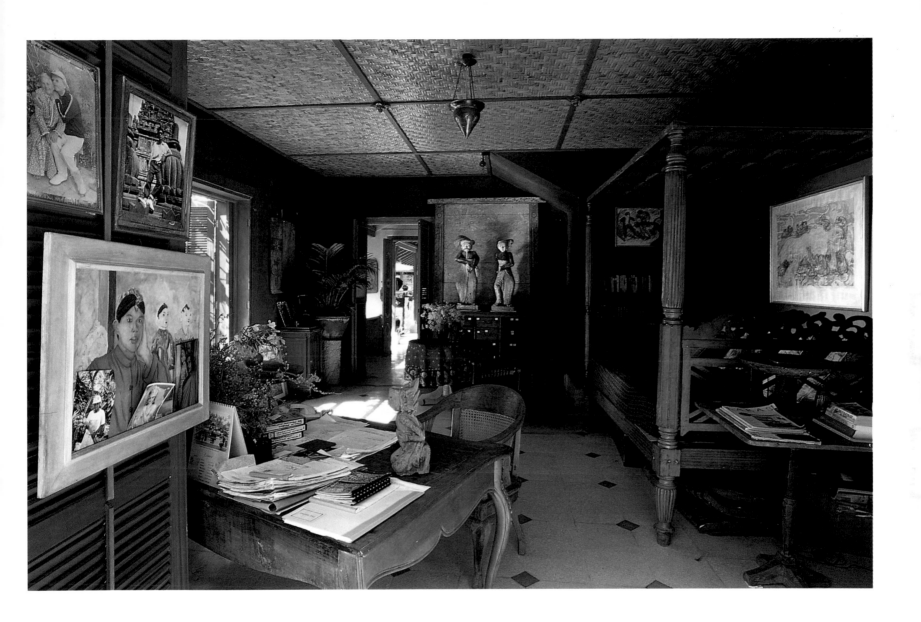

Left and above: *Deep forest-green walls of Made Wijaya's bedroom and study at Villa Bebek (Duck House) has a beckoning coolness on sunny afternoons in Sanur. Bali's warm and humid climate is tempered by traditional architectural techniques of open verandahs, thick thatched roofs for insulation and cool tile floors underfoot.*

The painted bed and other furniture were collected throughout Indonesia. Carved silhouettes inset in louvered doors are dancers in a wayang kulit *style. Woven bamboo* bedeg *ceiling showers the room with a honey-toned warmth.*

Made Wijaya is a noted landscape architect in Bali.

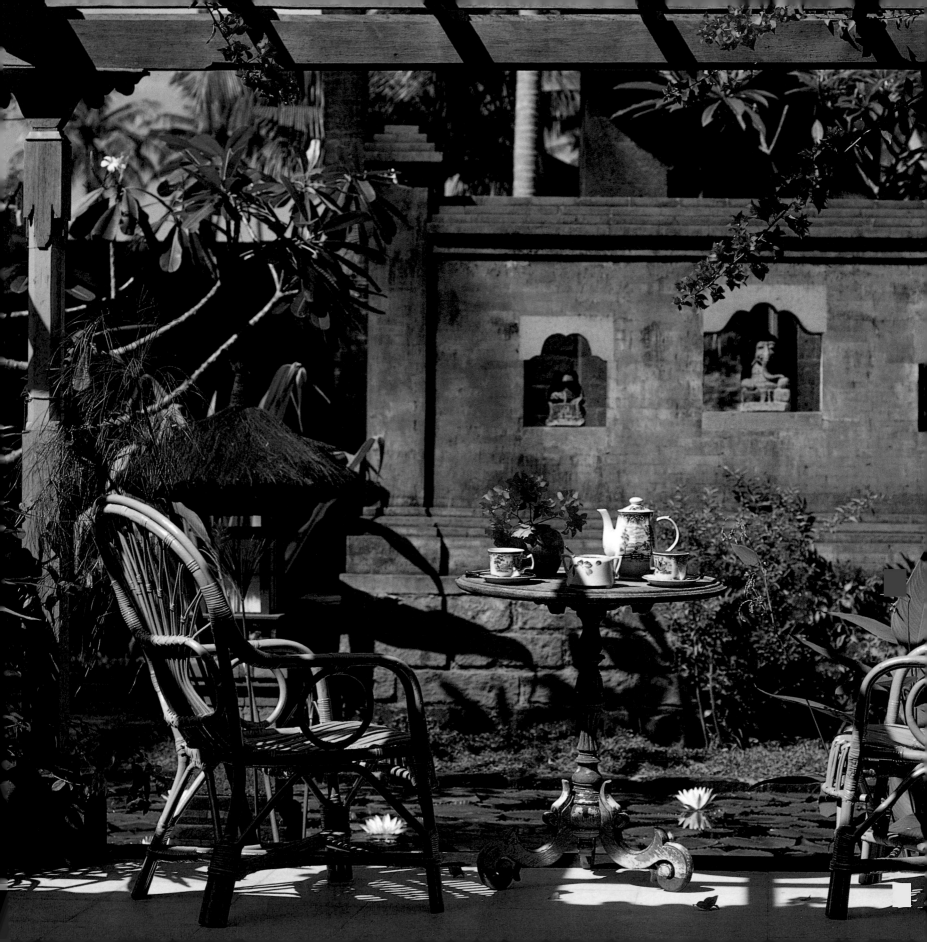

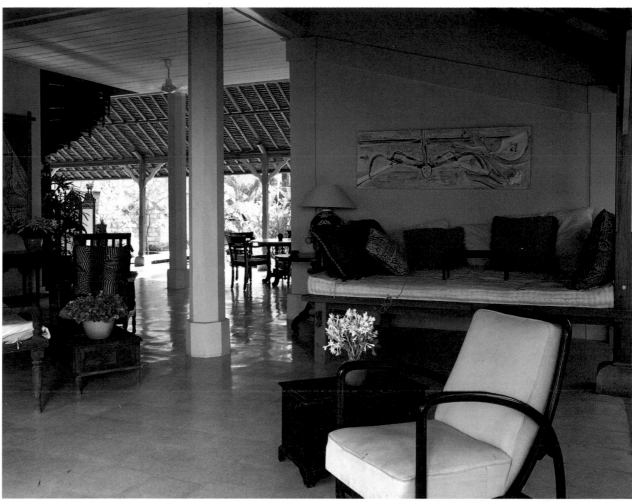

Left: *Colorful bougain-villea and fragrant frangipani grace this terrace overlooking a lily pond at Villa Bebek. The stone and brick wall detailed with niches for the display of sculpture adds an anchoring focal point. A garden lamp with palm-fiber roof resembles a Balinese shrine.*
Above: *High ceilings and open terraces sweep cooling breezes through the Villa Bebek. The spiral stairs is to sleeping rooms upstairs.*
Right: *Old painted bench on an open terrace is an invitation to sit and enjoy the tranquil greenery of the garden.*

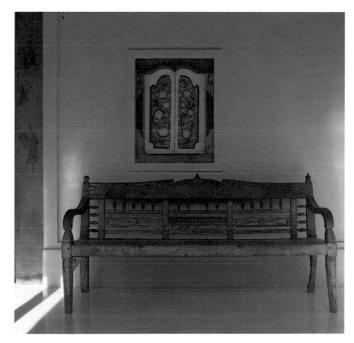

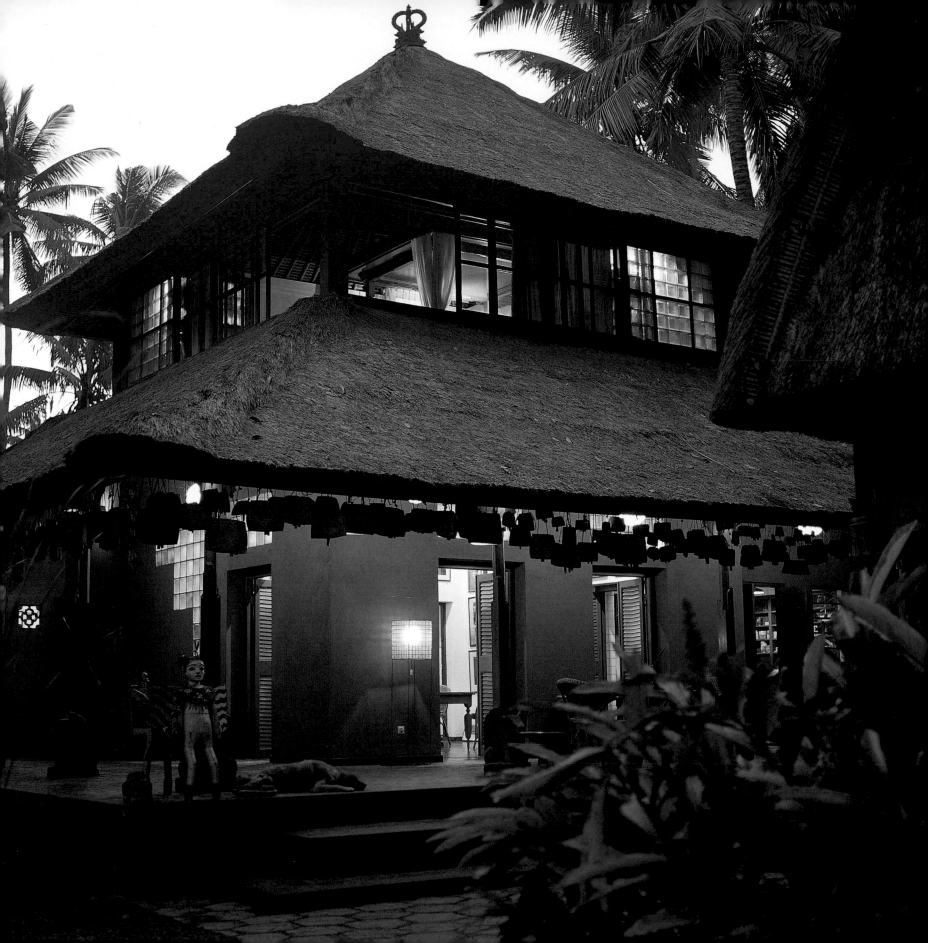

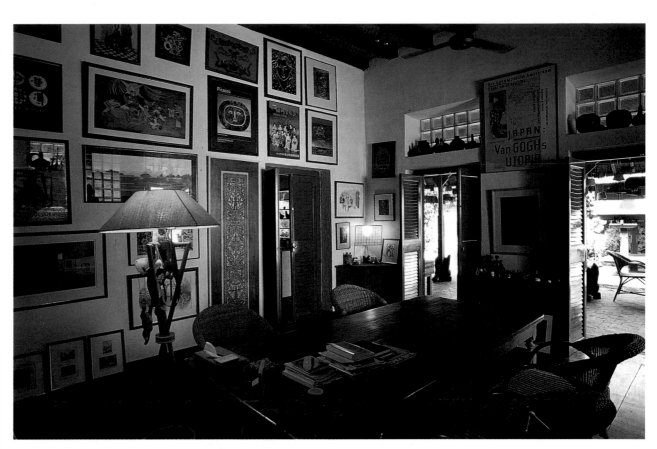

Left, below and right: *Brent Hesselyn's Sanur home incorporates a traditional alang-alang grass roof on an otherwise modern, Western house. Wooden cow bells of every size march around the soffit of the first floor.*

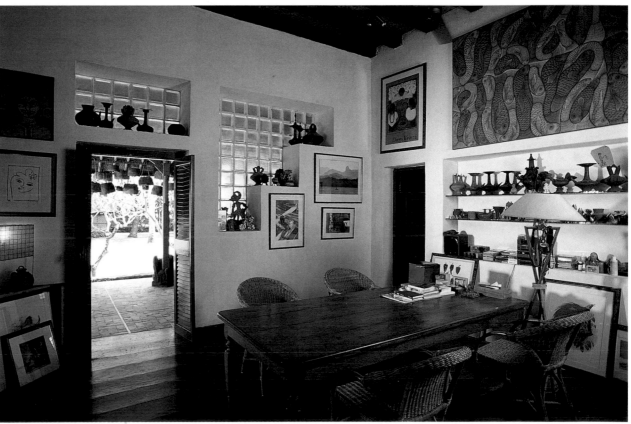

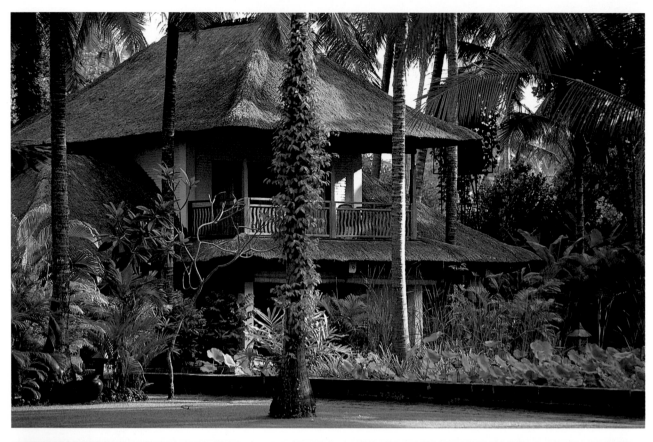

Left: *Western design concepts of a vacation home adapt* alang-alang *grass roof as well as the hip-roofed, square proportions often seen in Balinese architecture for a blend of East-West. This home is Frank Morgan's Taman Mertasari house in Sanur.*

Right: *The entry gate to the swimming pool area of Taman Mertasari.*

Below left: *Tall, steep thatched roofs of the* lumbung, *rice barn, is an excellent design for shedding tropical rains as well as providing interior volume to an otherwise small guesthouse in Tom Chapman's Sanur home.*

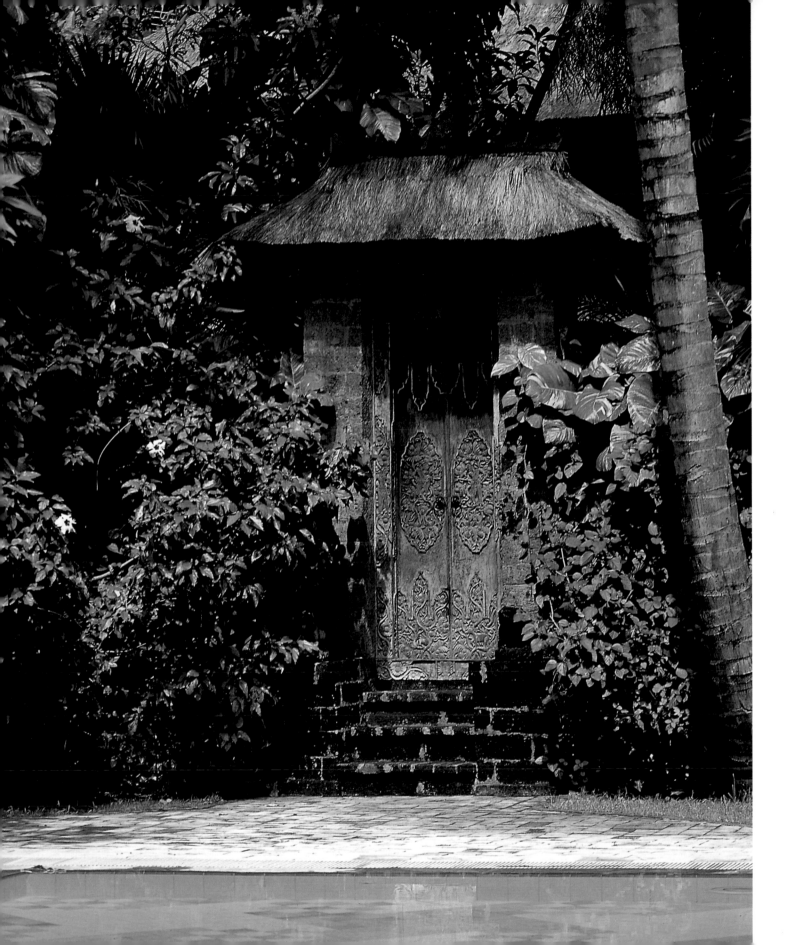

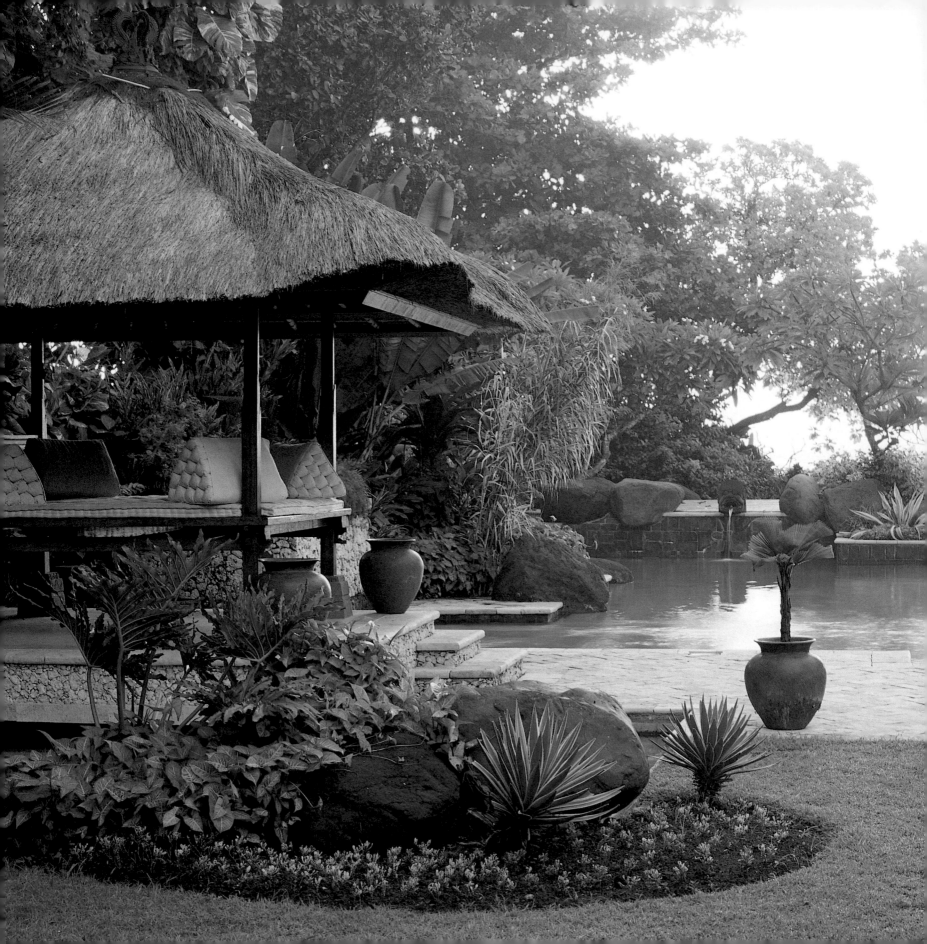

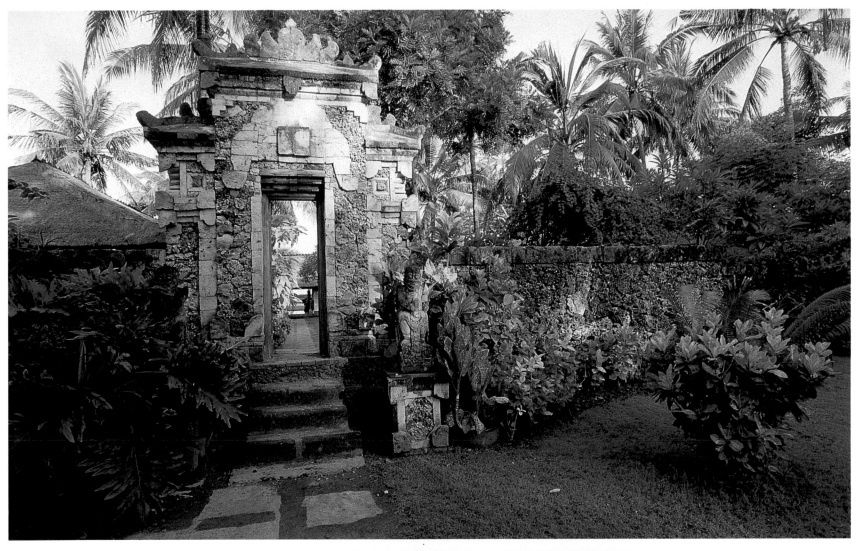

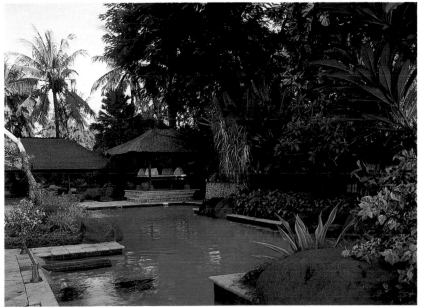

Far Left: A poolside, *resting* bale *with a view of the sea and gardens at House "A" in Batu Jimbar, Sanur, is a typical design of sleeping* bale *in traditional Balinese compounds. (See Architectural Notebook for schematic plan of a* bale.)
Above: *Coral rock* kori *(gate) and wall are the main entry to House '"A" at Batu Jimbar, Sanur.*
Left: *Turning away from the sea and toward view of the pool and* bale, *House "A."*

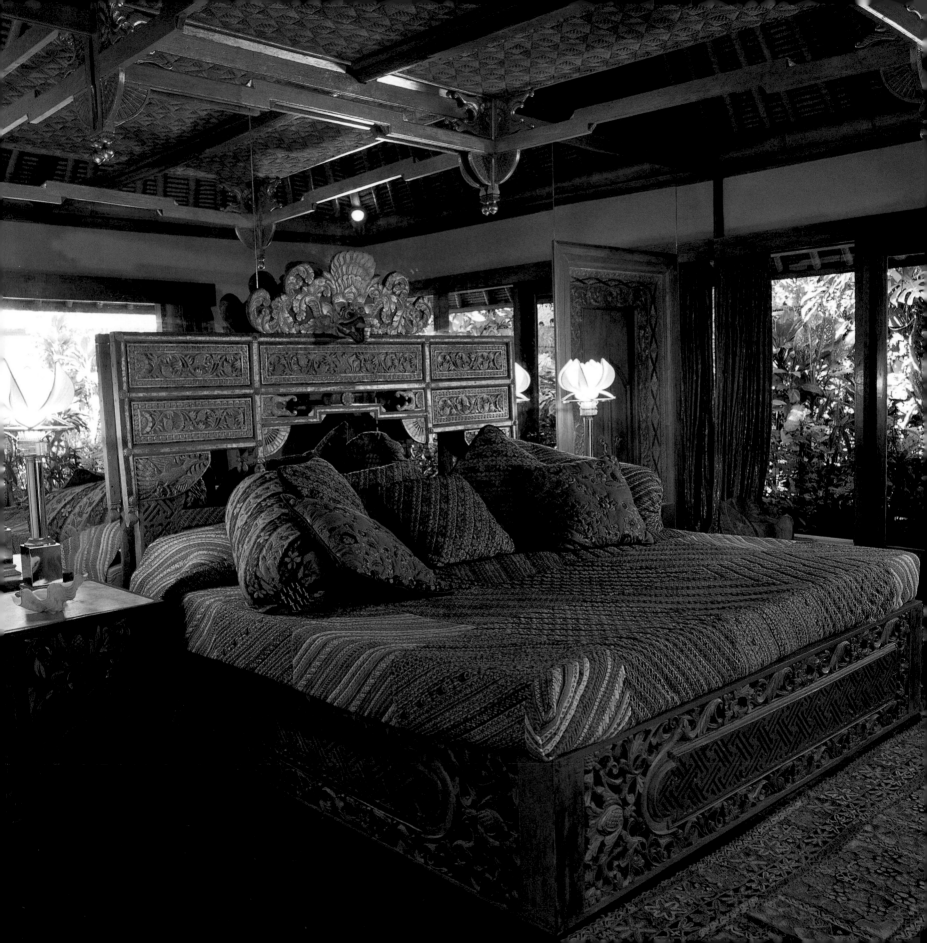

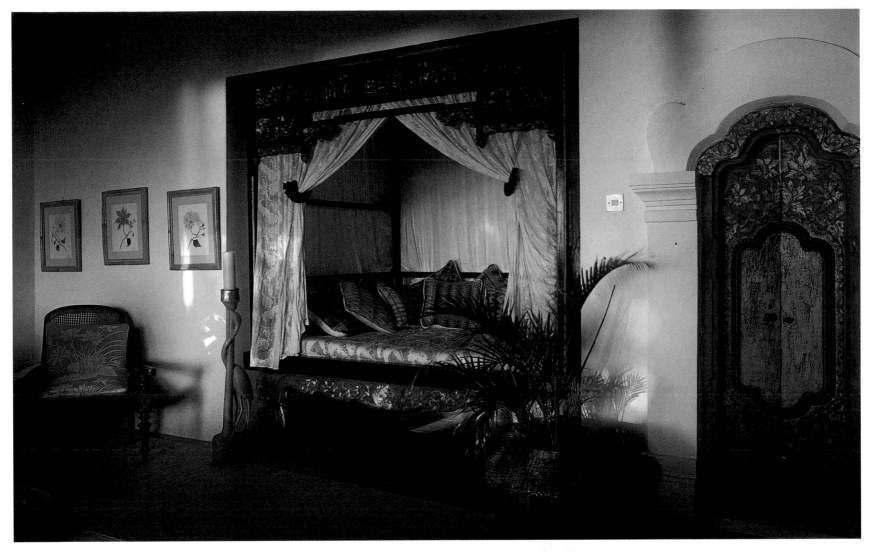

Far Left: *Reflected pattern on pattern on texture enhances the richness of this guest bedroom in House "A." The carved headboard is from an old Javanese bed while the bed frame is made from panels carved in Bali. Fabrics are quilted batik from Java. A bamboo ceiling frames the entire room with additional texture. The interior design of this room is compatible with the Balinese love of busyness although this room is certainly an adapted style for foreigners.*

Above: *Sleeping alcove in the master bedroom pavilion. The carved wood and gilded double-door is a fine old Balinese treasure.*

Left: *Indoor/outdoor guest bathroom in House "A" features a free-form concrete bathtub.*

BALI FUNK

There is an incredible lightheartedness on Bali, an irrepressible buoyancy of spirit that is present in the Balinese and quite infectious to foreign visitors. Whimsical, capricious designs are the creative output of an effervescent, enterprising energy that permeates the island as steadily as the balmy sea breezes.

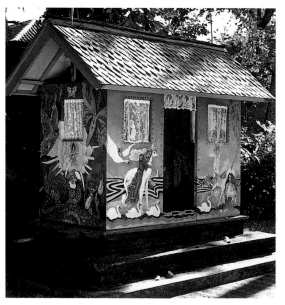

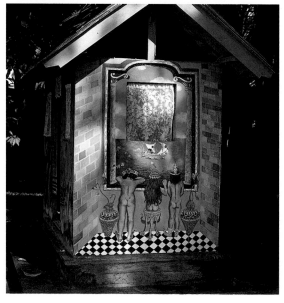

Left and right: *Joyfully complimenting the Balinese love of color and imagination, playful* trompe l'oeil *scenes were painted in the exterior and interior of this playhouse at the home of Soosan and Wana in the village of Legian.*

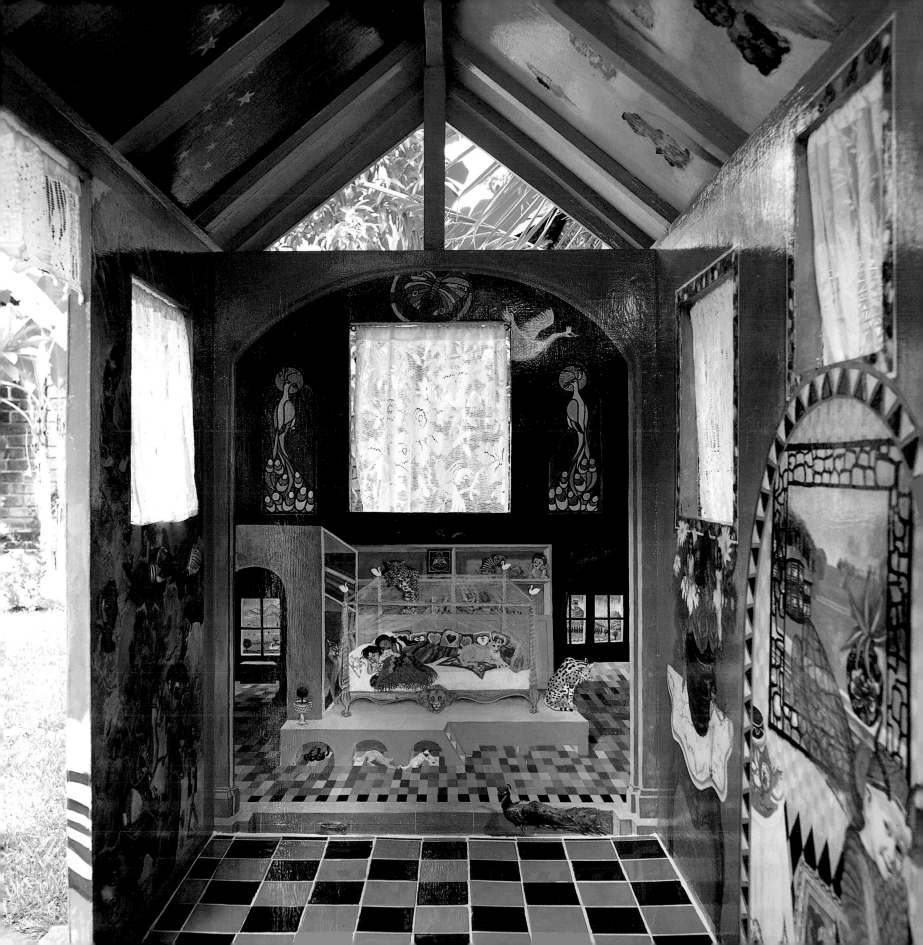

This page and next: *Semi-modern exteriors of homes in the mountain villages of northern Bali illustrate the Balinese love of color. Even this young boy's chicken is dyed his favorite shade of pink.*

(Following left page)

Top: *A colorful family compound in Bangli uses intense pastels on shrines in the family temple as well as on the surrounding wall.*

Bottom left: *Only half-the money, so build half-a-shop. Half-finished shop in Denpasar is designed to be added onto later when there is enough money ...typical Balinese sense of economy.*

Bottom center and right: *Contemporary adaptation at an early shop in Tabanan contrasts with a very modern version.*

(Following right page)

The Balinese love of color is vividly displayed on these recently built shrines in northern Bali.

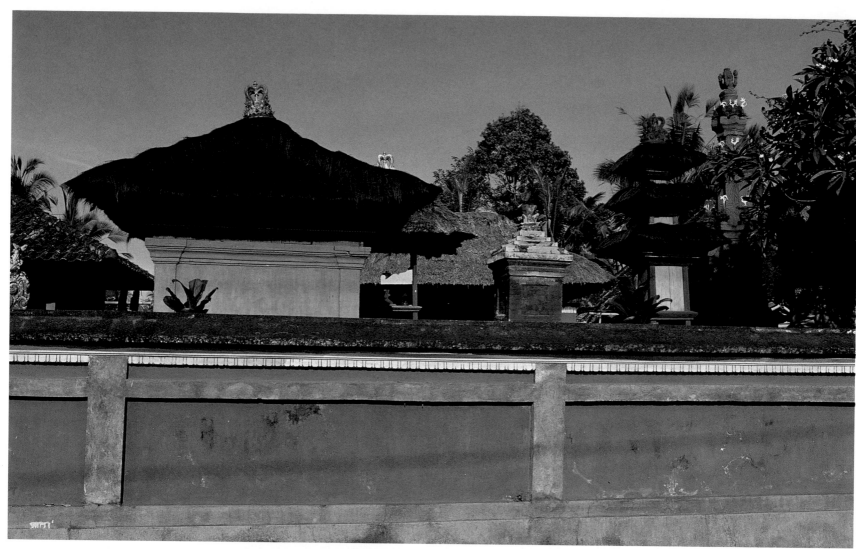

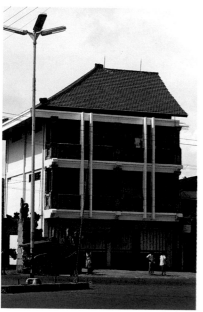

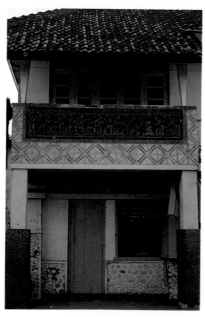

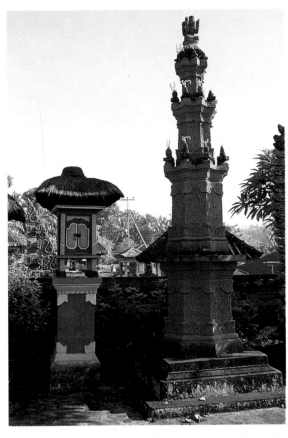

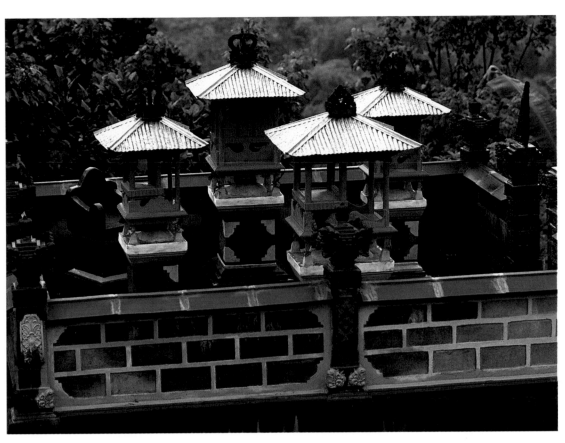

The Balinese sense of humor and appreciation for colorful detail is often exhibited in unusual ways in the most unexpected places.
Above: *An incense burner at a temple in Mas is a voluptuously carved wooden statue cartooning a woman carrying tray.*
Right: *Completely dressed for the occasion, these water buffaloes have left their work in the sawah for a day of racing in Negara, West Bali.*
Far right: *Colorful delight in a family compound, this rice barn in Payangan is painted with scenes of Bali and figures from the Mahabharata.*

176

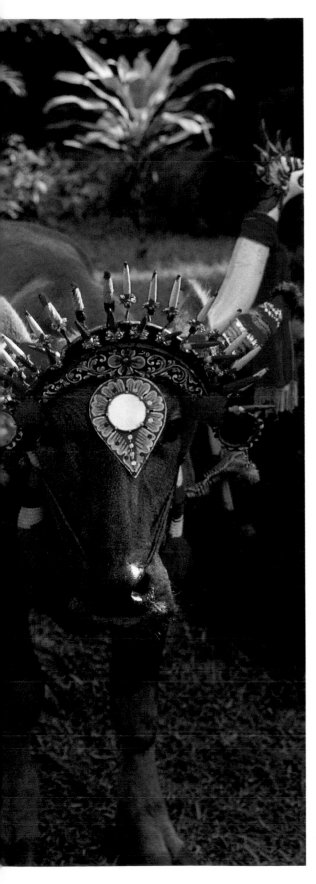

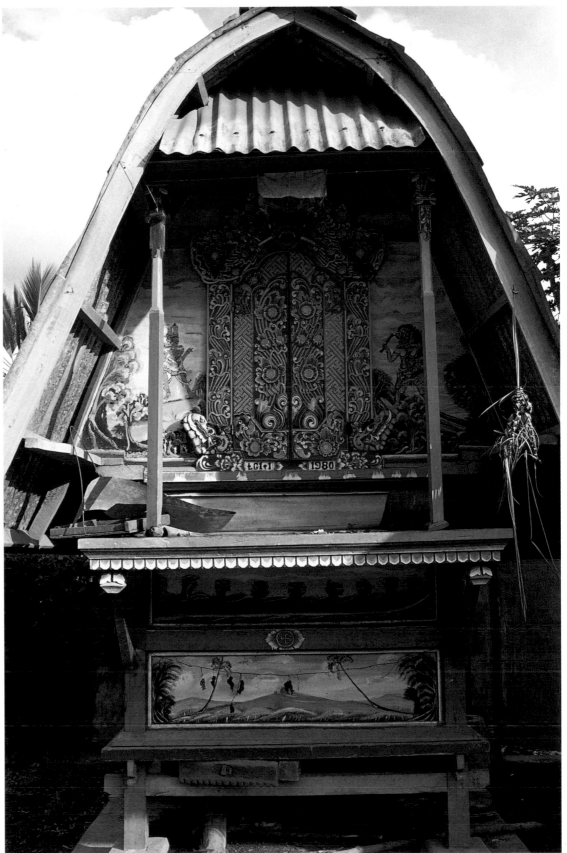

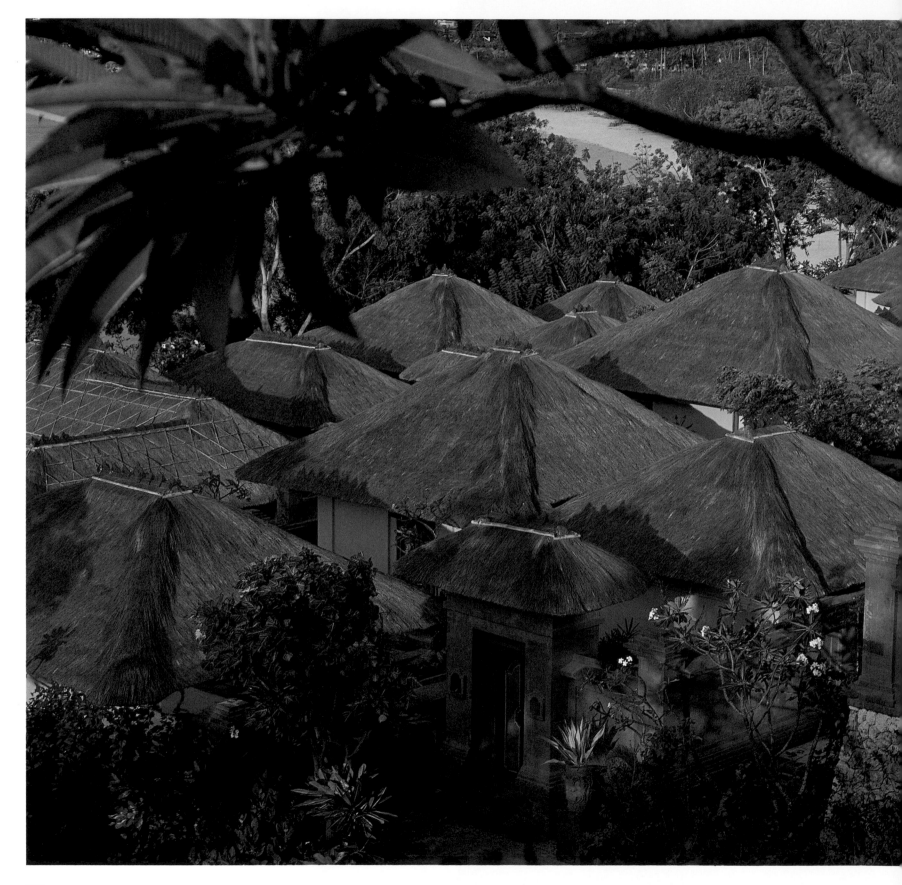

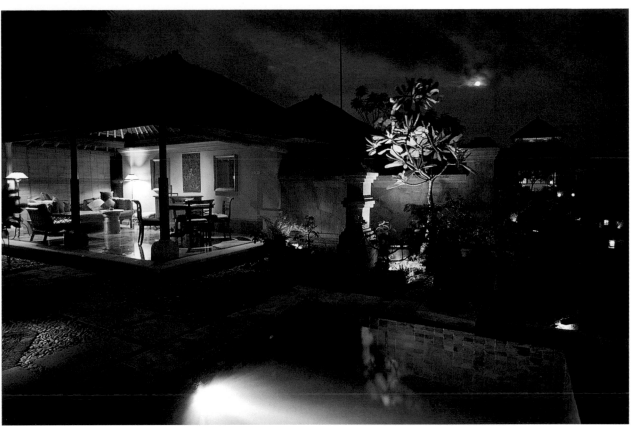

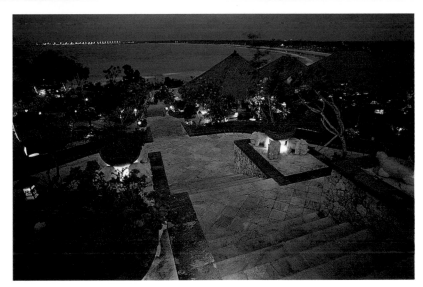

Left: *Thatched rooftops of villas and traditionally designed entry gate calls upon Balinese architectural elements for design, at the Four Seasons Hotel.*
Above top: *Standard rooms at the Four Seasons are separate pavilions with an open-air sitting room overlooking a private plunge pool.*
Above bottom: *A grand stairway of limestone pavers and coral rock walls leads past the main dining pavilion toward the white sand beach of the Java Sea. The lights of Kuta and the Ngurah Rai International Airport sparkle from across the Jimbaran Bay.*

Far right: *Narrow village lanes throughout Bali are defined by walls punctuated here and there by compound entry gates. This traditional village plan has been expanded in the resort architecture of newly built hotels such as the Amandari near Ubud or the Four Seasons in Jimbaran. This picture could be a walled lane leading past compounds of Balinese families, however, it is a path to villas at the Four Seasons Hotel. Designers and site planners have excelled in utilizing Balinese traditional architecture in this resort complex. Organic structures placed in natural settings provide guests an opportunity to personally experience the tranquil impact of Balinese architectural features.*
Right: *Entry to a private villa is a typically carved and painted double-door with curved top. Wall niches are for the placement of daily offerings.*

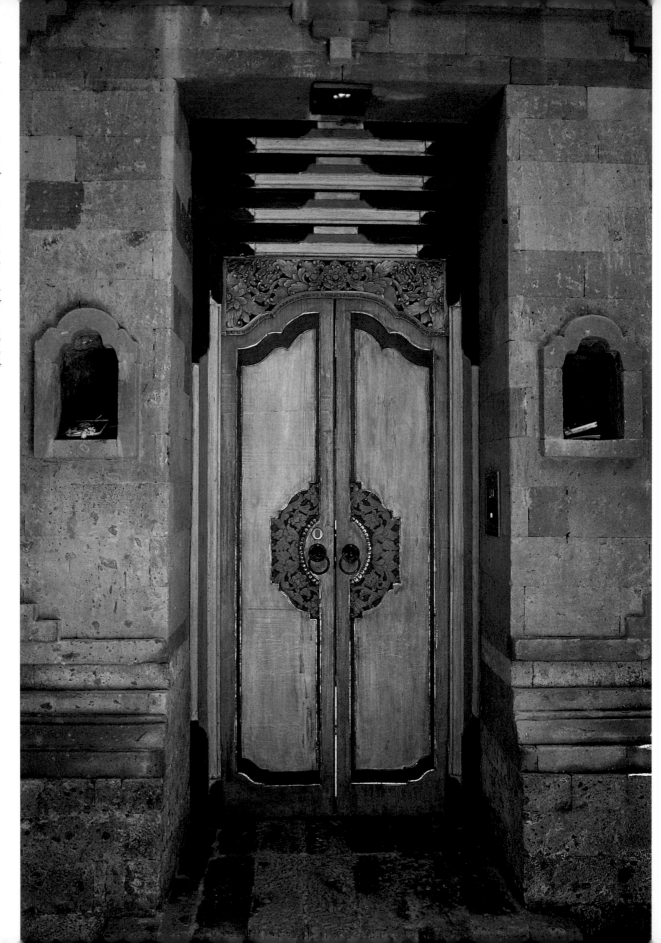

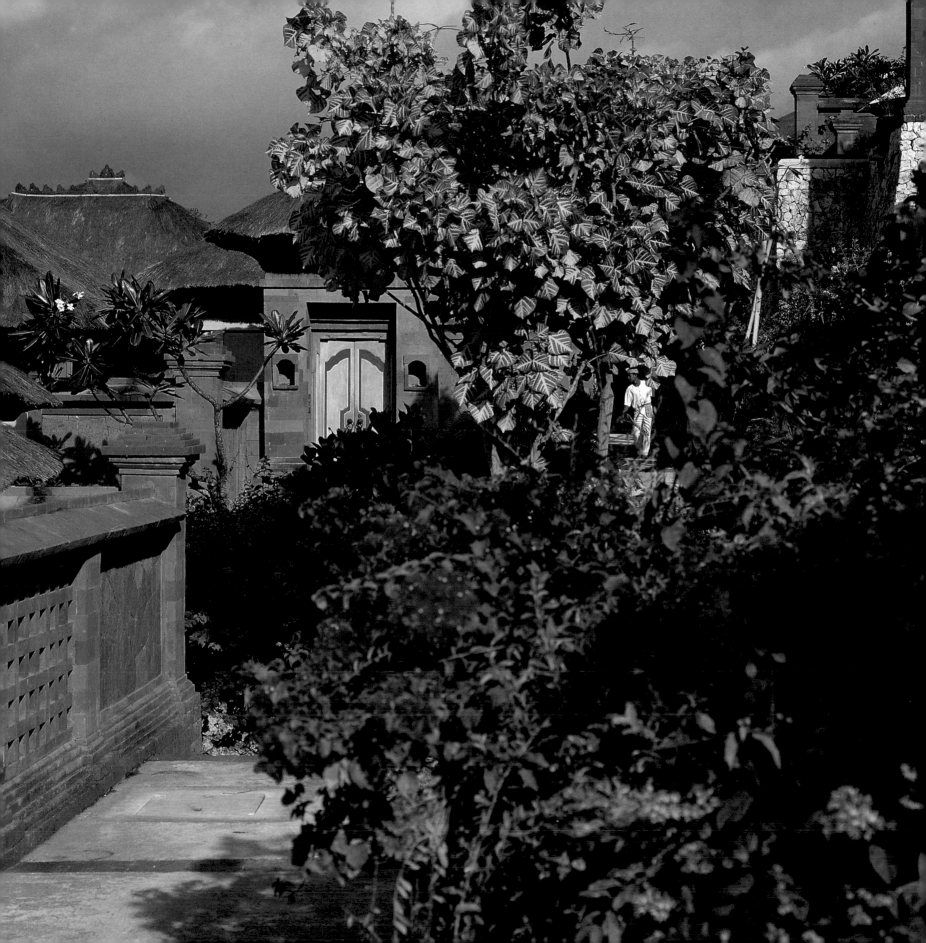

Above: *A view up the stairs from the main dining pavilion toward the reception pavilion of the Four Seasons Hotel.* Alang-alang *thatch roofs of the large reception pavilion has a lacework of bamboo battens to anchor grass from lifting in prevailing winds.*
Right: *Paths for strolling and enjoyment of nature connect villas at the Four Seasons.*
Far right: *Stone carvings from* paras *stone and various Indonesian decorative objects are placed throughout the gardens of the Four Seasons.*

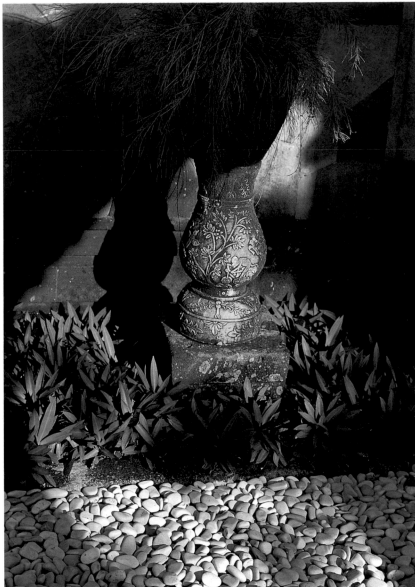

185

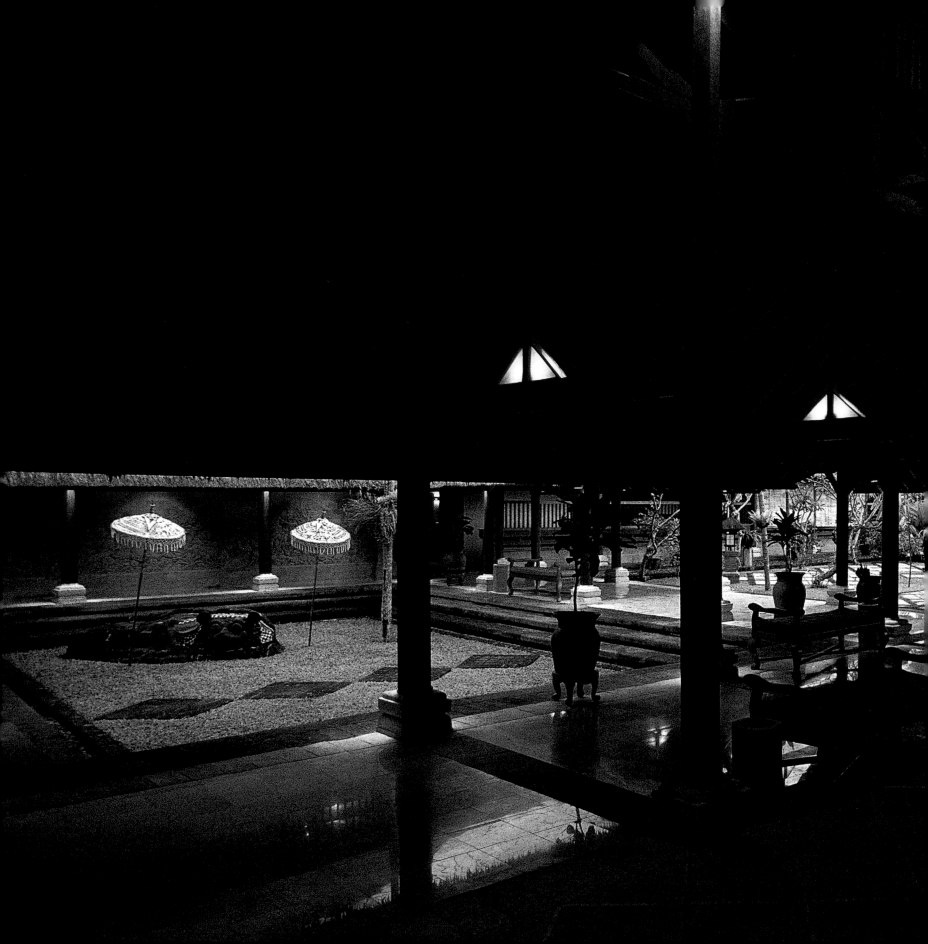

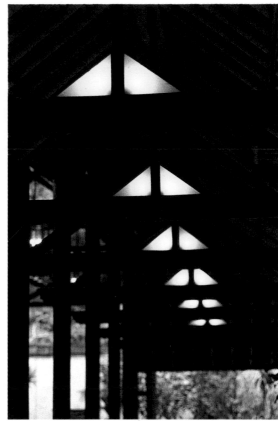

BALINESE INTERNATIONAL STYLE

Exquisite in every detail the Amandari Hotel near Ubud is truly a grand example of Balinese architecture adapted to international comfort yet upholding the basic principles of traditional philosophies. Organic, indigenous materials are utilized using local construction techniques which create space that is open yet closed, simple but elegant, grand but personal. Polished Indonesian marble is brilliantly combined with the rough-cut limestone pavers floating beneath the bamboo and thatch roofs of the reception desk pavilion which looks toward the lounge. Lighting is indirect, designed within the framework of the structure.

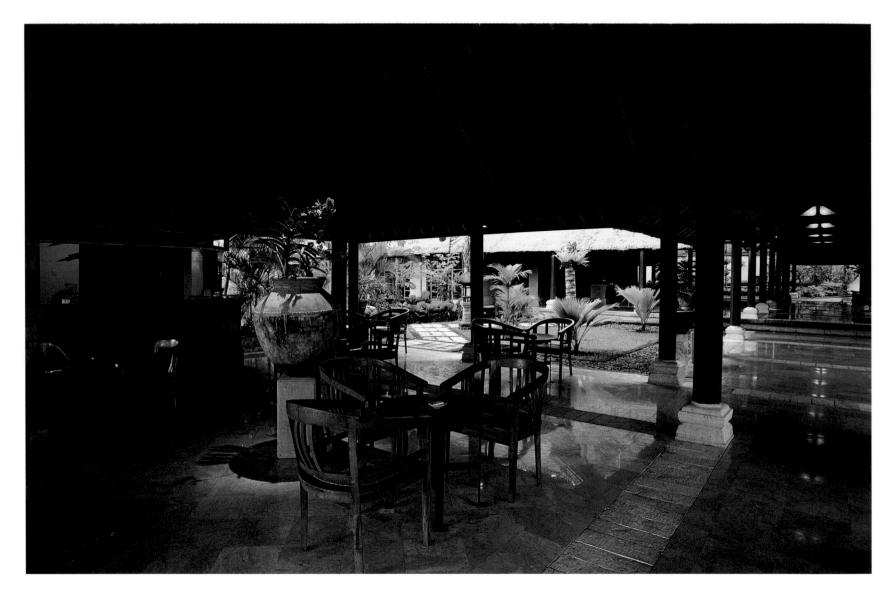

Above: *Just off the swimming pool of the Amandari Hotel is the bar/lounge pavilion. This view is toward the reception pavilion as pictured on the previous page. Orchids abound on this tropical, humid island, but their quantity in no way diminish the joy of their colorful display. The jardiniere in which the orchids are placed is similiar to those from Lombok. The dining chairs displayed here are a design commercially produced in Java for export.*

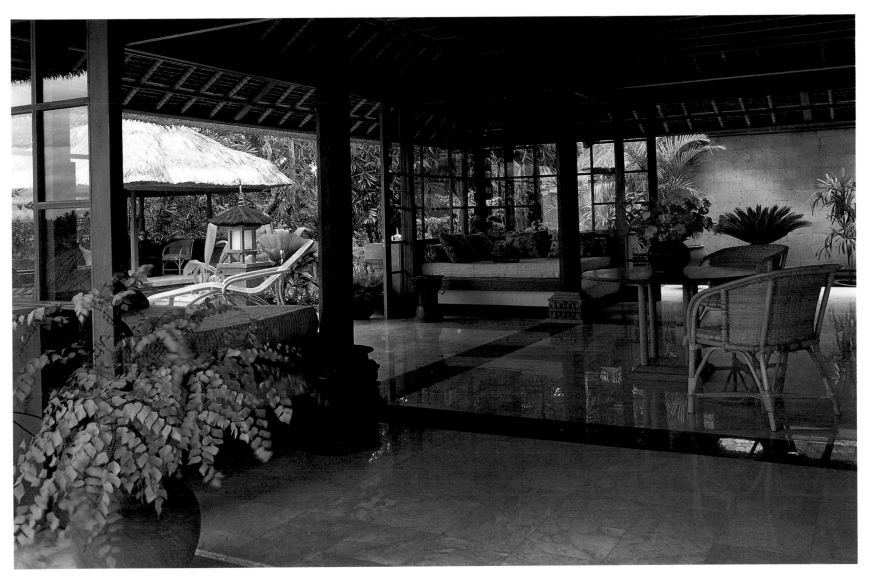

Above: *Beautiful refinement is achieved in this living area on the garden level of a two-story villa at the Amandari Hotel. Glass sliding doors are opened to permit the open-air feeling of a traditional Balinese bale. The private garden pool and lounge area are for the exclusive use of residents of this divine "hotel" suite.*

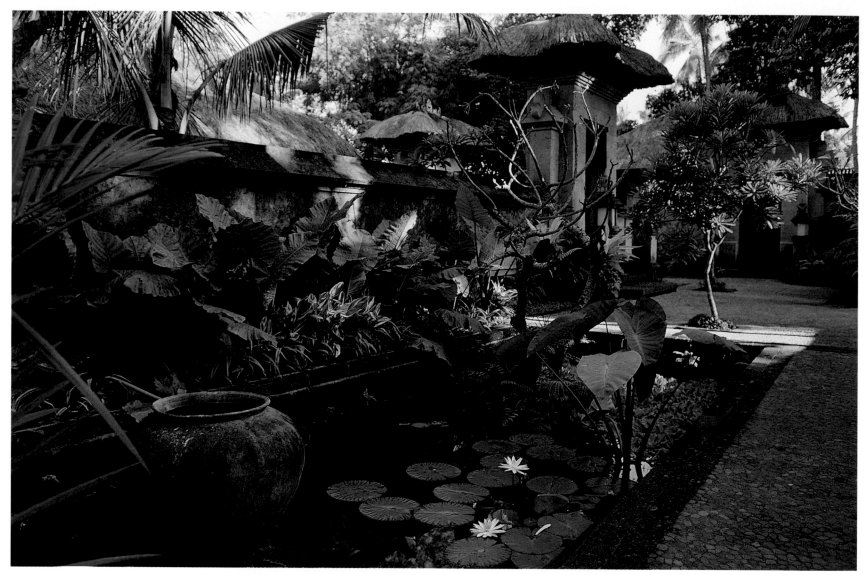

Right, above and opposite top:
Mud, stone and thatch of the villas at Amandari Hotel speak an architectural language of original Bali. The primitive aesthetics of village streets are faithfully adapted with paths bordered by mud walls leading guests to private villas. Each villa is accessed by an entry gate much like the traditional gates of Balinese families. Appealing lily ponds and lush foliage complete the feeling of timelessness created on the grounds of this tasteful resort property.

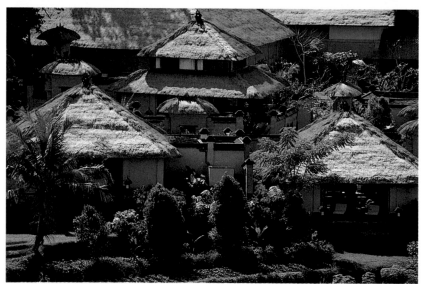

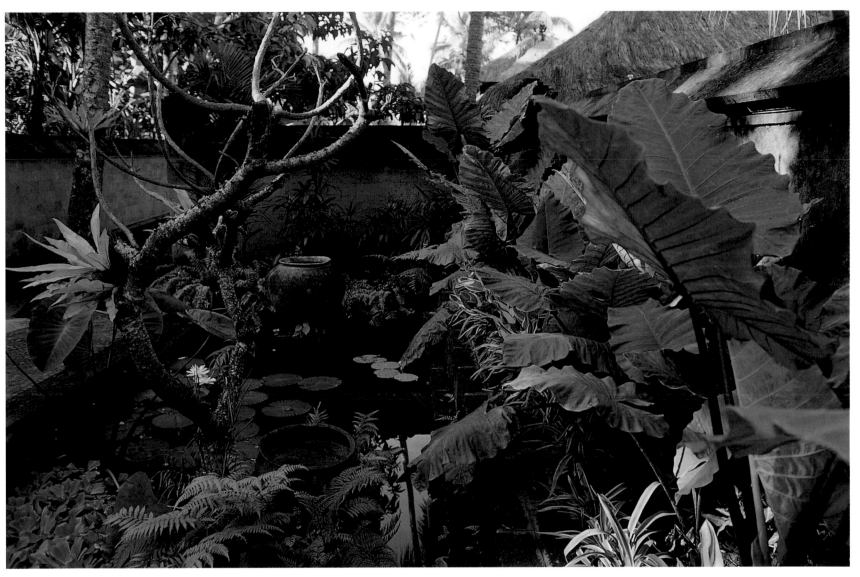

Left: *The swimming pool at the Amandari Hotel is ingeniously designed to fit into the* sawah *landscape that terraces down the ravine to the River Ayung. The appearance of the pool is that of a rice field overflowing as in a* sawah. *The tiles at the bottom of the pool, varying from medium to dark green, cleverly blend this modern amenity with the surrounding landscape. View from pool area is directly across the steep ravine toward Mt. Batu Karu.*

Far right: *The Hotel Oberoi has been established in Seminyak for many years, on a quiet, white sand beach not far from Kuta. Coral rock is used extensively for the pavilion and garden walls.*
Right and above: *The "Presidential" suite has a private pool and separate lounge and sleeping pavilions.*

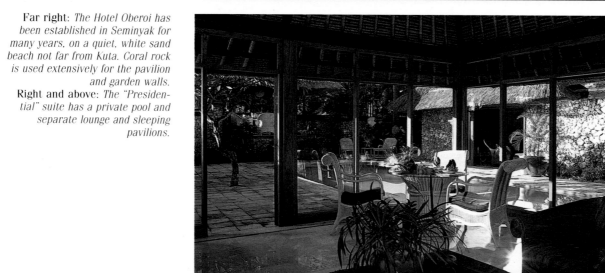

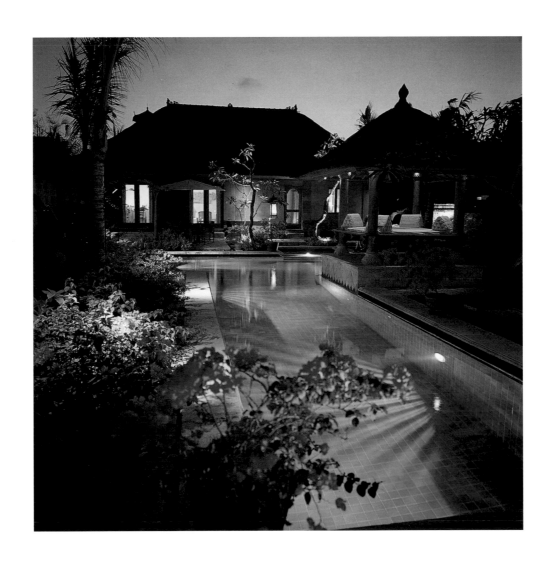

Left and above: *Quarried* paras *stone blocks form a handsome background and lend privacy to the garden pool area of a private villa at Hotel Bali Imperial, Seminyak.*

GARDENS, COURTYARDS AND GATEWAYS

Bali is an island of profound beauty, small but unique in variety. Dramatic high mountains and rugged seascapes are backdrops to artfully terraced rice fields, jewel-toned crater lakes and river ravines in the manner of a Henri Rousseau painting. Tigers no longer roam the forests where monkeys, tropical birds and butterflies continue to live in abundance. A profusion of flowers and luxurious tropical foliage are no surprise in this paradise where warm temperatures are near constant year-round, soils are enriched by volcanic ash and tropical rains create a greenhouse environment.

Alfred Russell Wallace traveled the Indonesian archipelago in 1869 and discovered the flora and fauna typical of Asia ends in Bali. East of Bali and only 35 kilometers away lies the island of Lombok. The deep-water Lombok Strait narrowly divides the two islands and marks a beginning of more primitive biological forms as found in Australia. Lombok is arid and thorny while Bali is blessed with an endless variety of plant life; some quite exotic in nature and all bountiful in production.

On Bali one is always aware of the plentiful extravagance of fruits and flowers: their presence is constantly and absolutely felt. The warm, gentle sea breezes of the night are perfumed with frangipani and jasmin while daytime activities embrace their availability. Flowers entwined in the hair or placed behind the ear of men and women are a natural accessory. Costumes of performers almost always include fresh blossoms, and petals are showered upon audiences as a welcome in the traditional *pendet* dance. Statues everywhere are arrayed with hibiscus blossoms jauntily stuck here and there. Each morning small woven *canang* offerings containing fresh flowers, rice and sweet-smelling grass are placed on and in vehicles, on doorsteps of shops or in a curve of the path or road. Blossoms are held in the fingertips by priest, women, men and children during prayerful worship. If it is thought the hands have touched something impure, a flower blossom is rubbed between the fingers. Flowers represent purity, an offering from the gods that gives the gift of fragrance and beauty to the splendid garden of Bali.

Practicality combined with beauty is the Balinese way in all aspects of life including their gardening. Gardens within the walls of traditional Balinese compounds are generally not particularly designed or laid out but are rather randomly planted. Any available open space is used for growing useful or edible plants, fruits and flowers. A typical compound is planted with staples such as coconut, banana, citrus, rambutan, coffee, mango, pineapple, and papaya. Flowering trees and shrubs are valued for beautifying the compound as well as providing blossoms for use in the constant making of offerings. Compounds in the higher elevations of north Bali may have apple trees or the delicious *salak* which has a crunchy sweet texture like a crisp apple but with a nutty flavor — the outer skin of the *salak* could easily be mistaken for brown snakeskin.

A familiar late afternoon sight is that of grandfather returning home from gathering grasses, sarong tucked up in pantaloon-fashion, carrying a large bamboo basket of greens

Left: *View through lotus blossoms to a converted rice barn, used as a video room in the gardens of Nancy Macy's house in Sanur.*
Above: *Terra-cotta jardinieres such as these are produced on the nearby island of Lombok.*

for his beautiful cow. Young boys and old men alike cut wild grasses to provide feed for the cows, goats and pigs kept in pens within the family compound or on tethers. There are no meadows for grazing as land has a premium value for cultivation of rice. The daily practice of cutting grass and weeds is a practical tradition that assures tidy roadsides and manicured pathways, including the terraced rice field paths.

A practical unity of people and nature is the environment of Balinese life. Garden courtyards are not just to be seen but to be touched, felt, smelt and used. Balinese compounds consist of interrelated open spaces surrounded by walls with four or more open pavilions. Pavilions placed within compound walls create courtyards as extended living spaces out-of-doors. An interplay of closed and open spaces provides an inner harmony, a balance of the yin and yang, that same philosophy of opposites evident throughout the Balinese culture.

There are contradictory and multiple levels of meaning in architectural planning of space surrounded by walls yet once inside the area there is in fact an interaction of space. Although there is a simplicity outside the compound walls, inside there is a complexity of many pavilions and sheds. Walls are directional yet static as a place. Albeit there is a gate, nonetheless there is the confrontation of a wall. These themes of complexity and contradiction are those seen in every aspect of the style of Bali — tension within tranquillity in architecture or in fabric design, dance, gamelan music...even within the subtle natures of the Balinese people there is contradiction and complexity. These next pages picture some of the magnificent gateways and garden spaces in Bali integrating complex architectural structures with the tranquil landscape.

The exotic garden paradise of Bali and its remarkable culture will hopefully be able to remain as true to itself as the *waringin* family tree, continually putting down new roots while remembering their ancestral ways.

A PRIVATE RETREAT

Cool, lush tranquil garden spaces in a private hermitage near the village of Payangan define a setting conducive to a meditative retreat. Stone work entwined with tropical foliage weaves the feeling of a magical garden.

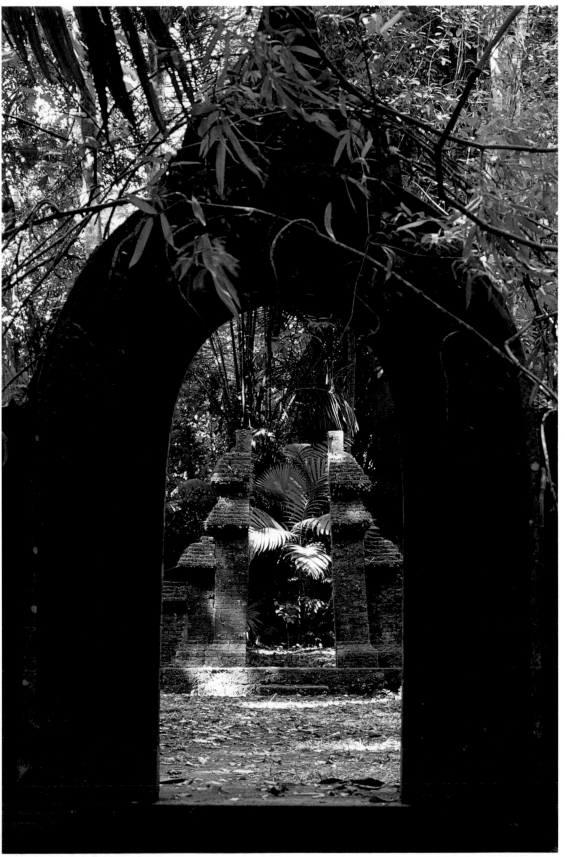

Left: *Enchanting garden courtyard has shrines with symbolic designs workcd with brick patterning. Figures are carved* paras *stone.*
Above: *An encased fern grotto is actually a stone meditation cave.*
Right: *Through this entrance gate can be seen a* candi bentar, *split gate. The sloping designs of brick coursings is reminiscent of the shape of* meru *shrine roofs.*

Above: *A bathing pool within the private hermitage in Payangan. A simple bale for meditation is placed in the center of the pool.*
Right: *Stone stairs lead to a bathing area of Candi Tebing in Tegellingah.*

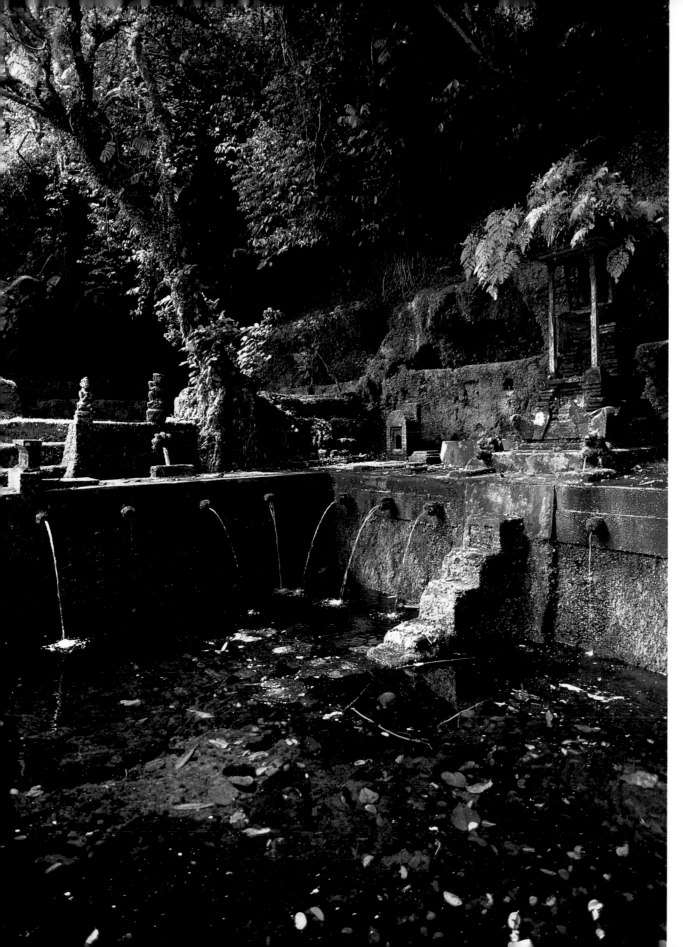

SACRED BATHING POOLS

Bali is rich in archaeological remains of temple grounds that include moss and lichen covered stone pools fed by natural springs with water so clear there seems to be no doubt of their pristine properties. The daily rituals of bathing and use of holy water in offerings has for centuries been of great importance to the Balinese. Their religion, the Balinese Hindu Dharma, is sometimes referred to as Agama Tirta (Religion of Water).

Stone carved gargoyles of mystical figures spout crystal clear spring water into pools such as those at Pura Sebatu or Tirta Empul. Local folks come for their evening baths in these deliciously refreshing waters, within the grounds of their temples, shaded by sacred *waringin* trees.

Left: *Pictured here is a bathing area of the Telaga Waja complex near Kenderan. The extensive complex is in an almost inaccessible ravine situated at the confluence of two rivers. The bathing area is considered sacred and outsiders are prohibited from visiting here without prior permission. Fragments of a printing mold for Bronze Age kettledrums were found near Telaga Waja.*

ENTRY GATES — BALI'S MOST RECOGNIZABLE FORM

At one time the status or caste of a family could easily be recognized by the style of his compound walls and entry gate. Today this custom is relaxed and the humblest of families may choose something more elaborate.

Every compound entry gate or the *candi bentar* gates of temples has an *aling-aling* wall positioned just inside and parallel to the surrounding wall. Somewhat like a screen, the *aling-aling* forms a visual barrier to the inner compound but also serves the same principle as a front door. Just as a visitor must hesitate at a door, the *aling-aling* stops one just a moment before entering the interior, walled space.

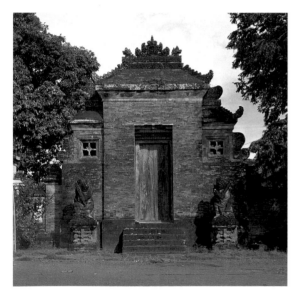

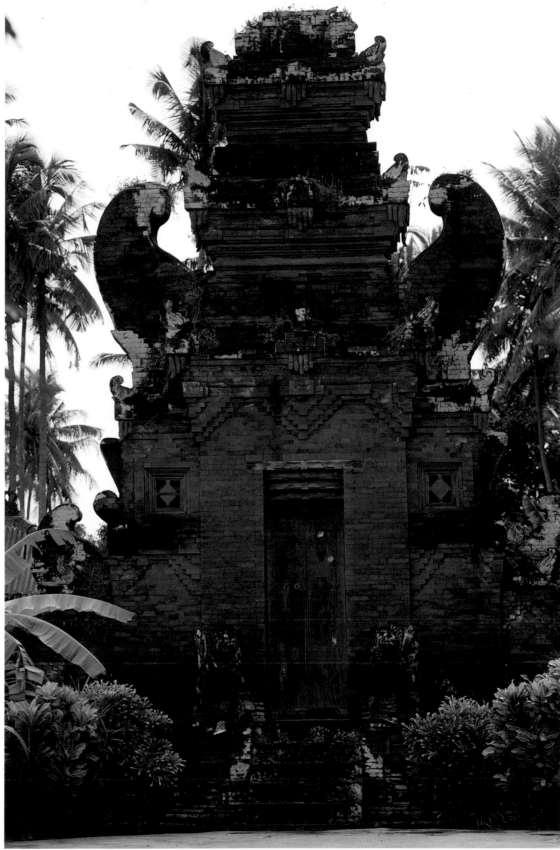

Left: *Beautifully detailed brick, stone and mud entry gate and compound walls of a Balinese home in Pujung. The slats of bamboo on top of the wall shed rainwater to preserve longevity of the mud wall.*
Above: *A* kori agung, *large entry gate, into a palace in Denpasar is probably of pre-Majapahit period as the details are of the less ornate style of the Bali Aga or monumental period.*
Right: *Extraordinary design motifs and proportions of this temple gate in a palace in Denpasar date it to the period of the Bali Aga.*

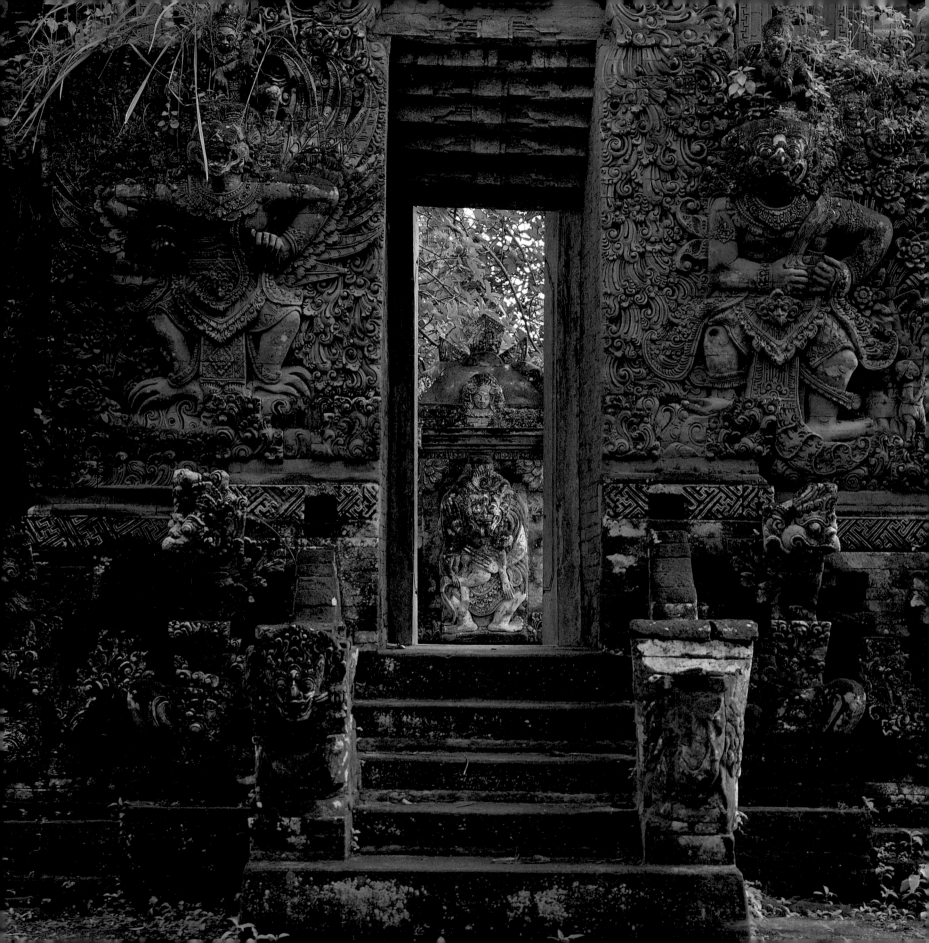

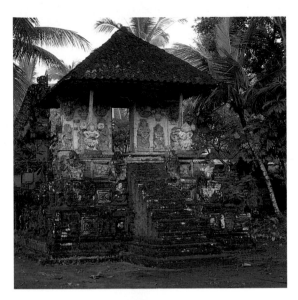

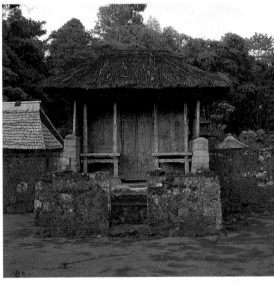

Left: *Complex carvings cover every possible space from the door frame to the edge of this entry gate leading into the shrine area of a temple of a minor palace in Bangli. The relief carvings and alto-carved figures in both the gate and* aling-aling *wall just inside are* paras *stone.*
Above top· *The entrance pavilion to the same palace is of the early architectural period called Bali Aga or monumental.*
Above bottom: Bale pegat *entrance into a temple in the Bali Aga village of Bayung Gede.*
Right: *View through an early entry gate of the temple in Bayung Gede. The larger shrine in the inner courtyard has a three-tiered roof like a meru, however the base is sitting directly on the ground rather than on a raised platform. The overhanging, underside of the roof on the entry gate shows woven bamboo shingles.*

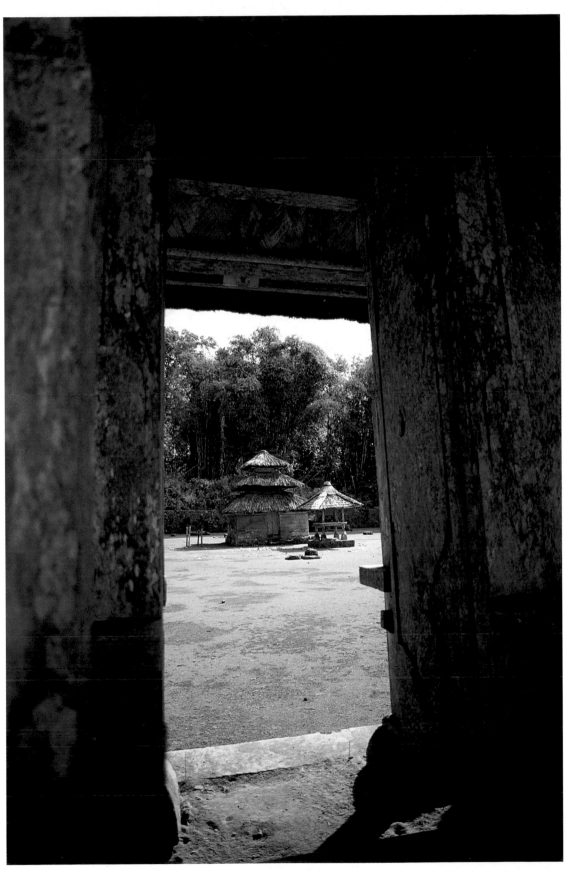

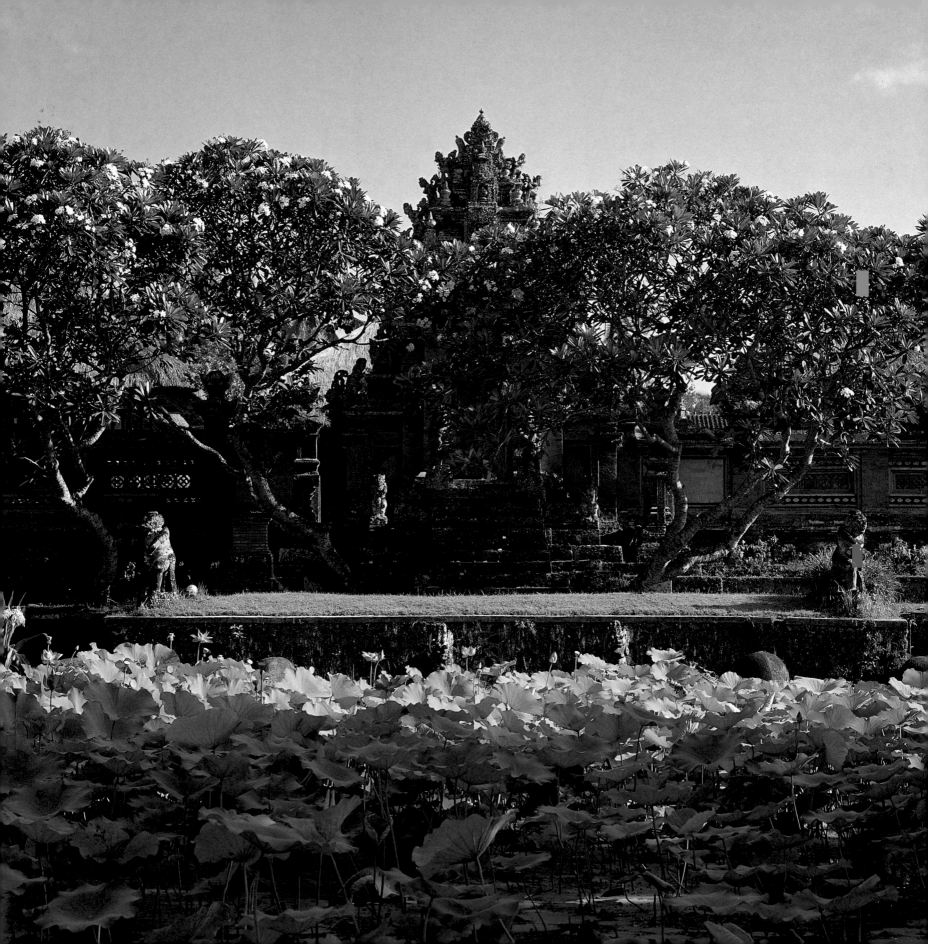

GARDENS AND GATEWAYS

The gateways of Bali are highly recognizable forms of Balinese architecture. Gateways are fashioned from the simplest of bamboo posts to the most extravagant brick and stone structure. Considered an important part of the garden land-scape, seldom is there a garden on Bali without a gateway. Homes for foreign visitors and international resorts have adapted this charming and beautiful traditional form.

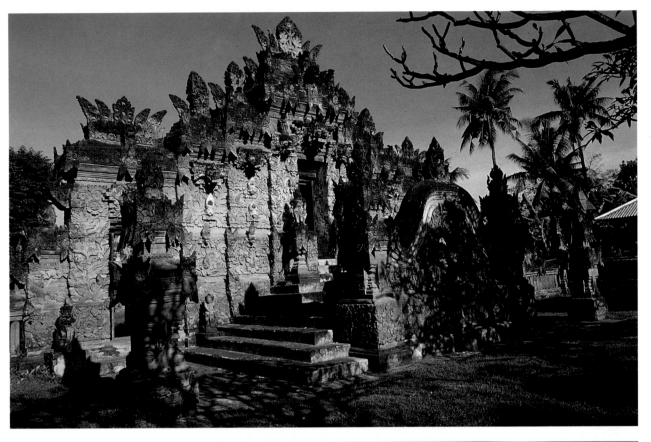

Left: *Old frangipani trees almost obscure the finely detailed Majapahit period gateway to the inner sanctuary of a royal family temple, Pura Langon in Ubud.*
Right top: *An amazing combination of carved stone relief and sculpture can be found on this gateway to Pura Beji in Sawan near Sangsit, north of Bali. There is an efferves-cent quality to carvings in this northern area compared to those of the south.*
Right bottom: *This magnificent candi bentar is not a royal palace surrounded by moats and water gardens fed by a prolific group of statuary spouting water but is instead the main entry to an international hotel, Nusa Dua Beach, near the Ngurah Rai International Airport.*
Following pages: *Splendid garden paths and lily pond gardens with papyrus and blooming ginger are cool retreats for guests staying at the Bali Hyatt Hotel in Sanur.*

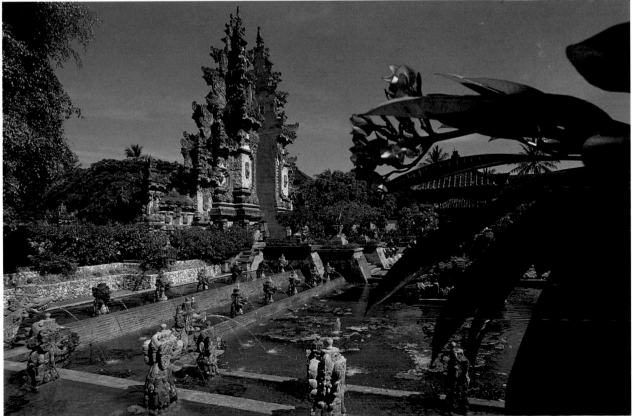

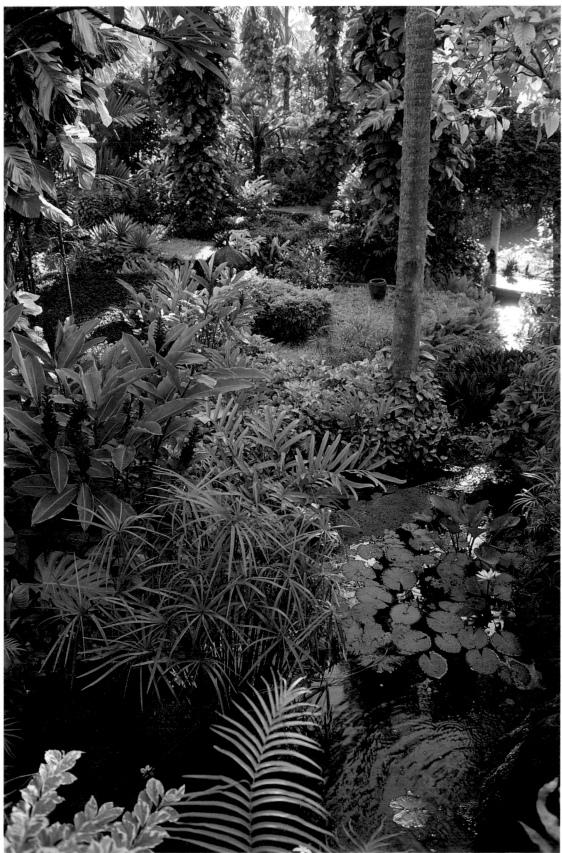

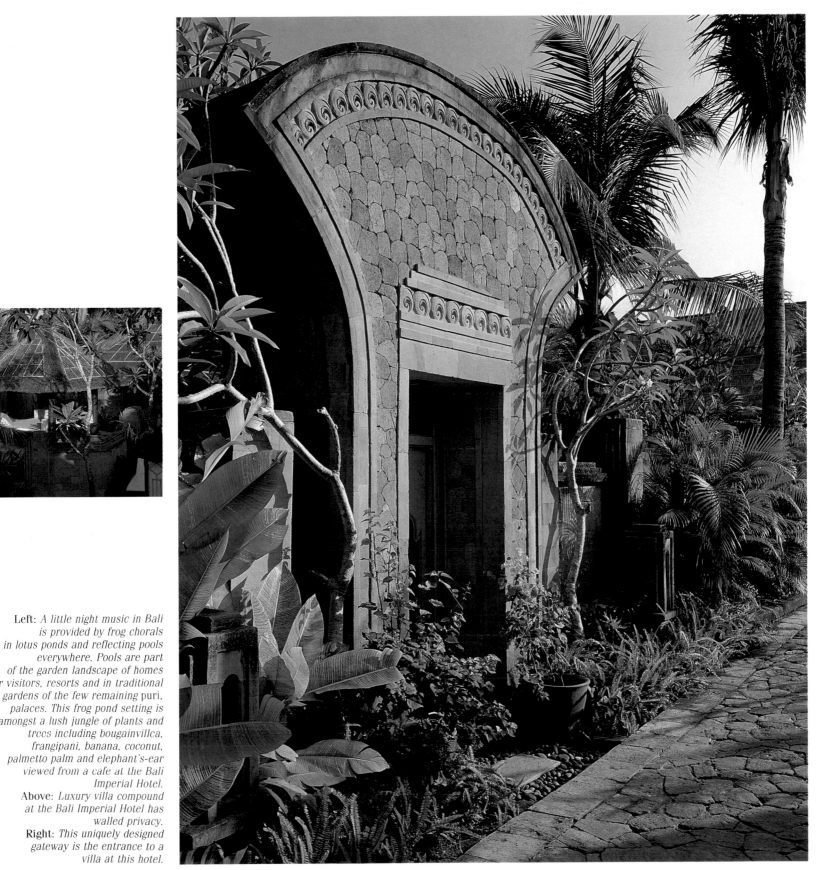

Left: *A little night music in Bali is provided by frog chorals in lotus ponds and reflecting pools everywhere. Pools are part of the garden landscape of homes for visitors, resorts and in traditional gardens of the few remaining puri, palaces. This frog pond setting is amongst a lush jungle of plants and trees including bougainvillea, frangipani, banana, coconut, palmetto palm and elephant's-ear viewed from a cafe at the Bali Imperial Hotel.*
Above: *Luxury villa compound at the Bali Imperial Hotel has walled privacy.*
Right: *This uniquely designed gateway is the entrance to a villa at this hotel.*

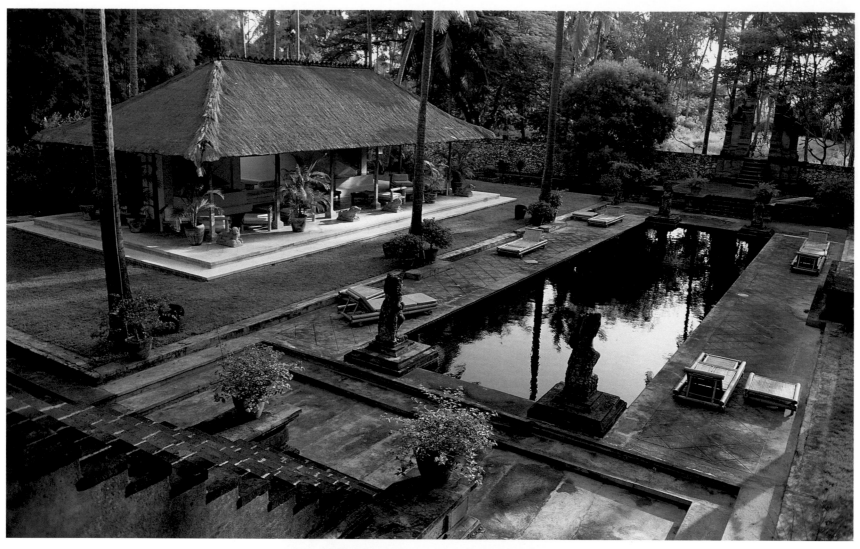

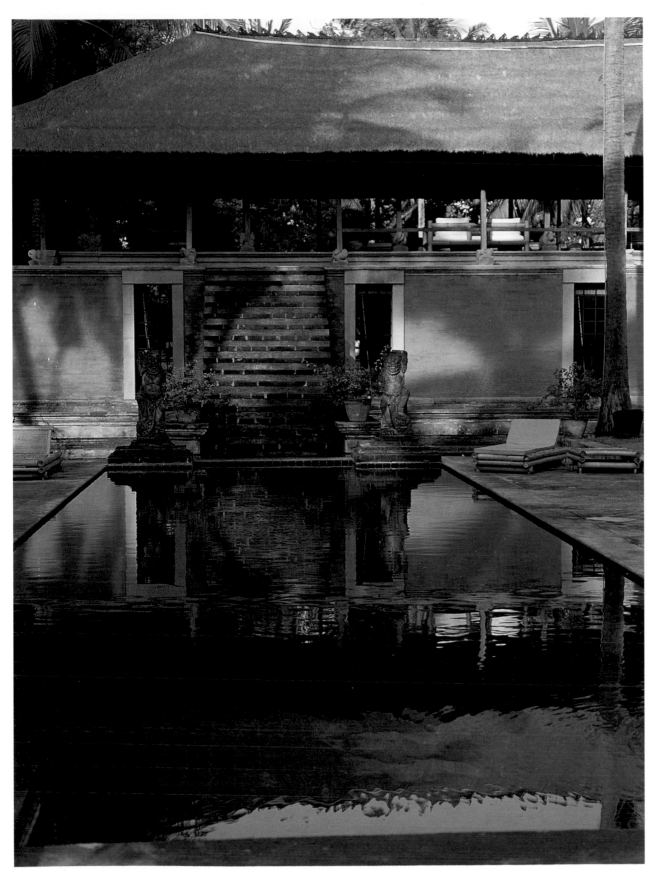

Pictured this page and the facing page is the home of Adrian Zecha in Batu Jimbar, Sanur. Mr. Zecha is owner of the Aman Resorts and has developed several hotels on Bali, including the Amandari in Ubud and the Amankila near Candi Dasa.
Left: *A modern pavilion with thatched roof is linked to the* candi bentar *by a reflecting/ swimming pool.*
Far left above: *The open-air pool pavilion is surrounded by coral rock walls of the compound. The* candi bentar *accesses a meadow and is a focal point from the pavilion.*
Far left below: *A coral rock and brick gateway opens to the beach.*

215

TRANQUIL ELEGANCE

Bali style photographer Rio Helmi's home utilizes traditional Balinese architectural elements incorporated with his personal sense of aesthetics. The garden settings of his home and open-air living spaces are exceptionally refined and elegant.

Left: "I like to think of it as a 'peaceful guardian' explains Rio Helmi of the statue in a niche in the walled entryway of his home in Ubud. This statue, a Buddha like figure sitting in repose atop a stone lotus blossom, was executed in paras stone by Balinese artists in Batubulan, a village known particularly for its stone carving. The artfully built surrounding slate walls are dry-laid and inter- locked for permanence. Slate is not commonly used on Bali, however there is a quarry in the northern part of the island.
Right: A stone candi is a temple meditation room. Candi (pronounced "Chan-dee") refers to old Javanese stone monuments dating from the time between pre-history and the Islamic period on Java. On Bali the word candi often refers to small replicas of free-standing buildings that resemble ancient Javanese temples both in the shape and decorative motifs.

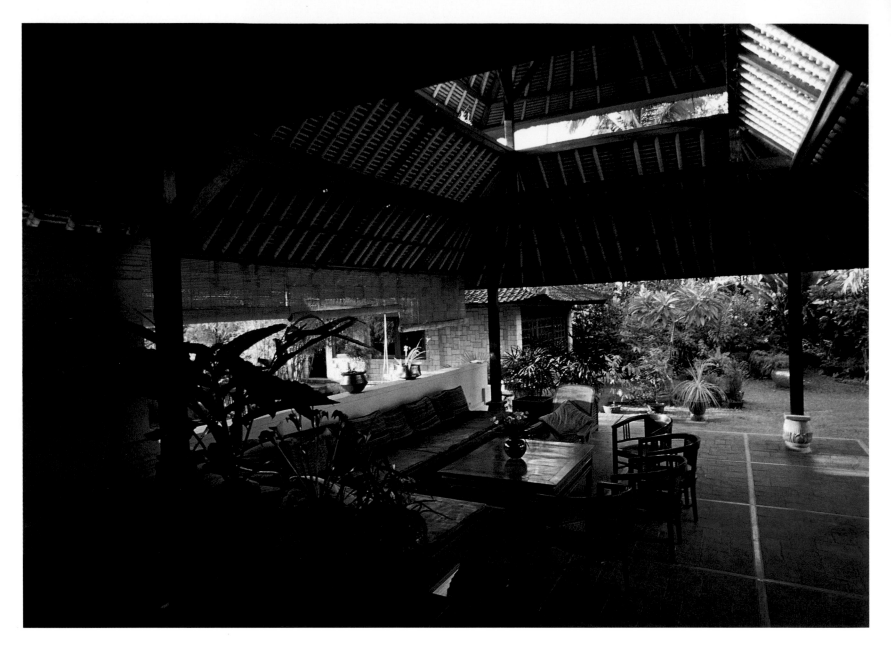

Above: *The split-level, open-air living room of the main pavilion of Rio Helmi's compound is a tasteful example of traditional Balinese architectural elements adapted to serve a contemporary family.*

A clerestory inserted in the bamboo and thatch roof affords a glimpse of green foliage and blue skies as well as permitting flow of air for cross-ventiliation. Handsome slate floors are divided and accented with polished teak inserts.

The stone pavilion in the background provides a studio cum office for photographer Helmi, but his main office is in the village of Sanur, a half-hour commute from Ubud.

Above: *View from banquette seating of the Helmi living room looks past lotus pond to a sweep of lawn and gardens and then on toward a* sawah *landscape.*
Following left page: *The courtyard just inside the stacked-slate walls of the main entry is a bamboo garden. Beyond the garden is a pavilion that was at one time the children's room. The children are now grown and the pavilion is converted to a guesthouse. The walls of this pavilion are bamboo matting.*
Following right page: *Traditional* wayang *figures of the* Mahabharata *are a central theme on this inlaid mother-of-pearl doorway. Style of the door is attributed to east Bali, Karangasem Regency, or perhaps West Lombok.*

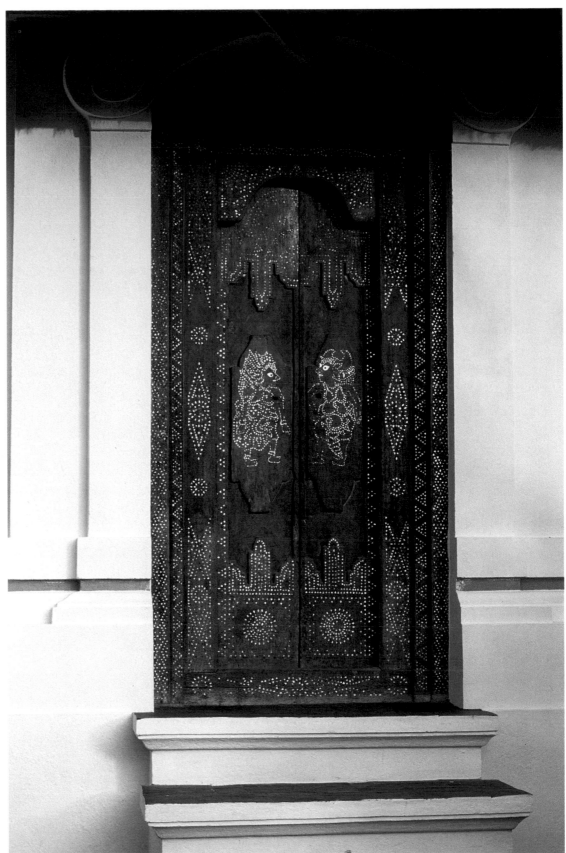

ACKNOWLEDGEMENTS

We would like to acknowledge the following people for their help, cooperation and ideas without which much of this book would not have been photographed: Aurora, Brian Bryce and Hyatt International, Michael Burchart and the Four Seasons, Chris Carlisle, Ida Anak Agung Gede Agung, M.A. Dion, Linda Garland, Nyarie Hassalabbey, Brent Hesselyn, Kamal Kaul Khan and the Oberoi, Ni Pollok Le Mayeur, Leonard Lueras, Nancy Mary, Milo, Frank Morgan, the family of Puri Denpasar — Bangli, the family of Puri Karangasem, the family of Puri Sidan — Bangli, Wayan Pendet and the sculptors of Nyuhkuning, Putu Suarsa, Ida Bagus Putu Suarta, Kenichi Tashiro and the Imperial Hotel, Soosan and Wana, Kent and Flora Waters, Wija Waworuntu, Made Wijaya, Adrian Zecha and Aman Resorts, and many others too numerous to be listed here. And a special thanks to the people of Bali in general for so generously allowing their homes and temples to be photographed.

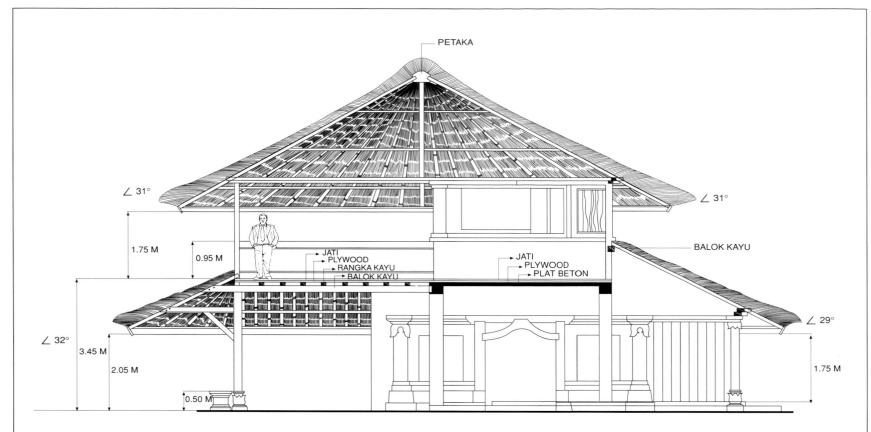

PETAKA

∠ 31°

∠ 31°

BALOK KAYU

1.75 M

0.95 M

JATI
PLYWOOD
RANGKA KAYU
BALOK KAYU

JATI
PLYWOOD
PLAT BETON

∠ 32°

∠ 29°

3.45 M

2.05 M

1.75 M

0.50 M

Plan A

Section drawing of the main pavilion, M.A. Dion's house in Kedewatan shows both lower and upper floors. Upstairs sleeping room is surrounded by four walls with a large thatched roof floating above the sleeping room and upstairs balcony.

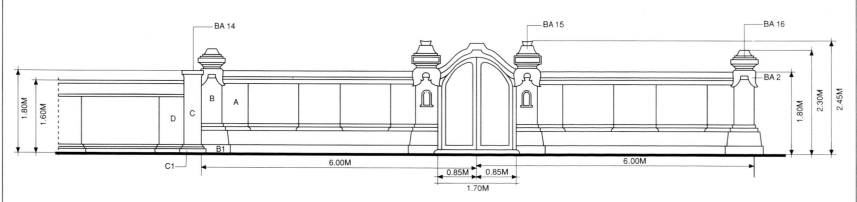

BA 14

BA 15

BA 16

BA 2

1.80M

1.60M

B

A

D

C

2.30M

2.45M

1.80M

B1

C1

6.00M

0.85M 0.85M

6.00M

1.70M

Plan B

Elevation of compound walls, M.A. Dion's house.

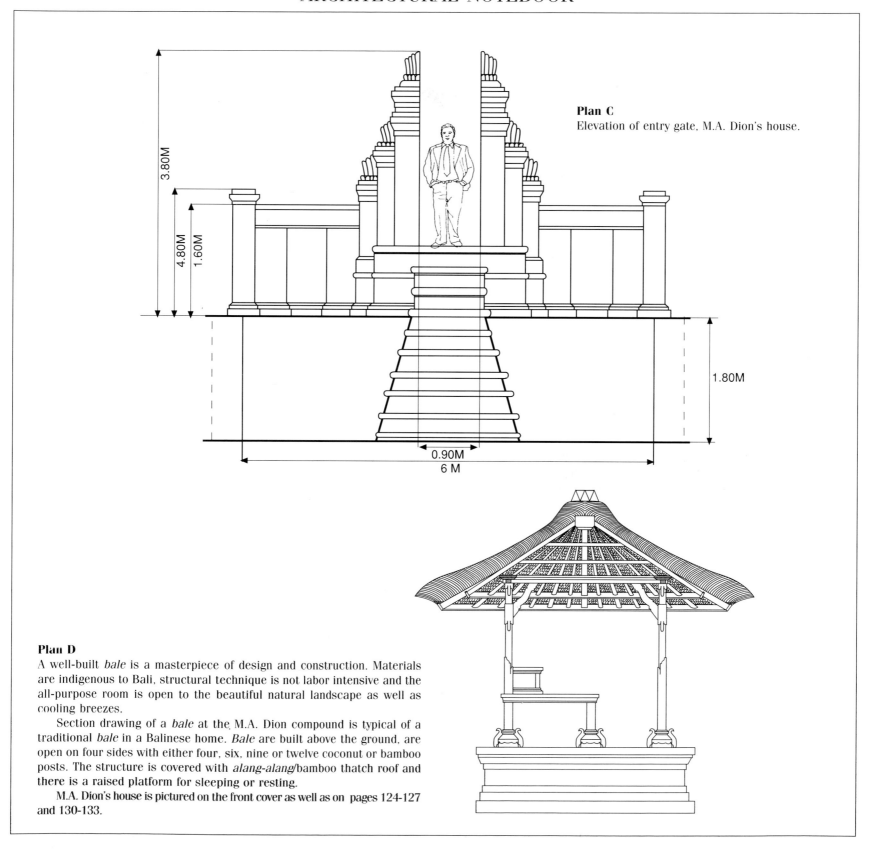

Plan C
Elevation of entry gate, M.A. Dion's house.

3.80M

4.80M

1.60M

1.80M

0.90M

6 M

Plan D

A well-built *bale* is a masterpiece of design and construction. Materials are indigenous to Bali, structural technique is not labor intensive and the all-purpose room is open to the beautiful natural landscape as well as cooling breezes.

Section drawing of a *bale* at the M.A. Dion compound is typical of a traditional *bale* in a Balinese home. *Bale* are built above the ground, are open on four sides with either four, six, nine or twelve coconut or bamboo posts. The structure is covered with *alang-alang*/bamboo thatch roof and there is a raised platform for sleeping or resting.

M.A. Dion's house is pictured on the front cover as well as on pages 124-127 and 130-133.

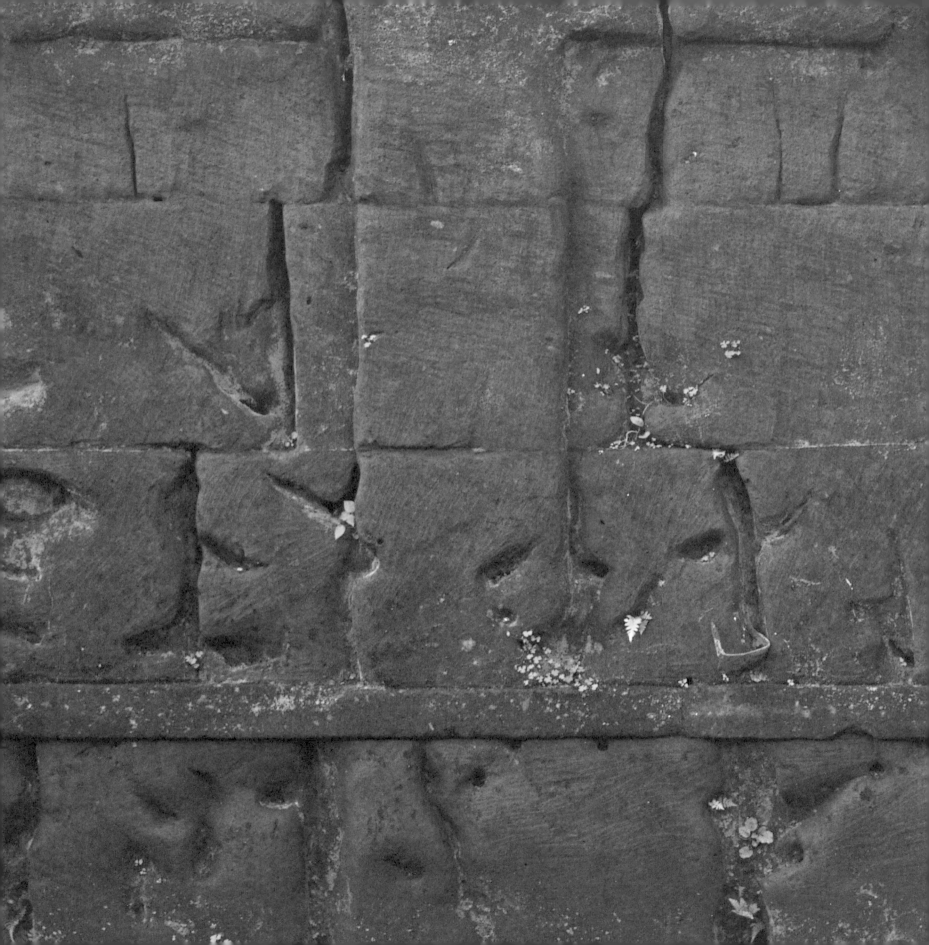